PRAISE FOR STEPHEN LEE NAISH

Create or Die: Essays on the Artistry of Dennis Hopper

'This painstakingly researched monograph is a welcome addition to the growing body of critical work on Dennis Hopper. Sharp in detail and perceptive on the popular cultural context, Naish strikes a judicial balance between loving portrait and his keen awareness that, above all, it is personal weaknesses and failings that have driven the phenomenon that is Hopper — an actor unable to play anyone other than himself; an artist, obsessive, as all great artists are. Naish's study comes closer than any other to understanding this phenomenon.'
— **Alexander Graf, Senior Lecturer School of Film, Photography & Digital Media, University of South Wales, author of** *The Cinema of Wim Wenders: The Celluloid Highway*

'Stephen Lee Naish offers a meticulous and passionate study of Dennis Hopper's astonishing output, which frequently broke with conventions. Naish shows Hopper as a man who considered himself a "social critic," but one who could never escape his most indelible creation. Naish writes with great clarity and sense, bringing to life this towering figure of Hollywood legend.'
— **Matthew Alford, Author of** *Reel Power: Hollywood Cinema and American Supremacy*

Deconstructing Dirty Dancing

'*Deconstructing Dirty Dancing* reveals what *Dirty Dancing*'s devoted fanbase has known for years: that the film tackled sophisticated, progressive themes with dignity, courage, and a catchy soundtrack. Rest assured, the political can indeed be pleasurable.'
— **Liza Palmer, Managing Editor of** *The Moving Image*, **Co-Editor-in-Chief of** *Film Matters*, **Contributing Editor of** *Film International*

U.ESS.AY: Politics and Humanity in American Film

'In this book, Stephen Lee Naish gives a discerning look at American film and popular culture over the course of the last half-century. Moving from Dennis Hopper to David Cronenberg, from the robot sexuality of *Star Trek* to the aesthetic aspirations of North Korean dictators, and from low-budget "mumblecore" production to Hollywood's disaster-movie blockbusters, Naish shows postmodern cinema as a funhouse mirror reflecting all sorts of quintessentially American (and anti-American) compulsions.'
— **Steven Shaviro, author of** *Post Cinematic Affect*

Riffs and Meaning: Manic Street Preachers and Know Your Enemy

'Like many bands worth obsessing over, the Manic Street Preachers are virtually unknown here in the States. [But this is a] passionate discourse about a divisive album that you should absolutely listen to again immediately.'
— **John Sellers, author of** *Perfect From Now On: How Indie Rock Saved My Life*

'In *Riffs and Meaning*, Stephen Lee Naish does a great service by creating a solid context for the band — how it developed and how it intersected with its rivals and critics (both in the press and on the stage). Centering his attention on one of their thorniest, most sprawling albums, *Know Your Enemy*, about which even the band has seemed ambivalent, Naish explores how the "untameable child of Manic Street Preachers' records" was a fundamental work, finally letting them escape the shadow of their lost guitarist/songwriter Richey Edwards and "to forge a different version of the Manic Street Preachers that was almost completely set apart from their previous incarnations."'
— **Chris O'Leary, author of** *Rebel Rebel: The Songs of David Bowie, 1964-1976*

Screen Captures
Film in the Age of Emergency

OTHER BOOKS BY STEPHEN LEE NAISH

U.ESS.AY: Politics and Humanity in American Film
(Zero Books, 2014)
Create or Die: Essays on the Artistry of Dennis Hopper
(Amsterdam University Press, 2016)
Deconstructing Dirty Dancing (Zero Books, 2017)
Riffs and Meaning (Headpress, 2018)

SCREEN CAPTURES

film
in the age
of emergency

STEPHEN LEE NAISH

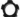 VANCOUVER | NEW STAR BOOKS | 2021

NEW STAR BOOKS LTD
No. 107–3477 Commercial St., Vancouver, BC V5N 4E8 CANADA
1574 Gulf Road, No. 1517 Point Roberts, WA 98281 USA
newstarbooks.com · info@newstarbooks.com

The publisher acknowledges the financial support of the Canada Council for the Arts, the British Columbia Arts Council, and the Government of Canada.

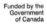

Cataloguing information for this book is available from Library and Archives Canada, www.collectionscanada.gc.ca

Cover design by Oliver McPartlin
Typeset by New Star Books
Printed and bound in Canada by Imprimerie Gauvin, Gatineau, QC

First printing September 2021

For J, H, and I

Hollywood and Disneyland are the legacy of Europe's cultural imperialism. We gave them nursery rhymes and they gave back film. Televised riots are as American as Barbie/Big Macs. Tomorrow the riots will be forgotten but Mickey Mouse will still be there. Welcome to Disneyland.

— Richey James Edwards (Manic Street Preachers)

Film is a very, very powerful medium. It can either confirm the idea that things are wonderful the way they are, or it can reinforce the conception that things can be changed.

— Wim Wenders

CONTENTS

Preface — xv

Shut Up, Capitalism! — 1

Star Wars Accelerationism — 13

Post-Catastrophe Cinema — 38

Metropolis Now! — 54

Men on the Verge of a Nervous Breakdown — 70

Northern Exposure — 99

The Middle Word in Life — 113

Being Nicolas Cage — 126

All-American Tragedy — 137

The Opening Line — 143

Crying at Robots — 148

The Slow Dissolve — 163

Afterword: Cinema During and After a Pandemic — 177

Acknowledgments — 185

Sources — 187

PREFACE

There is a scene in Noah Baumbach's 2005 film *The Squid and the Whale* in which the middle-class, Brooklyn-based Berkman family debates what to go and watch at the nearby movie theater. As the film is set in the year 1986, Walt Berkman, the family's teenage son, suggests they all should go and see *Short Circuit*, which stars Steve Guttenberg as a robotics scientist tracking down an escaped talking military robot that thinks it's alive. Walt's father, Bernard, an English professor and once-promising novelist, comments that "*Blue Velvet* is supposed to be quite interesting." We then cut to a packed movie theater in which the audience watches Isabella Rossellini naked and screaming and Laura Dern breaking into a silent sob. Yes, the family goes to watch *Blue Velvet*, the supposed intellectual film that features rape, violence, and sinister bad guys, over the film that is disregarded as mere childish popcorn entertainment.

I like this scene for several reasons, but it also neatly explains this book and my own love of intellectual art-house movies and Hollywood entertainment spectacles. I still have the same debate with myself that the Berkman family had whenever I'm scrolling Netflix or Kanopy. Whatever I settle on, I have always believed that film, no matter where it comes from, how much money was thrown into its production or marketing, who it stars, or whether it is considered high art or low entertainment, still says a great deal about who we are, where we come from, and what we can strive to be. This book is hopefully a testament to that internal battle.

And, yes, you will find *Short Circuit* and *Blue Velvet* within these pages.

SHUT UP, CAPITALISM!

Does it sometimes feel like you don't exist?

That is a hard question to answer when your existence is right in front of you and surrounding you as you read this. The question, I suppose, could be better reframed along the lines of "Does it sometimes feel like *they* don't know you exist?"

Our lives feel as if they are spent in the confines of a Morrissey lyric — lonely, sad, ignored, and belittled at every turn. Heaven knows we *are* miserable now. Everyday *is* like Sunday. At work, the clock ticks to knock-off time, and on the long commute home we might alleviate the tedium with a pulse-racing game of *Candy Crush* or *Pokémon Go* on our phones, or allow a Spotify-created playlist to soothe our souls while we scroll through the rich kids of Instagram, or doomscroll Twitter. Life might be bad, but there's always something worse out there. Small victories need to be found in the one-sided game that is neoliberalism. We exist, we are sure of it. Do we count? That we can't be certain of. We are not seen, at least not in the way that the super-rich and the super-influential are seen.

And to the wealthy and privileged inhabitants of Earth, we don't exist. Their own existence is so far-removed from ours that they inhabit what is by all accounts a parallel dimension, one that seamlessly occupies our own, but where we are invisible. We can, thanks to social-media feeds, gawk into this dimension at any time, in fact we are encouraged to do so, but we can have very little interference or interaction with it. We can't influence anything the rich and powerful do, think, or feel. We can tag them in a retweet or

1

a comment that condemns their awfulness, or try to cancel them when they endorse a problematic product or position, but they have muted our existence. They will not respond to our DMs or "like" our comments.

Electorally, we vote to have our say, but as many have realized in recent times, they are "all the same anyway" and "only out for themselves." We are on our own. They show little connection with the common folk, and when they do try a little human touch they come across as grossly fake and phony. We see right through their act and we ridicule them for it online, yet the criticism, if acknowledged at all, simply rolls off their back and they go on being the charlatans and schemers they have always been.

The answer to this might be to tax the wealthy and powerful at a much higher rate than they currently are, and to break up their monopolies and enact a public takeover of their assets. There is no better way to level the playing field than to bring them into our realm of existence.

Yet, when there is a hint of debate about higher taxation on the rich, as has been mooted on numerous occasions by U.S. Congresswoman Alexandria Ocasio-Cortez and Senator Bernie Sanders, the rich suddenly attend exclusive economic forums and turn up on television chat shows arguing for their right to be billionaires and the inherent good that the moneyed class offers in philanthropic support. Occasionally, a billionaire, seeing a spook in their future, runs for a public position of power (as Starbucks CEO Howard Schultz considered doing in 2020), and sometimes they even win (here's to you, Donald!) on a catastrophic collection of lies and false promises about "draining the Washington swamp" in order to rid the top echelons of the elite and powerful.

From an American perspective, though one I believe translates well to any situation across the globe, journalist Chris Hedges talks about this in an interview with the Real News Network's Paul Jay, where he states that the uber-rich "live in self-encased bubbles. They

have no real contact with reality. I mean, they don't even fly on commercial airlines."[1] Hedges continues to point out that the rich and powerful operate on a separate astral plane from the rest of us, one of private, gated communities, plush travel arrangements, and the brute force of security personnel that, when they do venture outside to breathe the same air as we do, shields them from any interaction with the plebeians. We can shout at them all we like. It is basically a Twitter comment they'll never read because the notifications have been turned off. We are ghosted by the rich.

Sure, we'll call it out when we see it. We must. When the Queen of England, for example, offers up a televised lecture about the need to put our differences aside and reunite as a nation after Brexit has ripped the very fabric of the country apart, and while doing so lies seated in front of a gold grand piano that, if pilfered from the castle by the revolting citizenry, would feed and clothe an austerity-hit community for years, we collectively meme the hell out of it. And when celebrities offer a rendition of John Lennon's "Imagine" (a song that received some well-deserved criticism even on its original release) during the Covid-19 health crisis, from the lush surroundings of their million-dollar homes, while the rest of us struggle with financial hardships and rented accommodation, we obviously must call it out, but the lesson is never learned. And when the rich and beautiful swan off to an exclusive luxury music festival in the Bahamas but it goes sour, with little infrastructure to support the influx of the pampered class, we collectively laugh at them as they endure what by their accounts is a minor humanitarian crisis. Minor humanitarian crises are, of course, becoming our daily lives. It feels great to use these moments to let off a little steam before an all-out rupture of anger engulfs us.

So here's the thing. The left is often ridiculed in the media and indeed by the wealthy class for wanting to believe in a better world and having the desire to strive for achievable goals and things that existed even a generation or two ago. Free education, subsidized

health care, workers' benefits, affordable housing, and fair taxation are now laughed out of the room as unreasonable wants. We are told again and again what we were told by billionaire Michael Dell at the 2019 World Economic Forum in Davos: "Name a country where that has worked, ever."[2] So we universally call out and point him toward examples where it has worked multiple times in recent history, including in the United States, and we are still informed that what we want is a fantastical version of socialism. "Who's paying for it?" they ask. "You!" is the response they should hear from us.

Beyond these reasonable demands, the dreams of a radical future that might include something like a universal basic income, full automation, or a Green New Deal are deemed magical thinking. To put it bluntly: these dreams could never come true under current forms of capitalism. Yet the rich, powerful, and privileged few have created their utopias. They are living a socialist ideal, one explicitly revolving around and benefiting them. The fiction that we are told can never become real already has.

Their magical thinking has become a reality. They roam the earth in a bubble of wealth, sealed off from the world's political problems, its uprisings and issues, and its environmental catastrophe; even though they influence all these events, they suffer little consequence in the outcome. Win or lose, it is always a win for them.

II

But what if we singlehandedly remove ourselves from the so-called neoliberal hellscape? How? It isn't easy. Sometimes the leap must be massive. Sometimes that leap goes beyond even rational thinking, bridging into pure fantasy. But, like I said above, the wealthy of the world have breached the fantastical barrier. They are living their own fantastical life.

So where do we look? Or who do we look to? What examples can we find in which the poor and downtrodden, the working class

and the precariat, kick back against the wealthy and corrupt and win the day?

Over the past decade or so, there has been an interesting and noteworthy influx of superhero movies in which the protagonists have zero superpowers and very little charisma. Yet they are overcome with an intense desire to fight crime and rid the world of evil, tyranny, injustice, and corruption. Taking on the persona of a comic-book superhero, donning a costume, and designing makeshift weaponry, the non-super-superhero vigilante tackles crime and injustice in often haphazard ways and at great personal risk to themselves and indeed others.

The recent trend started, at least to my mind, with the low-budget Canadian film *Defendor*, which was released to little fanfare in 2009. The film follows Woody Harrelson's shy and naive Arthur Poppington and his superhero alter ego Defendor in a battle against his archnemesis, Captain Industry, who turns out not to be a lone mastermind but a cabal of "captains of industry." Basically, Defendor is fighting against the tyrants of capitalism.

The non-super-superhero idea reached a more mainstream audience the following year with the comic-book adaptation *Kick-Ass* (2010), in which nerdy high-school student Dave Lizewski becomes the superhero Kick-Ass in a vain attempt to become popular and cool with his peers. Kick-Ass dons a dark green scuba suit and picks up a pair of nunchucks. He does have a superpower of sorts: after being knocked down by a car and having several bones replaced with metal, he realizes that he can endure more pain than the average person, as well as take and dish out harder hits. The same year that *Kick-Ass* hit cinema screens, two smaller productions followed. In the James Gunn–directed *Super*, lifelong loser Frank Darbo (Rainn Wilson) receives a vision from God and adopts the persona of the Crimson Bolt — whose calling card is "Shut up, crime!" — to take revenge on the drug lord Jacques (Kevin Bacon), who stole his wife and forced her into drug dependence. In the process of his vengeance,

he even picks up a plucky sidekick who goes by the name of Boltie (Elliot Page). Boltie also has zero superpowers, but does have a keen interest in comic-book lore and a thirst for bloody violence and drama.

The Australian film *Griff the Invisible* ventured into sweet romantic territory, an element often ignored within the subgenre, when Griff is encouraged by his love interest Melody to delve further into his imaginary superhero persona.

Then, in 2011, director Michael Barnett went looking for real-life vigilantes on the streets of America in the documentary *Superheroes*. What might have been an opportunity to ridicule a delusional subculture emerges as the most positive reinforcement of the idea of the non-super-superhero. Barnett tracks these everyday heroes performing acts of generosity and charity around their cities and placing the well-being of others above their own. In some instances, it's as simple as temporarily taking the keys from a drunk driver or handing out leaflets advising about a potential flasher in the vicinity.

Kick-Ass 2, released in 2013, continues Dave Lizewski's story as Kick-Ass. This time, because of his immense self-sacrifice, other non-super-superheroes join the cause, creating a team called Justice Forever, led by a former mobster turned born-again Christian, Colonel Stars and Stripes (Jim Carrey), who borders on violent vigilante instead of do-gooder superhero. Most of Justice Forever are regular people without violent tendencies who just want to raise awareness of the dangers the city provides and wear awesome costumes. On the flipside of Justice Forever is the film's antagonist, the Motherfucker (Christopher Mintz-Plasse), who with his enormous wealth recruits low-life criminals to form a non-super-supervillain team called the Toxic Mega Cunts.

The emergence of these movies was somewhat timely, considering the political and cultural climate of the era. From 2008, in America, and indeed in the rest of the world, the biggest economic crash since the Great Depression of the 1930s had affected millions of citi-

zens, foreclosing on their homes, leaving them unemployed, taking away their livelihood and health care, and slashing their benefits and pensions. While this was happening, a handful of CEOs and shareholders of major corporations and banks took home excessive bonuses on top of already unimaginable annual paychecks. The damage done by the financial institutions to the world economy was devastating for most people. This takes us back to our original point about the wealthy not operating within the same realm as the rest of us. Despite the obvious criminality of their actions, no banker, hedge-fund manager, or financial speculator has been imprisoned.

Further afield, demonstrations and vigils for democratic change and accountability spread throughout the Middle East and North Africa, with citizens calling for fair elections and more personal, political, and religious freedoms. Libya, Tunisia, Egypt, and Yemen ousted their long-time dictatorial leaders and instigated a democratic uprising, which is still today unfolding and facing the challenging extremes of putting a fair and representative democracy in place where one hasn't existed in living memory. The world from 2008 onward seems like a very fraudulent place. The rise of non-super-superhero vigilantes in film and their predecessors in comic books allows for an outward venting of anger and frustration toward the wider world. But it works both ways. While the protagonists of these films get their vengeance by justified means, we the audience can relish the results. As the non-super-superhero has limited powers and is just as walked-over and belittled as we are in real life, we can place ourselves in the frame and imagine it's we who are taking back power and delivering justice. This is the very reverse of what the superheroes of the Marvel Cinematic Universe or the DC Universe represent. Captain America, Thor, Hulk, and Captain Marvel have inherited or been granted powers beyond anything we ourselves could ever imagine. Of course, one could argue that Iron Man, Black Widow, Hawkeye, and even Spider-Man represent the common folk by being ordinary humans with extraordinary capabilities comple-

mented by immensely powerful AI suits. I would argue that their involvement with super beings and the protection that offers mean that they have no right to be representative at all. Most of us do not have the privilege of being under the protection of benevolent gods or jacked-up super soldiers.

And therefore these non-super-superhero films that have been discussed above are so impactful and offer a more realistic narrative that anybody from any background can relate to. In these films, Kick-Ass, Defendor, the Crimson Bolt, Griff, and the legions of real-life non-super-superheroes in Michael Barnett's documentary don the outfits of superheroes, adopt the manner of crime fighters, and attempt to promote and preserve good community spirit. They are just like you and me. Good people trying to do some good in the world. They just happen to wear a cape and a mask.

There is some irresponsibility in the form of extreme violence in some of the films mentioned above. In *Super*, for example, the Crimson Bolt smashes a queue jumper across the head with a wrench, while Jim Carrey denounced *Kick-Ass 2* a month before it was due to be released to theaters because of the film's scenes of violence and torture. But putting this aside, what emerges is an interesting thread. In all these films, there is a desire in the protagonists to fight corruption and right societal wrongs that have been inflicted on the individual by the unseen forces of capital. This is an interesting idea because it is so out-of-step with the normality of the real world and superhero movies in general, where the desire is often to maintain, as Superman states, "Truth, Justice, and the American Way." The non-super-superheroes of these films, while certainly out for "truth" and "justice," are actively against the jingoistic rhetoric of the "American way." They have seen that this way of life is crippling to many and leaves great swaths of people behind.

The trials and tribulations of late capitalism have deeply affected us or, at the very least, someone close to us. We are ultimately aware of the culture of corruption, double-dealing, and fraud that is awash

within financial and political sectors the world over. We know that massive corporations cheat to get what they want and take from those they regard as inferior or those they exploit and withhold resources from. We know that governments use ever more evasive technology to spy on us, intercept our emails, record our phone conversations, log our every move online, and continually squeeze our personal freedoms. We know that vast portions of the media are owned by a few billionaires who are happy with the status quo and will falsely report, or simply ignore, unflattering stories of elitist corruption. At work, we either run ourselves ragged trying to make the grade or are installed in what the late anthropologist David Graeber so eloquently titled "bullshit jobs," jobs that pay us to occupy a space for eight-to-twelve hours a day without doing much of what might be considered actual "work."

The media constantly feeds us false leads, showers us with inane and distracting celebrity gossip, and uses its power to enact a regime of influence and propaganda. Collectively, we have made our voices of discontent heard, through movements, protests, and online petitions, yet no absolute change has been forthcoming from the institutions that have rendered our world grossly imbalanced. Even voting in a fair election cycle is turbulent, with the loser knowingly sowing the seeds of fraud in the results.

The lone non-super-superhero offers us a reprieve, an icon of justice and caring: an individual who is willing to face down corruption from any angle and fight for the common good. With no special physical powers to speak of, they are just like me and you.

There is still a disconnect between the way we feel and what we witness on-screen. When, having just witnessed Kick-Ass deliver a mighty bazooka blast to the bad guy — or heard the Crimson Bolt scream into the face of Jacques that "You don't butt in line! You don't sell drugs! You don't molest little children! You don't profit off the misery of others! The rules were set a long time ago! They don't change!" — we leave the cinema, we return to a world that is still in

the later stages of corrosion, misery, and trauma. All the things that the Crimson Bolt thinks shouldn't happen are continually happening on a larger scale than ever before.

However, there is still hope. The real-life, non-super-superheroes documented in Michael Barnett's film, who walk the dangerous city streets and promote awareness of personal safety while the police avoid or antagonize the situation, who give food and clothing to the poor and homeless when the funding for such vital things is cut by government spending reviews and austerity measures, who organize community events when the idea of community and togetherness has all but evaporated — these people should be applauded for bravery and raised to the status of real-life heroes for acting out and acting against the monotony and corruption of our modern existence.

The media might want to paint these superheroes as kooks, drunks, psychos, and troublemakers who stand in the way and make a mockery of real justice often dealt out in savage terms by law-enforcement officers. But those who are lucky enough to have been on the receiving end of a real-life superhero's generosity and compassion will know different.

The modern idea of a superhero has been ingrained in our culture for nearly a century. And well before this, we had myths, legends, and epics that informed the reader (or listener) of superpowered men and women. We have all imagined having those powers and using them for the good of all humanity. Yet we all have within us the greatest of superpowers, the powers of compassion, generosity, and love. We have been told that we can't have a world that is ruled by these instincts — that our world must be dominated by greed, conflict, war, and injustice to be stable and to keep progressing. As citizens, we don't need to don a mask (though, let's face it, 2020 and beyond is proving to be the era of the mask!) or a costume, nor to create a persona, to be superheroes. We don't need to partake in acts of extreme heroism. But we do need to begin living in a way that embodies a moral superiority to unfettered capitalism and

what we are told we must want through advertisements, celebrity, and the manipulation of the truth by the media. As individuals, we can enact small changes, but determination is the key to creating a world we all desire.

We've always known this, but the Covid-19 pandemic has shown us more clearly than ever that heroes exist in real life: first responders, health-care workers, grocery-store clerks, public-transport workers, teachers and educational assistants, food-delivery drivers, and taxi drivers, to name a few of the essential workers who have kept the threads of our societies functional. A reorganization of the economy and society around these real-life heroes will give us the language and the demonstrative powers they/we hold. It will be up to us to continue this trend when the pandemic subsides, and "ordinary" life continues. But let's not settle for ordinary, let's strive for extraordinary. As the Crimson Bolt says, "I can't know that for sure, unless I try."

We will exist again.

The Watchlist

Defendor (2009)

Super (2010)

Griff the Invisible (2010)

Superheroes (2011)

Kick-Ass (2010)

Kick-Ass 2 (2013)

Chronicle (2012)

STAR WARS ACCELERATIONISM

When Bill Murray famously sang "Star Wars/Nothing but Star Wars/Give me those Star Wars/Don't let them end" in the guise of Nick the Lounge Singer on *Saturday Night Live* in the late 1970s, he probably had no idea how much Star Wars Lucasfilm and Disney would actually be giving us. The sheer abundance of Star Wars content that is set to land on the Disney+ streaming service, and potentially in theaters as well, in the not-too-distant future is mind-boggling. It is safe to say that we have entered a fourth phase of the space-based saga. The first three phases, the Original Trilogy released between 1977 and 1983, the Prequel Trilogy released between 1999 and 2005, and the Sequel Trilogy released between 2015 and 2019 have created a nine-film narrative arc of tragedy and redemption on a galactic scale, and all have followed the lineage of Anakin Skywalker and his offspring Luke and Leia. Alongside the films, television shows such as *Star Wars: The Clone Wars* (2008–2020) and *Star Wars Rebels* (2014–2018) have filled in some exposition around the main story arc of Anakin's fall to the dark side of the Force and Luke's redemption of his father.

The coming phase, which has already begun with the first two seasons of *The Mandalorian* series, is clearly opting for a scaled-down version of storytelling that is better viewed on a television screen rather than a cinema screen. Though films are still expected in the future, the real thirst in the fanbase is for Disney to create content for its streaming service and to get audiences excited about the idea that the Star Wars Universe can begin to incorporate a whole host

of new ideas, perspectives, and characters that do not rely on or have any relation to the grandiose Skywalker saga. The whole enterprise can play out in much slower and much more precise ways than a movie can muster in its limited time onscreen.

At the moment of writing there are nine Star Wars television projects in the pipeline. All of these will be released on the Disney+ streaming service in the coming years. This is an unprecedented abundance of content, rivaled only by the Marvel Cinematic Universe (MCU) franchise of films (also owned by Disney) and the influx of Marvel television shows that began with the debut seasons of *WandaVison* and *The Falcon and the Winter Soldier* in early 2021. The key word here is *content*. While these shows will no doubt contain elements that tap into the surrounding universe of Star Wars lore, they are primarily designed to support a business model that has come to rely on the small screen as opposed to the big. Streaming is becoming, if it is not already, the dominant format for release of new films and shows.

There is a second industry that Star Wars supports, and that is the fan theories that crop up and are dissected via forums such as threads on Reddit and extensive videos on YouTube. The content of the whole history of Star Wars movies and now Star Wars television is being torn into to find little nuggets that feed a bigger theory, one that basically suggests that the audience interpretation of anything Star Wars–related is the correct interpretation. The war within the Star Wars fandom is somewhat confusing, but it is one that is creating an interesting cultural moment that demands exploration. It boils down to two sections of the fandom. The first involves fans of the Original Trilogy of the late 1970s and early 1980s, which also encompasses the Prequel Trilogy of the late 1990s and early 2000s. This could be considered the pre-Disney era of Star Wars. You don't have to have seen the original run of the films in theaters; you just need to be passionate about and supportive of Star Wars creator George Lucas's vision. The second section is the younger

fanbase that is happy with the abundance of new Star Wars content and, although passionate about the Original and Prequel trilogies, is more excited about the diversity that the Disney future holds in the hands of various directors, writers, showrunners, and actors.

When Disney purchased the Star Wars brand toward the end of 2012 for over $4 billion, the entertainment conglomerate pushed to have a new film in theaters with almost immediate effect and committed to releasing a film almost every year to claw back its vast investment. And from 2015 to 2019, that is exactly what it did with the Sequel Trilogy and the two standalone movies, *Rogue One: A Star Wars Story* and *Solo: A Star Wars Story*. It also created a run of new animated shows, *Star Wars Rebels* and *Star Wars Resistance*, that fell in and around the Original and Sequel Trilogies.

This chapter will predominantly deal with the Sequel Trilogy released by Disney from 2015 to 2019. It will also take in *Rogue One* and *Solo*. These two films, though distant from the Skywalker saga, do directly link to it via events and characters that appear. In *Rogue One*, for example, the Rebel Alliance, our team of heroes who fight against the dreaded Galactic Empire, steals plans for the Empire's new planet-destroying weapon called the Death Star. This act is mentioned in the opening crawl of *Star Wars: A New Hope*, and the Death Star suffers obliteration because of the Alliance's earlier infiltration of the Empire's facility. Although never touted as such, *Rogue One* acts as a direct prequel to the Original Trilogy.

Solo also exists within the timeframe and events of the Original films and features the early career of Han Solo, Chewbacca the Wookiee, and the rogue Lando Calrissian. *Solo* even shows us legendary events such as Han Solo's infamous Kessel Run that he boasts about in *A New Hope*.

The collection of movie trailers that first appeared in the promotion of *Star Wars: The Force Awakens* in late 2014, and, one could argue, the entire strategy that Disney employed for the film's marketing campaign from then on, were a successful exercise in the art of the

tease. In November 2014, a short one-minute-and-twenty-six-second teaser trailer revealed very little of the forthcoming film's narrative or characters, yet still had fans salivating for what was to come. The fandom began by picking apart bits of information and posting theories and opinions to forums such as Reddit and the comments sections of YouTube videos. These theories were then picked up by the mainstream media and fed back to the wider fanbase through articles, tweets, and blog posts, causing a feedback loop of excitement that spread wider and beyond the Star Wars hardcore.

In April 2015, a more satisfying extended trailer was released that featured some incredible action footage, revealed some new characters, and reunited us with old ones from the Original Trilogy of Star Wars films (Han and Chewbacca, in this case), yet still didn't give away any narrative pointers. The international trailers and TV spots that were issued in the run-up to the film's release on December 18, 2015, were variations on the April trailers, adding and retracting footage to entice the fans and working them up in anticipation. One overzealous YouTuber even spliced together all the available trailers and on-set footage into one 13-minute short film, which is a remarkable and titillating experience; yet, as a viewer of this concoction, you soon realize that even within 13 minutes of actual on-set footage and thrilling effects there appears to be no concrete narrative arc, no solid character development, and no precise nature in which these random scenes coherently fit together. It is genius. We've been duped, and the decision to dupe us was always a conscious one.

I am a Star Wars fan myself, and this strategy in equal measure frustrated me and increased my interest in the film and the franchise as a whole to an almost fever pitch. It seemed to prompt a similar effect across the blogosphere of the time. The snippets of information, or lack thereof, amplified speculation about the film and created some far-fetched theories about the story arcs and character development. For example, so little at the time was known about *The Force Awakens* chief antagonist Kylo Ren that online writers and

bloggers argued that he could be a fallen Luke Skywalker or, at the very least, a dark-side acolyte of an evil Skywalker. The most absurd theory imagined that the mysterious Supreme Leader Snoke, who was completely absent from any marketing materials, was actually Jar Jar Binks, the clumsy and much-despised character from the Prequel Trilogy of films, who had somehow manipulated and masterminded an entire galaxy to his evil will. It was, out of many theories, the one that generated the most laughs, but some serious discussion and debate was had about Binks's motives for being the bad guy all along.

The whole marketing stratagem of *The Force Awakens* resulted in overwhelming excitement. Any still images from the film's set, the slightest morsel of information online or in print, and any quotations or tweets from the actors and crew were dissected for the tiniest of clues.

In this respect, the film's director, J. J. Abrams, and the Disney marketing department appear to have taken advice from the most experienced tease on the planet, the American burlesque dancer Dita Von Teese, although it could be argued that Abrams has used this tactic not just for *The Force Awakens*, but for all of his previous projects in film and television. His most prominent TV series, *Lost*, which aired from 2004 to 2010, was a masterclass in teasing the viewer to want to believe one thing or another, while never revealing the true nature of the series.

In the front matter of her 2006 book *Burlesque and the Art of the Teese/Fetish and the Art of the Teese*, Von Teese states that "I sell, in a word, magic, a world of illusion and dreams,"[1] and indeed Star Wars, with its notions of the unifying Force, its illogical approach to space and time (parsecs?), and its swashbuckling adventurism, also sells magic, illusion, and dreams to its audiences. Like the best forms of magic and illusion, it becomes apparent that the less one knows, the better the experience will be. Von Teese would obviously agree, as later in the book she informs the reader that "I entice my audience, bringing their minds closer and closer to sex and then — as a good

temptress must — snatching it away."[2] Indeed, *The Force Awakens* operated on the same titillating principle, without the "sex" of course. The release of enticing tidbits of information encourages the mind to speculate and build all kinds of absurdist scenarios and connect many unrelated dots. Then, as the "good temptress must," it is all snatched away, leaving us with more questions than answers and, dare I say, deeply unsatisfied with the actual outcome.

II

Yet the fan dissatisfaction with *The Force Awakens* didn't stop the same strategy from being applied to the film's sequel, *The Last Jedi*. Upon its release on December 15, 2017, thousands upon thousands of reviews, opinion pieces, YouTube videos, blog posts, and tweets were published within hours of director Rian Johnson's film hitting cinema screens across the globe. The critical response was overwhelmingly positive. Film critics jumped over themselves in a lavish display of righteousness as they universally proclaimed that, at last, a Star Wars film could be considered serious art.

Many noted that the visual spectacle was something to behold, the twists in the plot were remarkable and genuinely surprising, the performances from the original cast and the newer recruits were impressive. The overall arc meant that the original fans of Star Wars who were now pushing past 50 years of age could happily sit and immerse themselves in nostalgia, while a 13-year-old newbie of the franchise, whose only familiarity might have come from the *Star Wars Rebels* cartoon series of the animated *Clone Wars* series, would be swept along to embrace a whole new trilogy. This would become a perfect bridging between old expectations and new perspectives.

Except the audience response didn't quite gel with the critical one. Some fans walked out of screenings fuming at what they perceived as mindless nonsense and announced via social media that they were done with the Disney reincarnation (or zombification) of their

beloved Star Wars, and that any ounce of hope for Disney's vision of the franchise was lost to the clusterfuck of swerves and misses that *The Last Jedi* presented. An online petition gained momentum to urge Disney to eject the film from the official canon, proclaim it as an overly expensive fan film, and instantly begin a remake, preferably without the involvement of the dreadful and deceitful Rian Johnson.

My own experience of *The Last Jedi* was less dramatic than these reactions. It was extremely positive, if somewhat bewildering. I came out of my own screening utterly convinced the film was brilliant, but I also acquired in the following hours a throbbing headache as my neurons fired in an attempt to construct new pathways that could cope with this much change, this many twists, this much elation, this much disappointment. I was dizzy with chemical contradictions and imbalances. One could say the dark side and the light side of the Force flowed through me all at once.

For sections of the audience, the bones of contention were many, but two stand out among the din. The representation of a grouchy Luke Skywalker hiding out and sulking on the remote planet of Ahch-To caused concerns even in Mark Hamill, the actor who has lived and breathed Luke Skywalker for 40-plus years. In this chapter of the Star Wars story, Skywalker has broken off from the galaxy and now lives in exile due to a mishap in the training of Ben Solo, who succumbs to the dark side of the Force and becomes the evil teenage emo-dream Kylo Ren. Yet the representation of elder Jedi in the original trilogy matches Skywalker's grumpy depiction. For example, when the young Luke Skywalker first meets Obi-Wan Kenobi in the Tatooine dust bowl in 1977's *A New Hope*, Obi-Wan is an old, bearded, crusty hermit living off the land. When Luke jets off to the swamp world of Dagobah to find the "great warrior" Yoda in 1980's *The Empire Strikes Back*, he meets a frazzled, old, eccentric exile who also refuses to train him in the ways of the Jedi. Hamill's most consistent argument against Johnson's version of Luke was that "Luke would never have given up," but both Obi-Wan and Yoda had

thrown in the towel decades before for a life of exile, meditation, and solitude, while Darth Vader (a product of Kenobi's failure) tore up the galaxy in the name of the Empire. We, as an audience, have placed an awful lot of faith in Skywalker and the Jedi if we think they cannot have a major brood occasionally. Go back to 1977's *A New Hope* and you'll see that Luke's shortcomings as a whiny teenager (remember the strop he pulled when Uncle Owen told him he had to stay on the moisture farm for one more season) offer a trajectory to a lonesome hermit quite well.

The other point that many people took issue with was the First Order's Supreme Leader Snoke, a reptilian villain of immense Force power who, since his introduction as a gigantic hologram in *The Force Awakens*, had been, as discussed above, the subject of countless debates about his identity. Anticipation of his big reveal was intense, yet in *The Last Jedi* Snoke is killed off quite unceremoniously by his apprentice Kylo Ren during a brief interrogation scene that involves the film's female protagonist, Rey. The demise of Snoke seems to have genuinely shocked fans who want their Star Wars baddie to have depth, purpose, and wisdom. The Prequel Trilogy was as much Emperor Palpatine's backstory as it was Darth Vader's. The expectation to fill in the gaps in Star Wars is, well . . . expected. Yet *The Last Jedi* seemed to be at once a denouncement that all Snoke theories were problematic and that any theory one ever had about Star Wars was at this point utterly useless. The rule book was being rewritten and then simultaneously torn up by Johnson.

Snoke's introduction and his death might not be as odd as you'd think. After all, Star Wars is now a Disney-owned property, and one need only look toward Disney's other mega-franchise, the Marvel Cinematic Universe, to see that powerful antagonists are two a penny. For example, 2016's *Doctor Strange*, directed by Scott Derrickson, introduced the ancient demon Dormammu, a seemingly immortal being that nonetheless was defeated within the timeframe of the film by Doctor Stephen Strange, a man who had only recently discov-

ered his powers of wizardry. In 2017's *Guardians of the Galaxy Vol. 2*, directed by James Gunn, the antagonist Ego, a godlike Celestial who has traversed the universe for eons sowing his "seed," succumbs to the rag-tag Guardians in fairly short order. Sadly for the theorists, Snoke is nothing more than a simple narrative device for moving the action along and giving our heroes something to fight against and eventually overcome.

As I've now lived with *The Last Jedi* for a while and read many other opinion pieces and Reddit threads, the film has sunk in, and it is easier to conclude that *The Last Jedi* acts as the final page of George Lucas's creation and vision and the first page of a yet unwritten and collaborative vision of future Star Wars films and television shows. In fact, we shouldn't have been surprised to discover this was the film's intention. These seeds have been planted since Disney's takeover of the franchise. In the in-universe lull between *Revenge of the Sith* and *A New Hope*, the idea that Jedi were roaming the galaxy along with the Rebellion seemed nonsensical to the viewer. The Empire had taken care of and disbanded the Jedi Order in murderous circumstances. Luke Skywalker was the first Jedi to arise in this era. Yet, the animated television series *Star Wars Rebels* introduced the characters Kanan and Ezra, two rogue Jedi who survived the onslaught and continued their teachings while adapting to the idea of resistance to the Empire.

Rebels also introduced new perspectives on the Force with the character of the Bendu, a large, ancient creature who occupies the center ground between the light and dark sides of the Force. This wider perspective has bled into the latest Star Wars films, with *The Force Awakens* introducing the Church of the Force, a kind of fraternity of Force worshipers; Maz Kanata, an ancient being who confesses that she is "no Jedi, but I know the Force"; and Snoke's Force abilities, which are up for debate because he's not a Sith lord like Darth Vader or a Jedi knight, but something else, which will be revealed in due course (or will it?). The best and boldest inter-

pretation of the Force was seen in *Rogue One*, directed by Gareth Edwards and released in 2016 as a standalone story and, as described earlier, a loose prequel to *A New Hope*. The film saw the introduction of the character Chirrut (Donnie Yen), a member of the Guardians of the Whills (old Jedi textbooks) on the planet Jedha and a zealot for the Force. Though Chirrut has no Force capabilities, his belief and devotion to it means that he is a formidable and spiritually attuned warrior who, while completely blind, takes out a squad of stormtroopers in a matter of seconds.

So, *The Last Jedi*'s mission is to embrace a wider perspective for future films that move beyond the Skywalker saga and not, as Chancellor Palpatine remarks in *Revenge of the Sith*, "the dogmatic view of the Jedi." These films should be inclusive to all in terms of both audience and characters. Luke's admission to Rey in *The Last Jedi* that "it's time for the Jedi to end" echoes Kylo Ren's statement that to move on and progress we should "let old things die": the Rebellion, the Empire, the Sith, the Jedi, even the notion of Star Wars itself. An all-new perspective must rise to replace the old, sacred texts. This needs to happen within the narrative of future Star Wars movies, but it also needs to happen for those who will continue to watch these movies.

Disney has also had to face the fact that the Star Wars franchise's reliance on aging Gen-Xers and baby boomers had to end. These viewers (45 and above) are no longer the main active cinemagoers. The largest demographic now appears to be 15 to 25, the youngest of whom might still have been toddling around in diapers when *Revenge of the Sith* was last in theaters. When, in *The Force Awakens*, Rey, upon hearing the name Luke Skywalker, remarks that "I thought he was a myth," she's talking both within the film and to those newbies watching who have heard this name uttered by parents, aunts, uncles, and grandparents, and within popular culture, but the significance of Skywalker (even Anakin) to this generation is subject to debate.

The embrace of a new audience, one well-attuned to the cinematic

spectacle, but also coming from diverse backgrounds and demanding more stories that reflect this fact, is how the subsequent movies, television shows, and tie-in books, comics, and video games will hopefully play out. There is immense freedom to be found in dropping the legacy characters and events that surround them and exploring further afield. No longer will we the audience be constrained by the Skywalker lineage, the royal blood of the Force, and the baggage it carries. Now the galaxy far, far away can be anybody's for the taking, and that means the audience can place themselves right there in the middle of it. Seeing heroes who come up from nothing and come from diverse backgrounds, gender identities, or sexual orientations on-screen (even those that occupy a fictional, magical universe) will be mesmerizing and inspiring to young audiences. New Star Wars heroes and villains will emerge and fade within the next few years, but one thing is certain: the hero's journey should always be the prominent theme of these films.

III

Yet it was perhaps the older audience's reception of *The Last Jedi* and its attempt at breaking from the past that sent J. J. Abrams running in the opposite direction of what I have discussed above, and of the premise set by Rian Johnson when he returned to take the reins of the saga's final instalment. That, or an unrelenting feeling to just finish the franchise and be done with the toxicity of certain online aspects of the fandom. Either way, *The Last Jedi*'s follow-up and final chapter, *Star Wars: The Rise of Skywalker*, seems to want to run and hide and be forgotten quickly. This sense of speediness hangs over the Sequel Trilogy.

It wasn't always like this. There is an intriguing short documentary in the DVD extras of *Star Wars: The Phantom Menace* that, thanks to YouTube, I often revisit. The scene begins on November 1, 1994, and features George Lucas in his writing cabin, beginning work on

what will become the Prequel Trilogy. He takes the camera crew around his den, showing them his fresh legal pads and boxes of pens and clunky '90s desktop computer. He then collapses in his chair, exhausted by the prospect of writing these movies, and sighs into the air, "Now all I need is an idea."[3]

What fascinates me about this footage is the fact that Lucas set out to write a film series that wouldn't see the light of day for another five years. *The Phantom Menace* hit theaters in May 1999, and the subsequent films would be spread out over a further six years, with *Attack of the Clones* coming in 2002 and *Revenge of the Sith* in 2005. The Prequel Trilogy represents over a decade of dedication, not just on Lucas's part, but on the part of a whole team of creatives. As Lucas comments in the same clip, "It starts with me sitting here doodling in my little binder, but it ends up with a couple of thousand people working together in a very tense, emotional, creative way." The Prequel Trilogy, despite its faults in direction, pacing, dialogue delivery, and acting technique, as well as its racist stereotyping and narrative elements that hinder the overall arc of Darth Vader's origins, still stands the test of time and, like the Original Trilogy, has become a cinematic classic that has found a new life in the world of online memes and Reddit and YouTube theory posts. The dedication to scope, world-building, and mythology that might have slowed the films down to a death crawl, narratively speaking, has actually paid off in the long run.

Let's talk a bit about the process of "slow." Though I'm sure he wasn't thinking about it at the time, Lucas's decade-long endeavor is an excellent example of the slowness philosophy that is often applied to other outlets: slow cooking, living, parenting, teaching, travel, and technology. Slowness philosophy promotes attention to detail, to savoring the moment, to experiencing something at a leisurely pace. These are attributes that rarely apply to blockbuster cinema. Knowing that a decade of one's life is going to be set aside for the writing and production of three sci-fi/fantasy movies is impressive, but what is

more impressive is Lucas's 15-year gap between the Original and the Prequel trilogies. In cinematic circles, at least, Star Wars was all but forgotten by the general public when Lucas decided to resurrect it in the mid-1990s. Yet it still lingered among the original fanbase, and books such as Timothy Zahn's *Star Wars: The Thrawn Trilogy*, the first volume of which, *Heir to the Empire*, was published in 1991, and video games such as *Shadows of the Empire*, released in 1996, saw the presence and cultural influence of Star Wars still intact for some in the early-to-mid-1990s. The reissue of the special editions of the Original Trilogy into cinemas in early 1997, and their subsequent release on VHS and DVD, was the turning point in setting up renewed interest in Star Wars for a newer generation. For better or worse (the argument will have to be settled elsewhere), Lucas's digital tinkering with his original films, adding new scenes, ships, and characters in the background, gave the films a new life. The digital restoration by Lucasfilm and Industrial Light & Magic made the films look and sound as spectacular as any major blockbuster movie released that year. Given what Lucas could achieve with new technologies, the forthcoming Prequel Trilogy became much anticipated not only by older fans but also by a whole new generation of younger ones who fell under the spell of Star Wars.

The Rise of Skywalker rounds off the Skywalker saga. What took Lucas 28 years to complete with his two trilogies, Disney has managed (minus one film, though the two seasons of the Disney+ show *The Mandalorian* is arguably an epic, film-like production) in just five years.

I'm raising this point for several reasons. First, the nature of cinema has accelerated to the point of collapse. The Star Wars franchise is an excellent case in point, but let's look to the Marvel Cinematic Universe for an even more hyperreal example. The first two phases, beginning with *Iron Man* in 2008 and ending with *Ant-Man* in 2015, saw 12 films issued, six films per phase. Twelve films over seven years is somewhat excessive, but in no way compares

to Phase 3 of the MCU, which unleashed 11 films, starting with *Captain America: Civil War* in 2016 and ending with *Spider-Man: Far From Home* in 2019. Second, the "quality over quantity" aspect of slowness has been reversed in this new accelerated cinematic landscape, plus the Sequel Trilogy and the Star Wars anthology films have been critically shredded and, in some cases, angrily dismissed by the fanbase. All aspects of Disney's production, from story to direction, art design to acting, casting to costumes, editing to dialogue, have been dissected, ridiculed, memed, criticized, and dispatched. A cottage industry has developed in which fans of the franchise call Disney out on public platforms such as YouTube and Twitter. Some of this criticism is justified — the narrative swerves and odd characterization in *The Last Jedi* might seem counterintuitive for a blockbuster movie — while some of the criticism is uncalled-for and downright cruel.

One example is the continuous hounding and abuse of the film's stars. English actor Daisy Ridley, who portrayed Rey throughout the Sequel Trilogy, and Vietnamese-American actor Kelly Marie Tran, who played Rose in *The Last Jedi* and *The Rise of Skywalker*, abandoned social media completely after countless misogynistic and racist insults and trolling incidents. John Boyega, the British-Nigerian actor who was the first face to be seen in the debut trailer for *The Force Awakens*, also faced extreme racist trolling online and, despite his character Finn being a leading voice in *The Force Awakens* and a deeply interesting narrative-arc set-up, saw the potential of his character diminished in *The Rise of Skywalker* because of remarks made by some vocal "fans" of the saga. Boyega has taken his grievances directly to Disney, and in an interview with British *GQ* stated that "I'm the only cast member who had their own unique experience of that franchise based on their race."[4]

Here we can see the toxicity of portions of the fandom in play, and it isn't anything new or even the result of the rise of the internet and the endless torrent of criticism and opinion we now have. Jake

Lloyd, who portrayed the young Anakin Skywalker in *The Phantom Menace*, and Ahmed Best, who voiced Jar Jar Binks, have both been subjected to incidents of abuse by what might be perceived as the Original Trilogy fandom. But there are factions within the newer and younger sect of fans that show that this bullying and trolling experience will no longer be tolerated, even when the trolling tactics are coming from within Disney itself.

The actor and mixed martial artist Gina Carano, who was cast as former shock trooper Cara Dune in *The Mandalorian* Disney+ series, was ousted from her role after numerous fan-led social-media pressure campaigns called out Carano's alleged racism — or, at the very least, her opposition to the Black Lives Matter protests that swept American cities in the summer of 2020. There were also allegations of transphobia when Carano used the pronouns "beep/bop/boop" in her Twitter bio, and her continued support for President Donald Trump, which seemed to grate with Disney's image of liberalism and acceptance of minorities and nonbinary gender identities. But the final straw for Lucasfilm came when Carano posted on her Instagram feed a story that placed American conservatives on the same plane as persecuted Jews in Nazi Germany. The explosion of fan outrage forced Disney to remove Carano from any future Star Wars project. Despite being cast in the role of a noble liberator, Carano might be more inclined to side with the Empire.

IV

I have genuine admiration for the Sequel Trilogy, but I also realize something is off. There is a hollowness and lack of depth to the overall arc, and coincidence and convenience have replaced storytelling. There are also the mismatched directing styles of J. J. Abrams and Rian Johnson, which don't correspond to each other with any fluidity. Although the Original Trilogy had a different director for each film — Irvin Kershner for *The Empire Strikes Back*

and Richard Marquand for *Return of the Jedi* — George Lucas was the ever-present overseer, creating a consistent set of movies and a forward-moving narrative arc. Here, Abrams and Johnson have set out agendas and arcs only to retract, change, react, or ignore them completely. These loose threads may be answered in time in books, TV shows, cartoons, comics, and games, and they will certainly be debated ad nauseam for years to come by Star Wars YouTubers and Reddit threads.

So, *The Rise of Skywalker* arrived with diminished fanfare and an expectation that the film would be a disappointment in one way or another. Script leaks suffered early criticism from those who dared to read them, and with the film's release and the relative narrative accuracy of those leaks, the recovery of the film's reputation among fans and critics seemed far off.

I'll not divulge the narrative of *The Rise of Skywalker* as such. This has been offered in countless forums across the internet and in print. What I want to discuss are elements that hinder its overall impact as a film and a conclusion to a massive arc.

The Rise of Skywalker suffers from plot devices (I'm refusing to use the term *MacGuffins*, though that is what they are) thrown in simply to get the action rolling at a chaotic pace: a Wayfinder device, an ancient dagger, an old adversary, a revealed heritage, the introduction of new and old characters, and new and unexplained Force abilities. In themselves, these are not bad ideas. But they are underdeveloped and rushed and would have benefited from inclusion and explanation way back in *The Force Awakens* or *The Last Jedi*, not in the last chapter. Suddenly, and as a reaction to the swerves taken in *The Last Jedi*, a whole new narrative apparatus has had to be created to get one movie back on track toward the saga's conclusion. It's an exhausting experience that leaps from one planet to another at dizzying speed. Time itself accelerates in this film's presence.

The literal resurrection of Emperor Palpatine for the final chapter is welcome only because of his utter and delirious wickedness and

the quality of performance that Ian McDiarmid brings and has always brought to the character. In reality, it makes little sense and is never properly explained, and despite denials from Abrams, the inclusion is an obvious quick fix for Johnson's quick dispatch of Supreme Leader Snoke in *The Last Jedi*. Hilariously, we learn from a glimpse and a line of dialogue that Snoke was one in a line of clones Palpatine and his cabal of Force worshipers has been developing. We're led to believe that Palpatine has been pulling the strings for the past three decades, and with only a few flourishes of dialogue ("Dark science, cloning, secrets only the Sith knew") the whole dilemma is snuffed out without question. At least, that is, without question within the narrative of the film. The fandom will be questioning this decision for decades to come.

Many complained that Luke Skywalker's grizzled and downtrodden turn in *The Last Jedi* failed to correspond with his optimistic and adventurous persona in the Original Trilogy. Characters we have known to be extremist zealots are suddenly performing actions contrary to this perception. Take for example General Hux (Domhnall Gleeson). In *The Force Awakens*, Hux is a sniveling proto-fascist zealot of the dreaded First Order — a man who, with spit in his mouth and tears of euphoria in his eyes, directs a destructive laser toward the heart of the New Republic government planets and snuffs out potentially billions of citizens. In *The Rise of Skywalker*, he turns tail on the First Order and allows our heroes to escape entrapment and set about the destruction of the First Order. This is not a realistic action for a character we've come to know as a repellent fash. It is an action that is nonetheless required by the script to get one set of characters from Planet A to Planet B.

And while the characters may physically move from A to B, their emotional arcs are pretty much stuck. The main character of Rey, for example, has garnered many Force abilities and earned wisdom from her adventures and studies. But ultimately, she ends up where she began this trilogy, alone on a desolate backwater desert world,

staring off into the horizon, not really knowing her place or her path forward. In the Original Trilogy, there was the knowledge that Luke, Han, and Leia had weathered many crises in the years between episodes. During the Galactic Civil War, there was genuine loss and upheaval. The end of the Original Trilogy showed (thanks to the Special Edition versions) citizens celebrating the fall of the Empire across many different worlds. It was a universal victory. In *The Rise of Skywalker*, the victory, if there even is one for the galaxy, is far more subdued and personal. Has Rey won a galaxy? Will she lead a new collective government or begin a new Jedi Order? We don't know.

Her story ends at the pinnacle of a new dawn with no victors as such, and raises far more questions for the wider galaxy than it can answer. Judging by some of her questionable Force actions (she shoots bolts of Sith lightning and destroys a ship supposedly holding her comrade), she might even be a danger to the future of the galaxy.

The only character arc that is worth the whole saga existing is that of Adam Driver's Kylo Ren/Ben Solo. As the chief antagonist, Ren has carried a weight around his neck, and his physical self seems in constant turmoil as the dark side of the Force eats away at his good side. When he eventually succumbs to the light side and drops the Kylo Ren moniker for his birth name, Ben Solo, his body language and facial expressions become as light as a feather. His whole persona in the last half of the film is one of relief, and we feel it with him. In this case, Driver deserves the praise that has been granted him for this performance. It might have been a better trilogy if it spent more time with the swashbuckling Ben than the dreary Ren.

Criticism can be placed at George Lucas's feet for many problems in past Star Wars movies. But his consistency in epic storytelling and worldbuilding was at least an asset. In *The Rise of Skywalker* and the Sequel Trilogy as a whole, the galaxy seems smaller, and you get the impression most of its citizens have given up on the outcome

of this conflict between good and evil, Jedi and Sith, light and dark, and that the battles are being fought on a much smaller scale in some deadbeat part of the galaxy. It is a reaction many audience members will also feel.

V

As a final chapter in the saga, *The Rise of Skywalker* is ultimately redundant because of the previous inconsistency of *The Force Awakens* and *The Last Jedi*, and now this film's inconsistency with the other trilogies. It feels disconnected from the past. As a stand-alone film, it might be a rollicking adventure that twists and turns and offers plenty of emotional gut punches and nostalgia kicks, but it's too little too late. The goodwill has been exhausted. The acceleration to reboot Star Wars for a new generation is obviously rooted first in making big bucks, second in pushing merchandise and toys, and third in signing up new subscribers to a streaming service. Intricately layered storytelling and gradual worldbuilding have been abandoned in this quest. As a film, it might stand as the final word in the Skywalker saga, yet what it should've been instead is the first word in a far broader and more expansive and diverse universe that was hinted at in *The Last Jedi*. As the trilogy and an entire saga are now at an end, the roots have been severed from any potential future. And while the future looks bleak for Star Wars movies, it is a far more depressing place within the Star Wars universe itself. Despite the so-called victory of the Force, there is a defeat for the common citizenry.

The Rise of Skywalker ends with the rag-tag Resistance defeating the combined evil forces of the First Order and the newly discovered Empire/Sith and, with this, the restoration of order and peace in the galaxy. This is what we are led to believe, anyway. After the battle has been won, the trilogy's main protagonist, Rey, takes a solo journey to Tatooine, the desert planet we first saw in *A New Hope*,

and a location we have returned to in *Return of the Jedi*, *The Phantom Menace*, *Attack of the Clones*, and, very briefly, *Revenge of the Sith*.

On Tatooine, Rey visits the old farm homestead of Owen and Beru Lars, Luke Skywalker's uncle and aunt, the couple who raised him since his birth. Rey buries both Luke and Leia's lightsabers in the desert sand and, when asked by a passer-by who she is, answers that she is "Rey" — long pause — "Rey Skywalker."

The place Rey chooses to bury Luke and Leia's Jedi lightsabers and the name she adopts are quite fitting when one takes into consideration the impact the planet and the Skywalker clan have had within the entire arc. Tatooine has been the home of Anakin and Luke Skywalker, after all. We have returned again and again to this dust ball on the outer reaches of the galaxy, and it has been the location of much struggle, pain, and peace. However, something is amiss with this ending. While we get only an inkling of the completion of Rey's story arc, there is little sense of how the galaxy will continue after this latest conflict.

Has democracy been restored? Does the defeat of Emperor Palpatine and the First Order mean that the Republic, the one that lasted thousands of years before the events of the Clone Wars and the rise of the Empire, has resurfaced to restore justice? We sense at the end of 1983's *Return of the Jedi* that relative peace and continuation of that era were to be re-established. After all, within the Rebellion there are remnants of that Republic. Seasoned senators such as Mon Mothma and military leaders such as Admiral Ackbar seem destined to lead the galaxy back to representative democracy.

Now, though, thanks to the Disney+ series *The Mandalorian*, set just a few years after Luke Skywalker's adventure, we know that the entire galaxy was not brought to peace and justice, and that lawless pockets and remnants of the Empire still hold incredible sway, hence the title character's ease in operating as a bounty hunter across an anarchic sector and within an organized guild of fellow assassins.

The Sequel Trilogy, set 30 or so years later, squashes this assumption even further. We are now aware that a new Republic did arise, but alongside it a well-funded military junta hell-bent on the Republic's destruction and the enslavement of millions to its cause.

The end of the Prequel Trilogy also gives us a galactic overview in these matters. We are made fully aware that the Empire has seized control. It's not a positive outcome in any way, but the overall arc is complete. With the Sequel Trilogy ending on such ambiguous notes, the fate of the galaxy is unknown. Here, I would point readers to the podcast *What the Force* (especially its episode reacting to *The Rise of Skywalker*), presented by Marie-Claire Gould and Ty Black. They dive deep into the Sequel Trilogy's lack of a fulfilling narrative arc, particularly in terms of the hero's journey, the monomyth set out by Joseph Campbell in his 1949 book *A Hero's Journey* and adopted by George Lucas for his own sagas. This journey is ignored in *The Rise of Skywalker*, which might add to its sense of hollowness. *The Rise of Skywalker* and the failings of the trilogy become grossly apparent when seen through Campbell's monomythic lens.

There are a few clues as to what might be in store for the wider galaxy. None of them, unfortunately, points to a very positive future. The final Battle of Exegol sees thousands of ships respond to the call put out by rebel hero Lando Calrissian (Billy Dee Williams) to take up arms against the revived emperor and his massive fleet of star destroyers. Piloting the iconic (to the audience, but also to the citizens of the galaxy) *Millennium Falcon*, Calrissian leads the charge of mismatched ships and vessels. Who are these saviors? As one First Order officer comments, "It's not a navy, it's just people." And that is what indeed the freedom fighters are, a random alignment of factions, organizations, militias, bounty hunters, spice runners, warlords, crime syndicates, and lone wolves. Anyone with a ship and a gun is welcome to the fight. In the grand scheme, it makes for an affecting circumstance. Across the galaxy, people have put aside their differences and rivalries to come together and fight against tyranny.

But with no real outcome for the galaxy in terms of what new ideology will be victorious, and no real leadership coming forward, surely the factionalism and rivalry will re-emerge as a leader of the rabble vies for control. Tin-pot dictators and quasi-fascist blowhards are maybe all that is in store. Certainly, no progressive figures appear to be on the horizon to promote the much-needed, though very unsexy, discussions about wealth redistribution, renationalization of hyperspace lanes, free education, job-creation programs, and free health care for all.

We don't, in this instance, need to look to the Star Wars Universe to know that revolution without consensus or demands about what comes after is usually a harbinger of more problems. We can look at real-world events.

Libya, to name one modern and still unfolding example, is a failed state of factions and military commanders fighting for power over regions and pockets of the country. The installation of a post–Gaddafi government has failed to quash insurrection, and day-to-day life for citizens is a terrifying ordeal. To put it mildly, an unplanned revolution often disintegrates into a much harsher set of circumstances. There are, of course, positive examples to draw on. The call for representative democracy that was the Arab Spring of 2010–11 engulfed Tunisia, Egypt, Bahrain, Yemen, Syria, and Libya, and overthrew or at least reduced the power of a whole gallery of merciless dictators. But again, without consensus, there has been a vacuum of power within these countries that has often meant an even worse predicament for those citizens who demanded change as loyalists fought for power or, as in the case of Syria and President Bashar al-Assad, violently suppressed the uprising and clung to positions of authority.

The Occupy Wall Street movement that began in September 2011 in New York's Zuccotti Park and spread throughout the world was a valiant attempt to forge a new world consensus based on individual participation and a collective agreement that the chips were

fully stacked with the richest one percent of the global population. In many ways, Occupy's message wasn't a failure as such, but was simply too opaque; with no list of demands or a vision for replacing corporate greed, the movement disintegrated and dispersed. Many of the movement's participants have splintered off toward other causes, such as calls for a $15 minimum wage, the abolishment of college tuition fees, climate action, Black Lives Matter, and Medicare for all. As a political training field, Occupy may still prove to be fruitful.

The Star Wars Universe is now reflective of our troubled times. Star Wars has often been political. George Lucas made sure that current events were signposted within his own trilogies. The Original Trilogy made connections to the Vietnam War, Nixon, and Carter. The Prequels landed smack bang in the War on Terror and drew comparisons between George W. Bush's power grab during the invasion of Iraq and that of Emperor Palpatine in his declaration of a new Empire. Yet the Sequel Trilogy made no such connections. At least, not explicitly so. The slapdash approach to creating the three films meant that no political arc could easily be established. There were vague notions of history repeating itself. The First Order occupies the same space as the Empire, but its motives are never really developed, and its endgame is never clear. In *The Rise of Skywalker*, it colludes with the re-established Empire, under the control of a resurrected Emperor Palpatine. The Resistance is a band of fighters, pilots, and politicians who unofficially side with the New Republic government, but their connection is extremely vague, perhaps intentionally. The New Republic has obviously learned lessons from the past, and the thought of having a Grand Army at its disposal is too close for comfort.

In the aftermath of the final battle in *The Rise of Skywalker*, a similar situation could easily befall the post-war galaxy. Yes, the evil Sith have been defeated; yes, the First Order is no more; yes, the ethos of the Jedi and the Resistance emerges victorious. But every potential leader, every guiding voice of reason, every legendary hero

has either vanished in death (Luke, Leia, Han, Ackbar, Mothma) or diminished in influence (Calrissian, Wedge Antilles). This means that the galaxy is now actually in a far worse position than when the saga began. No Republic, no Jedi Council, no obvious leader among the rabble of combatants that fought at Exegol. Tyranny, on a mass scale, may have been vanquished, but now sectors, planets, and star systems are on their own, with little in common and perhaps no real desire to unite for the betterment of the galaxy. The citizens of the galaxy might have hated the Empire, but they also barely saw democracy work for the Republic, or the New Republic, in matters that concerned them. Factionalism and internal squabbling will become abundant in this new era. Now the galaxy far, far away may also become a galaxy very distant from itself. Surely, this is not the outcome that was foreseen all those years ago.

The Watchlist

Star Wars: The Phantom Menace (1999)
Star Wars: Attack of the Clones (2002)
Star Wars: Revenge of the Sith (2005)
Star Wars: A New Hope (1977)
Star Wars: The Empire Strikes Back (1980)
Star Wars: Return of the Jedi (1983)
Star Wars: The Force Awakens (2015)
Star Wars: The Last Jedi (2017)
Star Wars: The Rise of Skywalker (2019)
Rogue One: A Star Wars Story (2016)
Solo: A Star Wars Story (2018)
Fanboys (2009)
Spaceballs (1987)

POST-CATASTROPHE CINEMA

To paraphrase a statement made by the late British cultural theorist Mark Fisher in his 2009 book *Capitalist Realism: Is There No Alternative?*, it is easier to imagine the end of the world than it is to imagine the end of Hollywood. Fisher's actual phrase ends on "capitalism," and he continues by noting "the widespread sense that not only is capitalism the only viable political and economic system, but also that it is now impossible even to *imagine* a coherent alternative to it."[1] As someone who was raised on Hollywood movies and to this very day is still enthralled by the creative acts of filmmaking and film-based storytelling, I also find it hard to imagine a moment in time when film will not be made and consumed in the same manner that it currently is. I can barely imagine an alternative. But, like it or not, the nature of film, much like capitalism, is changing radically, and filmgoing as we have known it, characterized by enormous budgets and controlled releases by major studios to be witnessed by a mass audience, is possibly in decline.

Attendance at movie theaters has been dropping for decades as the advancement of "home entertainment" has shifted audiences' collective bums from theater seats to sofas. First, it was the availability of VHS-cassette rental; then came DVD and the abundance of extras and audio commentaries that were included; now the epoch is online streaming on smart TVs, laptops, and phones. A movie can now be accessed by a device in your pocket in an instant, and mostly for free. Only the spectacle of a franchise cinematic event — a film from the Marvel Cinematic Universe, or an episode in the Star Wars saga — brings out the masses in droves.

On occasion, a smaller oddity might rise above the din and become a box-office smash hit, such as Jordan Peele's 2019 horror film *Us* or Todd Phillips's *Joker* movie, also from 2019, or a film made by Christopher Nolan, which usually incorporates mind-bending narratives with extraordinary special effects. Yet, raising a hit from these mid-range movies is becoming a rarity.

The reliance on domestic audiences to recoup on blockbusters has also dwindled. Hollywood now must look to foreign markets such as China for returns on its investments. And that word *investment* is key to understanding the current state of mainstream filmmaking. In his 2018 book *The Big Picture: The Fight for the Future of Movies,* author Ben Fritz explores the dire situation that filmmaking is in and its future, or lack thereof, as studios such as Amazon and Netflix (and now the Disney+ streaming service) produce mid-priced dramas, comedies, action-adventure stories, and binge-worthy documentaries to keep their consumers in-home and, in Amazon's and Disney's case, purchasing goods, toys, and paraphernalia associated with the shows.

Is this the future of mainstream film? Will it become only a commodity that keeps audiences/consumers wired in and sells them something, an investment to turn a profit, a two-hour-plus exercise in product placement designed to shift toys, clothes, and lifestyles? But if (or as) capitalism unravels, or catastrophe strikes, film may be unleashed from this undesired future of commerce and become something of a saving grace to those who remain. Surprisingly, the one thing Hollywood is exceptionally good at is the big and expensive blockbuster movie, and this might well become an informative exercise in how to survive post-... well, post-whatever.

While of course not envisioning its own demise, Hollywood has envisioned the end of the world for us by catastrophic and spectacular means over its quite short history. The disaster-movie genre plays out our fears of mass death and the end of civilization, but also allows us to enjoy the destruction from a safe distance and the

apparent utopia of renewal that often comes post-catastrophe. This renewal could be considered a payoff for the devastation on-screen. We, the audience, desire to witness the end of the world because we want to witness the restoration of society just as much.[2]

The world we live in now is a different and more divided place than it was even 10 years ago. A lot has happened in the space of only a few years. Some of it feels like a trope from a comedy film, too ridiculous to contemplate; some of it has been drawn directly from a tragedy and is too scary and heartbreaking to imagine.

By the 1990s, with the aid of CGI, it was easier to envision the end-of-the-world scenario in dramatic and vivid detail. The death tolls were catastrophic, the damage to urban centers was mind-blowing. In the 1998 blockbuster film *Deep Impact*, great ocean waves caused by crashing asteroids rise up and wash over towering cityscapes. The waves are as tall as the greatest skyscrapers. In *Armageddon*, also from 1998, a hailstorm of meteorites rains down on downtown New York, causing considerable destruction of major landmarks. In the 1996 film *Independence Day*, whole populations are wiped out in minutes by invading aliens and their advanced technologies. In the 1995 film *12 Monkeys*, a deadly virus infects and kills billions. In 1996's *Twister*, a series of tornadoes tear up a fractured landscape. In 1997's *Starship Troopers*, an army of invading insectoids demolishes entire buildings and kills countless populations. In 2004's *The Day After Tomorrow*, Earth is plunged into a global ice age and the survivors traverse a frozen wasteland. More recently, we've been presented with incredible destruction in films such as *2012*, from 2009, and *San Andreas*, from 2015. Hollywood cinema can cancel our future easily and spectacularly.

In most of these disaster films, the world is simply reset. After the devastation, life is somehow renewed and yet continues in much the same way. For example, in *Deep Impact*, despite the death of possibly millions and the exhaustive costs of the rebuild caused by near-global destruction, the man who is president of the United

States — Tom Beck, played by Morgan Freeman — survives and continues the work of that office, even though the structures that held the Senate and Congress are decimated. The same goes for Bill Pullman's President Whitmore in *Independence Day*, who, as we learn from the film's 2016 sequel, *Independence Day: Resurgence*, serves a successful second term in office after the initial invasion. The structures of the worldwide system of organization, i.e., capitalism and liberal-democratic governance, remain the same in all these films.

This has been made even more explicit in the 23-film "Infinity Saga" of the Marvel Cinematic Universe (MCU). As each film progresses, the threat increases, and although most of the saga is based on Earth, the perception of the threat widens to include villains who are not of this world, but are demigods, actual gods, intergalactic warlords, and legions of armed alien warriors from other realms. The sustained menace of planetary annihilation plays out and hovers over these 23 interconnected films. In most cases, cities are wiped off the map, yet the populace of Earth seems to continue in a dream-like state, regardless of the dramatic loss of life and the demolition of the cities they lived and worked in. The faith placed in the Avengers, the team of superheroes and their cohort, to reset the standards of living is absolute and unwavering.

In 2018's *Avengers: Infinity War*, half of the population of the universe (and so, assumedly, half of Earth's population, also) is "snapped" out of existence by the mad tyrant Thanos. This catastrophic event is eventually reversed by the team of Avengers in *Avengers: Endgame*, released the following year but set five years into the future of the narrative universe. All those souls that were snapped out of existence are "returned" by the team's actions in time travel. There is no permanence to this destruction, and, as in the first MCU post-return film, 2019's *Spider-Man: Far from Home*, life continues more or less the same, including a European school trip for Spider-Man and his high-school buddies who were, just a few months back, all assumed dead.

So, times have changed, but the reset can now happen again and again within a single franchise. No threat lasts forever, but still dangers continue to come that can be swept aside by a team of superheroes.

II

Yet this is not the world we live in. We have no noble superheroes among us, and the people we put in charge of our daily lives, the leaders, politicians, and representatives we elect, are mediocre at best, tyrants and imbeciles at worst. Soon, our own world might succumb to the scenes of continuous destruction that prevail in Hollywood blockbuster cinema. The threat won't come from mad space tyrants, but from circumstances of our own making, or events such as the Covid-19 pandemic that we have little control over. It will likely be less dramatic than the scenario we see in Hollywood's versions of events. There will be no swelling music to accompany the scenes, no brave, muscular superhero to swoop down and drag us out of harm's way. We'll live or die through these events, and the aftermath of any disaster will be just as devastating for the survivors. No reset or utopia, just hardship and survival.

We've seen this play out at various times in the past decades. The terrorist attacks of September 11, 2001, felt and were meant to feel, by their very nature, like a scene from a Hollywood disaster movie.[3] The Indian Ocean tsunami of December 2004, which struck the coasts of Indonesia, Sri Lanka, Thailand, India, and the Maldives, with an estimated body count of 227,898 people, could have been ripped right out of a Hollywood disaster film. The earthquake and tsunami that struck Japan in March 2011 was also a real-life disaster, and footage of the first wave sweeping across the country had cinematic overtones. Hurricane Katrina, which struck New Orleans in August 2005, offered a post-apocalyptic landscape of submerged city streets and cadavers floating in the waters. The wildfires that tore through California in 2020 burned up four percent of the state's

land mass. And of course, we can't ignore the slow disaster of the Covid-19 coronavirus pandemic.

These are the most devastating and newsworthy examples that come to mind, but on a day-to-day basis, people across the globe are facing what we might consider to be personal apocalypses of miniature devastation. Covid-19 is an obvious example, and one that will be addressed in due course. But even after Covid has dissipated, climate change will still be frying the forests and melting the ice caps, and the burning of fossil fuels will continue to pollute our air and change the dynamics of our oceans. The devastation of land means a desperate wave of displaced people. As the planet heats up and becomes horribly humid, more water is evaporated and falls as great deluges and frequent mass storms that cause flash floods and leave a trail of wreckage and submerged land now unable to support agriculture. People will be on the move to survive.

War and unrest in places such as Syria and Libya have pushed an exodus of people to take extreme measures in migrating to what they perceive as safer environments in Europe and the United States. These civil conflicts are having wider repercussions throughout the world as governments retract decades of financial assistance and aid relief and refocus themselves nationally, while dismissing the waves of migration as another region or country's problems.

These are prolonged and dangerous events that will play out and worsen over the decades. But these events are not Hollywood material. Their slowness softens the impact. As with climate disruption, we only heed the warnings at the very moment when an environmental disaster impacts us. But people are also subject to smaller devastations brought on by capitalism and greedy corporations that inflict themselves on the landscape and then abandon it without remorse once the exploitative labor becomes cheaper elsewhere. These pockets of economic devastation, or "sacrifice zones," are discussed at great length in Chris Hedges and Joe Sacco's joint study *Days of Destruction, Days of Revolt*, where "human beings and

the natural world are used and then discarded to maximize profit."[4] They exist across the globe and are the end times in miniature form.

Catastrophe, big or small, happens on an almost daily basis and is nudging us at various intervals toward even bigger devastation. There will be survivors of any large-scale natural or man-made disaster. In the harshest of circumstances, pockets of existence will continue in some way or another. The end of civilization does not always mean the end of humanity. How we rebuild or even prolong our existence will depend on the stories we recall and choose to pass down. In his 2002 book *On Stories,* philosopher Richard Kearney details how stories from the past "assumed many genres — myth, epic, sacred history, legend, saga, folktale, romance, allegory, confession, chronicle, satire, novel."[5] Whatever their form, they informed the people around them of the past, present, and future. "Every life," Kearney states, "is in search of a narrative."[6] This narrative supplies our meaning as humans; to humans, reciting narratives is, as Kearney continues, "as basic as eating. More so, in fact. For whilst food makes us live, stories are what make our lives worth living."[7]

Today, the stories that reveal our contemporary culture are held within modern literature, popular culture, games, apps, social networks, and, of course, film. The direction of societies has always been informed by stories of the past, present, and future. Film cannot be excluded from this just because it is considered a form of entertainment. Film has, in my opinion, always also been a form of education and an apparatus for personal and societal change and progression. Film is made *in* society and *from* society, and we *live* in society, therefore film is us. It can guide us toward a world we want or away from a world we don't.

In any post-catastrophe world, film will still be available to survivors. The means by which it will be made and screened is up for debate. The worst-case scenario might involve the hacking of the discarded technology that will litter a post-catastrophe world. More likely, it will simply still be available as it is now, but hopefully the

surviving inhabitants will initiate a kind of library lending system for the aging technology.

The reason why film will still need to be made is quite simple. We will need to tell stories to stave off the hardships and immense boredom, and to strive for betterment. We will require creativity to overcome the predicament we find ourselves in. This scenario recalls Bertolt Brecht's 1939 poem "Motto," about the need for "singing" during "the dark times," in Brecht's case, those of Nazi Germany.[8]

I've always felt that Brecht's poem expresses something far greater than what is contained within this brief verse. While the focus is on "singing" to elevate and lighten the darkness, really any artistic expression is acceptable. Humankind has a desire to explain its times, a longing to record its moments, anything to overcome the trauma of living in and through the "dark times." Even in the harshest of environments, facing the toughest of odds, art and literature have prevailed and must prevail for humanity to express itself.

Our societies now have film and popular culture ingrained. This will go nowhere and will stay with us for an exceptionally long time to come, regardless of our predicament. Showing a young child an image of a popular-culture artifact, a character from a popular show, a logo, a theme song, a superhero insignia, will bring almost instantaneous recognition. There is enough access in any form, physical or digital, to know that film will continue and must continue. What type of film comes after the crash is anyone's guess. Film, or at the very least its mainstream Hollywood variant, is tied to capitalism and globalization, and with any measured catastrophe, capitalism and globalization will collapse. One must assume that this kind of film will be impossible to replicate, and maybe that is for the best, anyway. In post-catastrophe times, humanity will divert, disperse, and regroup into smaller, more localized forms. Film will most likely follow suit after the collapse, and instead of needing to communicate on a global scale, it could become the engine of change to smaller pockets of society. It would be gratifying to think of film and its

current audience implementing this change before a catastrophic event, but like the climate, we'll probably have to wait for a full disruption before we even consider it.

III

To this end, I'm reminded of former U.S. Army private Roy Scranton's book *Learning to Die in the Anthropocene: Reflections on the End of a Civilization.* The book could be considered a field guide on how we welcome and survive the post-catastrophe world.

The term "learning to die" might appear to reflect a gloomy frame of mind to find oneself in. It sounds similar to how Tim Robbins's incarcerated character Andy Dufresne, in the 1994 film *The Shawshank Redemption*, frames his existence as a matter of "get busy living or get busy dying." Of course, in this context, Dufresne is planning his prison escape, a plan he set in motion almost 20 years prior to making this statement to his friend and fellow inmate Red (Morgan Freeman). Almost from day one of his incarceration, Dufrense has been digging out of his cell and tunneling toward freedom. In *Learning to Die in the Anthropocene*, we can conclude that humankind has built the walls of its own prison in the form of a carbon-based capitalist model, and our options to escape and "get busy living" are sadly losing traction. We need, as a civilization, to get behind the concept of "get busy dying" to survive the coming environmental cataclysm. It is not as doomy as it sounds. There is hope, even if small, to be found in Scranton's book.

The first part of *Learning to Die in the Anthropocene* is an investigation into our troubled future. Scranton doesn't sugar-coat the findings. "We're fucked," as he so bluntly puts it. He continues: "The only questions are how soon and how badly."[9] And with the rise in global temperatures set to soar in the next 50 years, bringing with it a feedback loop of melting ice caps, rising seas, and a toxic cocktail of carbon dioxide and methane that has remained locked in the Siberian permafrost for centuries, no argument can really be made

against Scranton's forthright statement. The rise in temperatures will bring unprecedented extreme weather events, hurricanes, storms, typhoons, and heatwaves. Low crop yields and scarcity of water and other resources will instigate countless wars and send a wave of human migration to parts of the world that remain relatively unaffected. We have already seen the beginnings of this over the past decade with the Syrian refugee crisis.

The second part of Scranton's book could be referred to as the "learning to die" aspect of the text, and it is more speculative and perhaps less clear about how the "dying" needs to transpire. Indeed, it could hardly be a more difficult question to answer. Referring to ancient texts such as *The Epic of Gilgamesh*, Scranton seems to point out that archetypes of our culture are found in records of past events, stories, and mythology, much as Kearney does in his findings on stories and narratives above. Today, our culture references nearly every living moment through tweeting, vblogging, and Instagram and TikTok posts. We share our every personal and political point of view on Facebook. In a way, we have created the arc for our modern culture; it lives on even after we die.

One of the outstanding points in this last half of the book brings home the fact that humankind is nothing more than a short blip in the universal radar. We are here because of so many inconceivable acts of coincidence that nonetheless have evolved along a path of almost perfect mathematical progress that synchronizes the entire universe. It is a nihilistic attitude to take, but we are only special in our own minds. We are the force that is bringing our world to catastrophe and it's a hard pill to swallow.

IV

We've focused primarily on the big-budget variant of the disaster-movie genre. These are the most dramatic and fraught stories that offer instant gratification through their portrayal of destructive power and human survival in the face of adversity. Alongside

the mainstream examples of the genre, there have always been low-budget films that attempt to do the same with fewer resources. They usually appear in the straight-to-video/DVD market at around the same time a big-budget disaster movie is hitting the big screen. An example of this that jumps to mind is the film *Tycus*, an extremely poor entry in the disaster-movie genre, which was released in 1998. *Tycus* concerned, coincidentally (or not), a comet directly impacting Earth. Also in 1998, mass audiences were lapping up the CGI destruction of *Armageddon* and *Deep Impact*. Films like *Tycus* were made on slim budgets, re-used stock footage purchased from bigger movies, and maybe one or two familiar faces to draw attention to it (*Tycus* "stars" Dennis Hopper) among a cast of relative unknowns. However, the thirst for these cheap imitations has lessened in the last decade or so with the rise of streaming services and an increase in audience demand for higher-quality content. The interest isn't in cheap destruction, shoddy sets, and dodgy dialogue, but in a post-catastrophe world where the destructive event has already occurred, and the survival of those left is the real story.

And this leads me on to the 2018 film *The Domestics*, which takes place in a post-apocalyptic world the likes of which could be torn straight out of the pages of Roy Scranton's book.

The film has an interesting premise. The United States government conducts a reset on society by poisoning the population and leaving those immune to fend for themselves. The film's opening scene of high-flying military planes oozing black chemical smoke over the entire United States is striking and completely terrifying. There is no reason why. There is no explanation. This criminal act is performed by the leading authority to root out internal strife. Left or right insurgencies are not discussed. The United States has "problems" that have been ignored and allowed to fester for years. The eradication of all causes of societal division is seemingly the only option left on the table. A total reset.

The Domestics sits comfortably in the low-budget genre of post-apocalyptic survivalist dramas that crop up from time to time on Netflix's recommendations. Films such as *How It Ends*, *Cargo*, *Into the Forest*, and *The Endless* all tap into our fears of life during or after the fall of society. How will we survive? Who will we rely on? The film also shares something with the classic film *The Warriors* in its premise of traversing the domains of extravagantly dressed gangs. Recent political events in the West, and particularly in the United States, make clear what anxieties films like *The Domestics* are both expressing and tapping into without explicitly stating the cause of the societal collapse.

Watching *The Domestics* through the lens of the presidency of Donald Trump and his authoritarian stance against the left, one can't help but see that the drastic course of action taken in the film is also in the realm of possibility in Trump's troubled and narcissistic mind. Trump is the man who once suggested nuking a hurricane and sent militarized police units to quash peaceful Black Lives Matter protests in Portland and other cities. He also allowed the Covid-19 pandemic to run rampant across the nation with little in the way of sympathy or support for the dead and their families. Covid-19 is Trump's version of the black poison that spreads across the nation in *The Domestics*. Brutality and humiliation are staples of Trumpian political leadership, as they have been in his business career.

In the post-reset world, the survivors have formed gangs that roam the wastelands between the main cities and the outer suburbs. They mostly provoke and pester each other over the limited resources, but they also hunt and menace those who might try and cross over their patches of territory. The seeds of this cultish gang mentality are already sewn into the fabric of American culture. The far right, for example, has fragmented into pockets of hard resistance, militant nationalists, and conspiracy theorists obsessed with race, gender, guns, and personal freedoms. In the minds of conspiracy wonks, the United States government is already poisoning them from the

air using chemtrails and whatnot. The gangs of survivalists shown here, the Gamblers, the Plowboys, Nailers, and Sheets, have roots in the current fractioning. Each has a mostly murderous ideology to anything that doesn't fall into their own slim outlook on life.

The Domestics takes place in an America where great swaths of the population have died out, and, by the looks of it, the black smoke that has triggered this new version of reality is an equal-opportunity agent, just like Covid-19. The poison has taken out the rich, the poor, the famous, and the common folk alike. Our heroes are Nina (Kate Bosworth) and Mark (Tyler Hoechlin), a young couple of middle-class suburbanites, who take the hard decision to drive from the relatively safe environs of white, suburban Minneapolis to Milwaukee, where Nina's parents are living in their own community of wealthy privilege. Mark has his reservations about the journey, one being that Nina's dad hates him, but with their marriage crumbling along with society around them, he reluctantly agrees to accompany her.

During the road trip, the couple stumble upon the scavengers and small pockets of civilization that still exist. When they meet Nathan (Lance Reddick) and his wife and two young children, realization kicks in that civility and even domestic bliss can still be achieved. They sit down for a delicious meal and a few glasses of red wine in Nathan's lovely home. However, all's not well in this version of domesticity. It soon becomes apparent that the meat served is cooked human flesh.

The domestic bliss of post-apocalyptic society has soured toward murder and cannibalism. It is a foreshadowing of what Nina and Mark must become to survive and thrive in the new world they now inhabit. Nathan's wife, Theresa (Jacinte Blankenship), informs Nina that "there is no happiness out there." Survival is all that's left. Eat or be eaten. Learn to live or learn to die.

There is another lens that one cannot help but view *The Domestics* through, and that is the situation surrounding Covid-19. Although

the film was made before the pandemic hit, there is a sense now that *The Domestics* has become an unintentionally timely film. The pandemic has ravaged most parts of the world and forced us into a kind of isolation humans are not accustomed to. We've had to rely on those closest to us far more for emotional support. Some of us have had to rely on the governments of our countries for financial aid. Our social circles have shrunk to a handful of family members. During the narrative of *The Domestics*, we learn that Nina and Mark were about to divorce when the reset happened, and in the aftermath, with all the institutions crumbling, they have had to cling to each other for support and survival.

Furthermore, Covid-19 has infiltrated populations not usually affected. Alongside those of us in the great unwashed masses, the middle class and the wealthy have had to lock down also — although it could be argued that their experience is wildly different to ours. They, of course, can reside in the comfort of their mansions, still go on luxury vacations to private resorts, and order food and groceries from low-paid gig-economy workers now deemed "essential." In the case of overpaid CEOs and celebrities, they can laze around their vast estates in absolute seclusion and safety and, as some celebrities have decided to do, record bizarre and unnecessary renditions of uplifting pop songs to ward off their own boredom, while the remaining populace copes with real stress, financial uncertainty, and emotional trauma.

The Domestics is right in showing us that wealthy and middle-class citizens will also have to fight for their own survival. In any post-catastrophe world, the damage has been done and the changes and challenges are already in motion. Most post-apocalyptic films, or films that depict society falling apart, show the underclass squabbling with each other and raising hell to survive. Here, the Domestics of *The Domestics* are your office buddies, your professor, your dentist, your veterinarian, your neighbor. Everyone is wrapped up in this downfall.

We're not likely heading toward the world of *The Domestics*, at least not yet, but we're also not going back to a world before Covid-19 and Trump. The economic ruin is festering already, the resentment felt by black and brown people toward the institutions of the police, education, and culture has reached its boiling point across the Western world. The abuse of indigenous peoples has led to protest movements and demands for land reclamation and rights. Most of us have had it with neoliberalism and the cretinism of most of our modern elite. There is no turning back time. The game is up.

What *The Domestics* gets wrong about a post-reset world — and I hope that I'm correct in this thinking — is the notion that those left to pick up the pieces will turn on each other and form a society of hunter-killers and timid prey. I hope that in any post-catastrophe world, those left will not take this path, they won't break off into class- or ideology-based factions and tribes, but join and reorder society in an egalitarian manner based on shared resources and shared knowledge. If the pandemic has shown us anything, it is that humans are resilient and, in the worst of times, caring and decent to one another.

The Watchlist

Armageddon (1998)
Deep Impact (1998)
Independence Day (1996)
The Day After Tomorrow (2004)
2012 (2009)
San Andreas (2015)
Last Night (1998)
Melancholia (2011)
The Domestics (2018)
Into the Forest (2015)
Cargo (2017)
Greenland (2020)

METROPOLIS NOW!

Growing up in a quiet rural village outside of one of the United Kingdom's major industrial cities does something to your sense of danger. The relatively safe environs, the wide-open spaces, the small populace of village life, where everyone knows everyone and knows each other's business, means personal safety is often taken for granted. As a kid, I'd walk alone through secluded woodland and back alleys and not feel a pinch of what dangers might lurk around the corner, simply because there weren't any. I grew up on a decent subsidized housing estate, which if you believe the current British Conservative government is, and always has been, rife with drugs and menacing characters. The government will call them "sink estates" because all hope has drained away, but this was not really my experience of these surroundings.

The city by far held the greatest threats. With its tall, imposing buildings, exhaust-fume-contaminated air, dirty streets, brash residents, and hustling commuters, it all seemed far away, though it was just a short journey by public transit or car. When I did venture into the city as a kid, it was always with my mum; my dad hated the place and hardly ever went along for the ride. With my mum, I'd stand close by as we went from shop to shop and market stall to market stall. I was always more aware of the danger the city possessed even in the safety of daylight. It was always bustling and extremely crowded, people pushed by each other. Gangs of youths only a few years older than me hung around various city monuments, huddled together and looking tough in large numbers.

In the main market square, the stall owners bellowed their fruit and vegetables offers of the day to their customers in an extraordinary use of verbal articulation that sounded less like a sales proposition and more like a threat of violence. The police seemed a rare sight, though when an officer was spotted patrolling the streets a wave of relief would wash over me. In my young mind, a police officer meant protection from anything and everything. This wasn't fear of the city as such. The city just happened to broadcast itself on a different frequency than the one I was attuned to. It was frightening yet oddly alluring, sinister yet exotic. There must have been a sense that the city turned perilous at a certain point in the day, because we were always back home by dinner time. As a child, my experience of what threats or delights the city held when night descended over it was to be found in film. And to a kid who was in some respects an innocent, the city was mostly portrayed as utterly terrifying.

The first cinematic encounter with the perilous city that springs to mind was in the 1987 comedy *Adventures in Babysitting* (also titled in some regions *A Night on the Town*). Here, suburban, middle-class kid Sara, her teenage brother Brad, and Brad's obnoxious best friend Daryl are led by their babysitter, Chris, played by Elizabeth Shue, to downtown Chicago (actually Toronto, as I'd find out when I visited the city years later) to pick up Chris's friend Brenda, who has run away from home and is now stranded at the city bus terminal, having all kinds of sinister encounters with gun-toting weirdos and hostile food vendors. Chris expects an hour-long round trip to pick up Brenda, but a tire blows out on the highway and begins an odyssey of misadventure that sees them in the firing line of a shootout between a cheated husband and his wife's lover, held captive by the menacing boss of a car-theft operation, and caught in the middle of a gang fight on the L-Train, where young Brad gets stabbed in the foot with a switchblade.

The city that the protagonists of *Adventures in Babysitting* must navigate is a despicable place. It becomes nightmare vision where

gang violence, underage prostitution, carjacking, and risk of injury and even death are rife. The only solace the group finds is in a blues bar, where they are told by the musicians on-stage that "nobody leaves this place without singin' the blues." At first, even the club looks unwelcoming. The crowd, predominantly black, inner-city working-class, sees the kids for what they are: white, privileged, suburban middle-class. However, the group wins over the crowd when they sing their tales of woe with the house band. They then leave the club, their spirits are high, but Daryl wanders off and gets flirting with a sex worker. Chris pulls him away and is shocked to learn that the sex worker is only 17, the same age as her, though their class backgrounds have led them to different outcomes and, even, different physical appearances. While Chris is fresh-faced and flush with youth and enthusiasm, the sex worker looks much older and drained of all optimism and hope.

While the city the group encounters is certainly sinister, its dangers become even more apparent when one considers the middle class background of the teen protagonists sharing the same space as the more working class residents of the city. Chris is shocked by the circumstances of the young prostitute, while Brenda, hungry and alone in the bus terminal, attempts to pay for a hot dog with a banker's check and is stunned to be turned down and for the proprietor of the hot-dog stand to suddenly become angry with her. When their encounter with the city is over and Chris returns the kids to the safe confines of their suburban home, they are relieved, yet Sara offers Chris another opportunity to babysit for her. Despite seeing her brother get stabbed in the foot and almost falling from a skyscraper while two gun-toting mobsters chase her down, Sara wants to do it all again. She hits upon the same conclusion that I did as a kid. The city is disturbing and yet ultimately intoxicating to the senses, and pushes the boundaries of what is considered normal for a kid growing up in relative comfort and safety.

The 1986 movie *Short Circuit* deals with a military robot that becomes sentient when it is struck by a bolt of lightning. The robot's

restless need for "input input" means that the robot, which by the end of the film has christened itself Johnny Five, digests an incredible amount of information in a very short space of time. Books are read and processed in seconds. Knowledge, for the nasal-voiced Five, is easy to come by, but relationships are harder to comprehend. This leads to many awkward moments with human beings who try to help it in its plight and those who try to hurt it. The robot possesses a childlike naivety and is easily manipulated by humans with simplistic explanations.

In the 1988 sequel, *Short Circuit 2*, Five is loaned to his co-creator Ben Jahrvi (Fisher Stevens), who has now been expelled from scientific research and is peddling a toy version of the Johnny Five robot on the street corners of Manhattan (again played by Toronto). When Five first arrives in the city, Jahrvi explains to him (as he has called himself Johnny, the robot is presumably now identifying as male) that he mustn't go outside and that there is nothing to see out there anyway. Jahrvi knows that a city is a corrupting place, and an innocent like Five will easily fall afoul of criminal elements. However, when Five inadvertently discovers he is in a city, his desire for input overwhelms him, and he heads out to explore the sights and sounds.

Unlike the comical original *Short Circuit*, the sequel is an incredibly sad film. The city dwellers exploit the naivety of Five to almost fatal consequences. First, a gang of young street toughs who call themselves Los Locos (the Crazy Ones) convince him that they are part of an overworked car-stereo repair team and that they need to remove and repair the stereos of an entire city block to feed their families. Five performs the task on their behalf in a matter of minutes. As a show of "gratitude," Los Locos vandalize Johnny Five, adorning his metal body with chains and scrawled graffiti. Second, when the co-director of Jahrvi's toy company, Fred Ritter (Michael McKean), learns that Five is estimated to be worth around $11 million, he attempts to sell the robot to the highest bidder. During the meeting, Five learns of Ritter's plan and abruptly escapes

through a high-rise window. Third, Five befriends bank worker Oscar Baldwin (Jack Weston), who convinces him that there are items in the vault that belong to Baldwin. He asks for Five's help in digging a tunnel from Jahrvi's toy workshop to the bank, located across the street. The tunnel is dug in a matter of hours, and Oscar steals a collection of jewels worth millions and flees. Realizing he's been duped, Five chases after Oscar. He apprehends the crook, but is graphically beaten in broad daylight by two of Oscar's thugs and is left for "dead." Within the city, Five is the dreaded "other," a freak who is not accepted even in a place of diverse cultures and erratic fashions. His innocence is beyond comprehension and is therefore ripe for exploitation.

Though I was much older when I first encountered Walter Hill's cult 1979 film *The Warriors*, its visual representation of the city at night made a more lasting impression. Set "sometime in the future" in a crime-riddled New York City where districts by night are almost completely run by various gangs, the Coney Island Warriors must traverse countless gang territories to get back home after being accused by a rival crew of killing Cyrus, leader of the Riffs, the city's biggest and most formidable gang, who had requested delegates from all gangs to hear his proposal to unite under one banner.

The city that the Warriors encounter is almost devoid of normal existence. The streets and subways are totally empty apart from the gang members who patrol their turf. The city ceases its usual momentum and instead becomes a wasteland of violence and peril where ordinary citizens, workers, and partygoers completely vanish from the streets. The city turns against the Warriors on their journey home. A subway service that will take them safely back to Coney Island is canceled when a fire is started on the tracks ahead. The gang must hightail it to the next station across enemy turf. The night-time radio DJ who keeps the gang community up to speed on the Warriors' movements drops songs such as "Nowhere to Run" by Arnold McCuller to intimidate the gang (though I doubt the

Warriors are finding much time to chill to the radio). Nowhere is safe; even a peaceful city park is overrun by face-painted gang members with baseball bats. When the Warriors finally hit the home stretch and catch the train home, a group of well-dressed young people returning home after a night out dancing boards the train and sits silently across from the ragged gang. A moment of reflection is allowed by both parties on how differently the city treats its young inhabitants.

Daylight brings little reprieve. The Warriors return to Coney Island and face off against the Rogues, the gang who actually did kill Cyrus. Before things turn nasty, the Riffs arrive and, learning what has really transpired, serve up some rough street justice to the Rogues.

The Warriors shares the same neon-lit-hellscape aesthetics of 1976's *Taxi Driver*. The streets are rain-lashed, reflecting the streetlights in a weird, eerie glow and casting a sinister light over the surrounding buildings and parked cars. While *Taxi Driver*'s Travis Bickle experiences the city from within the confines of his taxicab, internally commenting on the ills of society, the Warriors are immersed in it and naked to the dangers all around them. In this sense, it is a far more fearsome experience. Though they appear much older, the Warriors are still just teenage kids roaming around the city without any adult guidance or supervision.

Many years after watching *The Warriors*, I found myself in a similar situation to that of the young protagonists of that film. Though I was certainly no hardcore gang runner, a house party in an unfamiliar part of town that was notorious for its crime rate left me having to navigate the strange streets alone at an early hour of the morning. Originally a grandiose Victorian district close to the city's central train station, the area was now rife with crime, drug use, prostitution, and gang activity. As I left my friend's apartment, I was directed to the quickest and least dangerous route out of the area. Somewhere I failed to take the correct turn. I was lost and alone in an unforgiving part of the city. Police sirens wailed

in the distance, the voices of escalating violence echoed through the gaps between the Victorian-style townhouses, cars screeched down distant desolate streets. Though I could hear all of this, I saw nothing and saw nobody. The streets I hopelessly paced, desperately looking for a familiar landmark or recognizable street name, were strangely absent of activity. The only immediate sound was my own footsteps pounding against the pavement while my heart sent thumping beats up to my ears.

This was my first experience of the city as a truly dangerous space. All the horrifying events of *Adventures in Babysitting*, *Short Circuit 2*, and *The Warriors* came flooding back to haunt me. I recently recalled this whole incident when I chanced upon Martin Scorsese's 1985 film *After Hours*, in which Griffin Dunne's character Paul Hackett is locked in a *Twilight Zone* version of New York's SoHo district, unable to escape. I also seemed unable to break out. As I continued walking, I saw another lone figure approaching me. His hood was up over his head, odd because it was a balmy summer night. This is it, I thought. This is where I experience the true treachery of the city. As we came into contact, the figure lifted his hood and looked me up and down, bemused by my presence on these dangerous streets. He was an older man, friendly enough. "You okay?" he asked. "No," I said. "Do you know how to get back to town? I'm lost." The man gave me directions out and waved me off with "You don't want to get caught around here at this time of night."

I hurried in the direction the man had pointed toward and finally saw some recognizable buildings on the periphery of the city center. A wave of relief washed over me. Like the well-to-do kids from *Adventures in Babysitting*, or the naive, innocent Johnny Five from *Short Circuit 2*, or the gangland runners of *The Warriors*, I survived my first truly terrifying encounter with the inner city, and in a way the representation of the city in film prepared me for the dangers I might encounter.

II

Many years later, I would find myself in a vastly different space of urban terror: the North American suburbs. I had moved to Canada, and one of the first jobs I acquired was delivering leaflets to businesses and shops. The first few days of my new job were spent in the bustling downtown core of Kingston, Ontario, a great way to acquaint oneself with my new surroundings. Toward the end of my leaflet-dropping tenure, I had to travel to an industrial park where a few businesses were located. To get there, I needed to haul my heavy bag of leaflets across a maze-like subdivision.

The journey started at an intersection of busy roads. I stood in a place where the long and wide roads sliced into the natural landscape, and where nature fought a losing battle for supremacy. Every blade of grass like a young jarhead sent to the frontline to be cut down or captured and conditioned to servitude. The road was like a demilitarized zone with two opposing sides staring across the void. It wasn't a depressing place as such, but the ambiance of menace and despair hovered over it. I stood in the relative openness, but before me lay an enclosure of absolute concrete. I remembered seeing, as a kid, where the young people in Hollywood movies lived. Vast expanses of houses and roads, some of them still in development. The kids in 1982's *E.T.: The Extra-Terrestrial* lived in a still-in-development cookie-cutter neighborhood — didn't magical things happen to them? After his adult adventure in the big city, didn't the young Josh Baskin from 1988's *Big* return to his safe suburban environment and the loving arms of his mother? The suburbs have been implanted in young minds as places of brilliant innocence and charm.

I had no reason to walk the subdivision. There was a bus service that would have took me up to the industrial area. But, as previously mentioned, I used the job as an opportunity to explore the city. There were, at least to my knowledge, no stores, no coffee shops, no parks, no businesses of any sort, no public resource centers, no community centers. There were only houses, and they all looked alike. It was a

cold but bright and sunny February morning. The gym bag cut into my shoulder blade even through the winter coat. The flyers advertised a charity walk in aid of the MS Society of Canada, a noble cause. The irony was that here I was, delivering a charity-walk flyer to a business park you could only reasonably access via car or public transit. Nobody would consider walking it.

Google Maps said the walking route would take 30 minutes to traverse; with the heavy load in tow, I estimated 40 to 50. The first paces were relatively normal. The surroundings felt familiar. There were trees that were sparse in the winter frost, but in the summer must have created a cooling canopy for the pavement below. The birds were tweeting a morning song in the gardens that were lush from a recent snow thaw. Then the trees and gardens suddenly dispersed, and I was left facing an unimaginably long stretch of road. The business blocks and a water tower loomed over the houses, but it all seemed extremely distant and even a little unreal. Like some weird architectural illusion, the buildings hung in a sort of steamy haze. It was only when I was five minutes into walking the long stretch that I understood why the towers looked so out of place. A strange heat emerged from the asphalt, the grassless driveways, and the white concrete houses. With the winter jacket, the heavy bag, and the long underwear (yes, that's right, long underwear, it was winter in Canada), I was working up a dreadful sweat, and this was in early February, when the weather network threw up a high of only -6. The sweat cooled and dried on my forehead and cheeks, but underneath my clothes was a torrent of sweat. I stopped and took off my winter coat and woollen hat, placed them over the bag, and continued walking in minus figures in a shirt and T-shirt, and with no hat.

Up until this point, there had been no signs of life. It was around 9:30 a.m. and most of the people who populated this suburb worked on the other side of the city, a 40-minute journey at best in heavy traffic. The people had vacated hours ago, and all at the same time, leaving a

car-exhaust cloud hovering above their houses that congealed to form a dangerous and toxic miasma. This was why the distant buildings looked as if they were hanging behind a cloud of smog.

But who is still here? The first person I see doesn't look like they belong in the suburbs. They look like some sort of '90s beatnik, raised on Sonic Youth and Sebadoh, and sent out into the world to find peace, love, and tranquility. Their hair is long and shaggy, their jeans torn at the knee. A camouflage jacket that has been in too many hot washes for it to act as useful camouflage hangs loosely around their thighs. It's only when we pass each other by that I realize this is no throwback to a more innocent age, this is a male teenager, a rebellious youth, retaliating against his environment. There can still be rebellion here. I did the same thing in my little British village when I grew my hair long and wore loose jeans and tie-dyed Pearl Jam T-shirts. The youth gives me an awkward teenage expression, a smile rolled in with a grimace. I figure he rarely sees anyone walking this road.

The houses are rowed up like little reflections of each other. It's strange how anyone knows where they live in this bizarre optical illusion of a street. It seems like an obvious question, yet I cannot retrieve an obvious answer. But with my brain sweating, an answer arrives. Perhaps the architects of suburbs want a contented populace. It makes sense. If a house sticks out for its disparity with the others, could it cause contempt for the owners? Could a suburban civil war erupt over who has the better house? In my heat-stroked mind, I believe it could. I wish war would break out right at that moment for something, anything to smash the monotony of the insanely long street. With war raging in my mind, I begin humming Arcade Fire's song "The Suburbs."

The street meets with another and at last I turn a corner onto yet another long street, which at least contains some diverse aesthetic qualities in the style of housing. There even appears to be a patch of hilly green space forcing itself upward, as if trying to infiltrate

the concrete from below. The greenery offers a relative cooling and I return my hat to my head and adjust the strap on my bag to allow the sweat that has accumulated underneath to dry off. There is a bench. I take a seat and drink a bottle of still water and take stock of my surroundings. The only people I'm aware of are those flying 10,000 feet above me in an airplane destined for warmer climates. No cars have passed me in over 30 minutes of walking, the suburb is dead until the workers return in the evening. I wonder for a moment if, when everyone does arrive home, the suburb suddenly becomes a wild and debauched place. The housewives and husbands drink copious amounts of booze and firebomb their neighbor's cars. The kids return from school to lead their household pets into a vicious blood sport in this very greenery where I sit and rest. Could it happen? If capitalism fails, the suburbs could become the new Wild West of criminality and unrest. I continue my journey now on painful feet. The suburb has an end in sight at last. I return to the bustling highway and then, after five minutes or so of running by the side of it, I arrive at my destination and unload the satchel. I wait around for a while and decide to return via the public transport shuttle that runs through the suburb along the same route I just walked. I watch the houses glide by like a reel of 16mm film showing the same frame repeatedly.

What worries me about the suburbs is not the people who live in them, though I do worry *for* them. They have chosen to live within the confines that feel comfortable to them, and that is fine, if our world can sustain this method of living, which, judging by texts such as *Suburban Nation* by Andrés Duany, Elizabeth Plater-Zyberk, and Jeff Speck, and *Walkable City*, also by Speck, time is running out on. What concerns me is the isolation they have, perhaps unwillingly, confined themselves to. From an outsider's perspective, there is no space for public contemplation or debate. The wrongs of our fragile society seem not to have affected the suburbs, the very creation of which is an act of capital and consumer worship.

To be living in the suburbs is to opt into the corporate machine. To live in this idyllic dreamworld, one must own a vehicle, perhaps two. A commute to work, a drive for the weekly grocery shop, a journey for the kids to the nearest (or most desired) school, a drive to find leisure activities for the family, a drive to a friend's house, which might be viewable from the bedroom window but is impossible to walk to. The nature of the suburbs is to keep everyone divided into their frequencies of comfort and delusion. In the suburbs, one spends time in a house surrounded by neighbors of similar wealth and social standing. One goes from the home, where the cable package has been tailored to the occupants, to the bubble of a car, where the radio is fixed to a station that relays news and opinions that correspond to the driver's own, and then to the familiarity of a shopping mall, where the high price of food means only the affluent can buy their groceries there. One is in essence locked into an undisrupted groove, one that does not allow for the observation of or mixing with other social classes, or the opportunity to be presented with differing political outlooks. When capitalism comes tumbling down, it will be residents of the suburbs who will be least prepared for the fallout.

III

The suburbs of North America were created as an antidote to the industrialized city. They promised those willing to escape a kind of gentry lifestyle away from the dirty and noisy inner city, as well as greater autonomy in their lives. But this hasn't been the outcome. Two documentaries on the subject of suburban living, *The End of Suburbia: Oil Depletion and the Collapse of the American Dream* (2004) and *Radiant City* (2006), reflect that this method of habitation is unsustainable in the long run. In fact, any sustainability that the suburbs might have had passed decades ago.

In *The End of Suburbia*, social critic James Howard Kunstler states that "suburbia is not what it promises to be. It's not country living,

it's a cartoon of country living in a cartoon of a house. It has none of the real amenities of country life, no connection with real organic systems or other living things, rivers, forests, fields, agriculture. You just get a lawn, an industrially produced artifact." The original dream of the suburbs may not have been like this, but as more and more people have flocked to the outer limits of the city, highways, expressways, huge shopping centers, and housing developments have eaten up the green farmland that existed between the city and the suburbs. Those who ventured out many decades ago might have lived this promise for a few years, but slowly their access to fields, woodlands, lakes, and hiking trails has been snatched away and, in its place, an unwalkable slab of concrete pasture has landed and cut into the natural landscape. To get to a shopping mall, a school, a friend's house, or a restaurant, a dweller of suburbia must get into a car. As town planner and co-author of the aforementioned *Suburban Nation*, Andrés Duany states in *Radiant City*, "Suburbia disaggregates the elements of daily life. So, you have to drive from one to the other."

The End of Suburbia lays out the argument that with oil production peaking somewhere around 2027–28, and from then on heading into a steep decline, the living standards of those in suburbia will also decline. The price of fuel will skyrocket over the next few decades, and will mean driving a car will become a costly exercise. As Kunstler cites, the suburbs will become "slums of the future."

Suburban living was meant to simplify life, but over the course of *Radiant City* we see the nuclear-archetype Moss family slowly disintegrate. The root of the family's problems is their disconnect from life outside their suburban shell and their reliance on the two cars that constantly move them around. The family's patriarch, Evan, has a two-hour commute to work, while Nick, the eldest child, takes bus journeys to school that are twice as long as the trip to his old school in the city. The family also relies on an incredibly detailed, color-coded calendar chart that plans their weekly events. The exhaustion is evident. On top of this, Evan has aspirations of being an actor

but must make do with a local community theater group. His group is in the rehearsal stage of a musical production that is critical of suburban living. As he explains to the camera on the production's opening night in a suburban community center: "It's like putting on *Apocalypse Now* in Cambodia." His wife, Anne, the driving force behind the family's decision to move to a newly built suburban neighborhood, cannot bring herself to attend the performance and drops their kids Nick and Jennifer off before driving away.

Intercut with the family's disintegration is an assortment of social commentators and architectural experts who explain the root issues of suburbia to the camera. *Radiant City* could be seen as an anti-suburban film with no story to tell from the other side of the argument. Why do people still move to the outskirts of major cities? Why take that lengthy commute on an ugly concrete highway? The big reveal in *Radiant City* is that the Moss family (like most nuclear families) doesn't exist. Evan, Anne, Nick, and Jennifer are fictional characters played by real suburbanites. When the jig is up, the "actors" reveal their true homes and families. They remain critical of their suburban status (Nick, now revealed as Daniel Jeffery, still can't name any of his neighbors), but there is a sense that those stuck in the suburbs have either learned to cope or have never been aware of their predicament or the idea that the suburban way of life is possibly coming to an end.

City living pushed us together and created communities that thrived. Everything was within walking distance. Your neighbor was your friend and your safety net. Suburbia is the opposite of community, as philosophy professor Mark Kingwell argues in *Radiant City*, stating that city dwellers moving out to the suburbs to escape the close quarters of city living are "fleeing from each other into isolation." This isolationism that is rife in the suburban setting could create future conditions that impact the whole of society. In *The End of Suburbia*, Kunstler makes a prophecy that "Americans will elect maniacs who promise to allow them to keep their McMansions,

their housing, their commutes, their suburbs, and their big-box stores, and that's going to cause a lot of political friction, probably a lot of violence, probably a threat to our democratic institutions." The 2016 election of Donald Trump to the office of president is an obvious picture that comes to mind when Kunstler suggests "maniacs" will be elected. But let's not kid ourselves into thinking that Trump's 2016 opponent, Hillary Clinton, or indeed his 2020 opponent, Joe Biden, would run on some anti-suburban ticket. Both of these democratic candidates are extremely comfortable with pushing the illusion that Americans can live and drive the way they have been for the past six or seven decades. Even a so-called progressive candidate, a Bernie Sanders or Elizabeth Warren, might pull back when confronted with the notion that the American way of life is at risk and that oil depletion will eventually be the downfall of oil-reliant societies.

Both documentaries push for a New Urbanism — that is, the promotion and creation of cities or communities that are walkable, with well-sheltered, tree-lined streets, well-served by public transport. This is in effect a return to the beauty and practicality of urban centers that Jane Jacobs spoke of in her books and writings. However, can we retrofit suburbia to accommodate this new vision? It would take extraordinary resources that, as Kunstler points out in *Radiant City*, are going to become harder to find: "We are entering an era of energy scarcity that is not going to permit us to live this way. The future is going to compel us to live differently whether we like it or not, or whether people want it that way or not."

The way we accommodate the future might mean that the suburbs become a forgotten, sparsely populated, and feared no-man's-land.

The Watchlist

Adventures in Babysitting (1987)
Short Circuit (1986)
Short Circuit 2 (1988)
The Warriors (1979)
After Hours (1985)
Drive (2011)
Radiant City (2006)
The End of Suburbia (2004)

MEN ON THE VERGE OF A NERVOUS BREAKDOWN

In the late '80s/early '90s, my parents would often record films that were shown on television onto VHS cassettes for later viewing. During these years, before the advent of DVD and online streaming, my family amassed quite a bulky collection of VHS tapes that I would watch repeatedly together with them or sometimes just alone. Three films in particular stick out as staples of my youth: 1984's *Bachelor Party*, 1986's *Short Circuit*, and 1988's *The Naked Gun*.

Bachelor Party was a film that gave me many repeated viewings. For the most part, the film was an attempt to jump on the bandwagon of popular teen films like 1978's *Animal House* and 1981's *Porky's* — basically and crudely, films that used sex, drugs, and boyish misbehavior as the primary points of their comedic antics. However, instead of following the sexual adventures of a group of teenage boys who didn't know any better, *Bachelor Party* wallowed in the exploits of seven white, straight, sex-obsessed, fully grown men who are desperately hanging on to the threads of their youth as one of them, Rick (Tom Hanks), breaks ranks and gets engaged.

Although marketed as a sex comedy starring the lovable and youthful Tom Hanks (not yet the superstar actor he would become later in the decade), there is in fact little sexual activity in the film. There are, however, copious amounts of leering, groping, and sexist remarks. The female actors in the film are all portrayed in a clichéd way — sassy prostitutes, nagging wives, or frumpy hags — and are included as the butt of many off-color jokes and degrading acts of perversion. (One woman attempts sex with a donkey!)

The misogynistic tone is set during the first few minutes of the film. As the friends sit in a diner and discuss the upcoming nuptials of Rick and his fiancée, Debbie (Tawny Kitaen), they suddenly realize that the best way to send Rick out in style is to have a debauched bachelor party that consists of "chicks and guns and fire trucks and hookers and drugs and booze!" They stand and smugly raise a toast to "girls with big tits," and the film progresses with its numerous set pieces of casual female humiliation and racial stereotyping.

Thankfully, I never grew into the gross-out comedy of *Bachelor Party*, but it took a long time for the film's entertainment value to work its way out of my system. So long, in fact, that the videocassette that the film was originally recorded on by my parents had multiple defects by the time I replaced it with a DVD copy sometime in the early 2000s. I suspect the film was recorded from television in or around 1990. It must have been before any major hormonal awakening, as I remember not being at all concerned or titillated by the scenes of nudity and suggestive dialogue throughout the film.

The main attraction of *Bachelor Party* for me at this age would have been Tom Hanks. He had become the universal boyhood hero of '80s comedy films such as *Splash* ('84), *The Man With One Red Shoe* ('85), *The Money Pit* ('86), and *Big* ('88). He endeared himself to a young audience throughout this decade with a physicality and goofiness that were childlike enough for kids to replicate and laugh at, and genuine and wholesome enough for parents to endorse. This must have been why my parents allowed me to watch the film in the first place; Hanks's roles were so childlike that even *Bachelor Party* was considered PG-13 material. Hanks would progress in his career to tackle more dramatic roles in the '90s and become the well-regarded actor, author, spokesperson, and producer we know him as today. But at this point in his career, he was mostly playing it for the laughs.

The original television screening of *Bachelor Party* was cut into by

advertisements every 30 minutes or so. These advertisements also made it onto the VHS cassette that was recording as we watched the film in real-time. There was an advert for the chocolate-peanut snack M&M's that featured a catchy jingle which still rings in my head ("The milk chocolate melts in your mouth, not in your hand"). There was an advert for the VW Golf GTi in which the male driver couldn't locate the source of an annoying squeak in his car (turns out it was his wife's earring). But there was more. Over the years of playing *Bachelor Party* on an old top-loader VCR, the tape had become pulled and skewed, thus glitching the image and dragging some of the dialogue out in momentary time lapses. The images also became distorted. At some points, Tom Hanks's forehead seemed to stretch and leave the frame altogether; other times, the image turned such a high-contrast red that it looked as if the cast had been on holiday to a nuclear power plant. There was also the matter of my continuous and childish misdeeds with the VCR remote control (which was attached to the machine by a long wire). While watching the film repeatedly, I had at numerous times hit the mysterious "Dub" button on the remote control either in error or on purpose, thus inflicting on the film seconds of random pieces of television that were playing at the time. For example, a tennis match momentarily interrupted the film's only tender scene between Rick and Debbie. All this damage to the cassette tape became an unintended but accepted part of the viewing experience. A personalized perception of the film had arisen.

When I found a DVD copy of *Bachelor Party* and sat down to watch it, the film felt wholly different. The scenes where commercials were meant to interrupt instead switched flawlessly to the next scene. The short blips of random television were gone, replaced by seamless audio and vision. Tom Hanks's head stayed firmly in the frame. What should have been a perfect viewing experience instead felt somehow hollow. My personal history with the film had vanished. These fragments had been placed within the film by me. It

didn't matter that they were imperfections or that they were never intended to be included.

Although the DVD viewing raised a few laughs, I was aware that my time of holding the film in such high regard was over. This is why I believe it took such a long while to get over *Bachelor Party*. My history was embedded in the version of the film I owned on VHS. The moments spent watching films with my family had dissipated over time, and *Bachelor Party* was a reminder of that shared experience. Also, the fragments of random television reminded me of points throughout my youth, lazing on a bed, eating a banana sandwich (not gross!), munching a packet of chips, drinking apple juice in bliss. In a way, the VHS copy of *Bachelor Party* was an artifact of my adolescence; through wear and tear, it created a map of my own growing-up.

Although I've been happy to dispense with the imperfections and the rewind and fast-forward awkwardness of VHS tape in favor of skip-back-and-forth DVD and Blu-ray and the fast skip-through of online streaming, I believe something is missing from these formats. We are now all watching the same film repeatedly. The digital framework of a DVD, Blu-ray, and stream means that our own history cannot be embedded in the film. The scratches and thumbprints that are common on the back of a disc eventually just stop it from being playable and are random at best. A VHS tape would warp and stretch, chew up in the machine, but it could be easily fixed with a little technical know-how, a butter knife, and some clear tape. As it played, it took on a life of its own, constantly moving away from its original imprint and changing.

Thankfully, I also moved away from *Bachelor Party*. I did not become a gross misogynist like the characters in the film. The breaks in the narrative deliberately inflicted throughout the years were perhaps glitches in my growing conscience as I reacted to the film's sexist tone. The videocassette that once contained *Bachelor Party* no longer exists. It has been erased and disposed of. The DVD

replacement offered a hollow experience, and in the first great cull of DVDs I performed before the big move to a new country, it was rightfully donated to a local charity shop.

II

It is easy to see that *Bachelor Party* comes from the perspective of male writers and a male director. The film oozes a deeply disturbing misogynistic perspective on the female gender. Of course, the film is played for laughs and isn't meant to be taken seriously as a piece of artistic filmmaking; yet still one could read *Bachelor Party* as a film that prioritizes the male perspective of the world in the era of Ronald Reagan's macho male-centricity.

The male psyche has been explored at great length in modern American cinema. Following the horrors of America's involvement in the Vietnam War, the male mind has been taken to the tipping point and all sorts of violent fantasies have spilled out from it onto celluloid. Travis Bickle, from 1976's *Taxi Driver*, is perhaps the poster child of the damaged post–Vietnam War male. His descent into paranoia and isolation is an explicit account of post-traumatic stress disorder. His only method of figuring out his environment is through violence and civil disobedience. He is an innocent child given the tools of adulthood to combat the cruel and bullying world and sent out without preparation or knowledge. Bickle's only strategy is to lash out violently.

Bickle is one of many males nudged to the point of no return. As is well-documented, the Reagan era brought about a cinematic machismo that complemented the administration's male-centric internal and external policies. The era was personified by the barbarism of Stallone, Schwarzenegger, and Willis, who all made use of extreme force to bring into line rogue foreigners and perceived internal threats such as drug dealers, corrupt officials, and street gangs. Films such as 1982's *First Blood*, 1985's *Commando*, and 1988's

Die Hard show wise-cracking macho men dishing out vengeance of an explosive nature. It's interesting to acknowledge that the above excessive reactions to the world are from a male perspective and play instantly into the hands of a male-dominated audience lapping up the fantasy of extreme retaliation and heavy-handed violence.

Male directors have conjured up an image of the male mind slipping into psychosis and acting out with brutal force to put their perceived worldview back on track. The image has shifted slightly since the action-movie heyday, but male directors still push the male psyche to breaking point. Todd Phillips's 2019 film *Joker* offers a more modern example. In *Joker*, Arthur Fleck (Joaquin Phoenix) is a party clown with aspirations to be a stand-up comic. The medical disorder that causes him to burst into laughter at inappropriate moments and his strange, quiet, and introspective nature signal him as an awkward outsider in the same vein as Bickle or De Niro and Scorsese's other on-screen creation Rupert Pupkin, from 1982's *The King of Comedy*.

It has fallen to female directors to explore the real nuances of the male mind without descending into the fantastical violence that so often occurs in the male-directed film. In Kathryn Bigelow's 1991 action flick *Point Break*, Mary Harron's 2000 film *American Psycho*, Kelly Reichardt's 2006 indie *Old Joy*, and Lynn Shelton's 2009 mumblecore film *Humpday*, the fragile male mind is subject to insecurity, trivial rivalry, insanity, and certain humiliation, yet with a sense of compassion and understanding from the female director that is deeply lacking from the male director's perspective.

Let us first discuss *Point Break* and *American Psycho*, as the two films share an emphasis on male ego and male rivalry.

Kathryn Bigelow's movies *The Hurt Locker*, from 2008, and *Zero Dark Thirty*, from 2012, both glorified the masculine desire to fight in hard-bitten wars. Both films, set in the conflicts of the Iraq War and the surrounding War on Terror, could be seen as a much-needed jingoistic push for support from a disillusioned American popula-

tion. However, Bigelow's films have always shown a darker thread of male desire that engages in violence for the rush of adrenaline it provides.

In her high-octane film *Point Break*, Bigelow focuses on the surfer community of Los Angeles and its thrill-seeking members, centering on the investigation by rookie FBI agent Johnny Utah (Keanu Reeves) and his older, jaded partner Angelo Pappas (Gary Busey) of a bank-robbing gang known as the Ex-Presidents. Utah goes undercover in the surfer community when Pappas proposes that the gang are a bunch of seasoned surfers. Although young and courageous enough to learn the basics of surfing, Utah begins to descend further into the subculture, picking up the slang and the posture of a surf bum, developing a sexual relationship with his surf tutor Tyler Endicott (Lori Petty), and becoming friends with the charming and charismatic surf guru Bodhi (Patrick Swayze).

Bodhi and his crew of surfers take Utah under their wing and discuss with him the spiritual aspects of surfing and extreme sports. At first, Bodhi comes across as some sort of bro mystic, bestowing his knowledge and lifestyle on the impressionable Utah. Around a campfire, Bodhi comments that Utah still hasn't "figured out what riding waves is all about yet," and continues to tell him that "it's a state of mind, it's the place where you lose yourself and find yourself." Everyone in his presence is in awe of his sensitive masculinity, as well as the intelligence he displays. Bodhi doesn't appear to be some total surf-bum dropout, but someone well-spoken and well-educated. When Bodhi expresses his desire to ride the waves in what he predicts will be a great storm at Bells Beach, Australia, he lets it be known that he is willing to sacrifice his life for the ultimate thrill: "If you want the ultimate, you've got to be willing to pay the ultimate price." He signs off on this statement by informing those listening that "it's not tragic to die doing what you love."

When it is revealed that Bodhi and his surfer pals are in fact the bank-robbing Ex-Presidents, it comes as no surprise to the viewer.

Yet Bodhi reveals aspects of his personality that were only hinted at before. His unquestioned need for control means that everyone who is within his orbit is suddenly at risk. When the gang members discover that Utah is an FBI agent during a high-octane chase scene, and discuss how to handle the betrayal, most vote to flee with the cash they have and disappear, but Bodhi exposes a detachment from the world that leaves him in the realm of fantasy: "This was never about the money," he tells his gang. "This was about us against the system. That system that kills the human spirit." The gang apprehend Utah and take him skydiving, where they reveal to him that his love interest, Tyler, is now in the hands of Rosie, a psychotic goon of Bodhi's. Bodhi gives Rosie orders to kill Tyler if the gang does not meet at a designated destination and time. They take Utah along for one last bank robbery, but Bodhi orders his gang to hit the bank's vault, a display of recklessness that puts them all in danger and is also at odds with the level of control Bodhi demands. By the end of the film, only Bodhi and his accomplice Rosie survive the getaway; the rest are killed. Bodhi seems unsympathetic about the loss of his friends and drives away with Rosie and the money from the last robbery.

Bodhi's thin veneer of spiritual calm and composure hides a deeply troubled and violent interior clinging to the edge of sanity. His philosophy of control through menace is frightening, and it's only in the last moments of the film that the audience realizes how disturbed Bodhi has become, or perhaps always has been. He explains to Utah just before the last robbery that "fear causes hesitation, and hesitation causes your worst fears to come true." It becomes clear that Bodhi is on a death trip, and the film ends with him paddling out on his surfboard toward a ferocious surf.

His speech about paying the ultimate price for doing what he loves could now be interpreted as a nihilistic sentiment, rather than a noble one. What also becomes apparent is that his initial friendship with Utah develops into a complicated rivalry. Bodhi has already

mastered his control over his gang of surf buddies, but it's clear Bodhi has something to prove to Utah, especially as Tyler was once his partner. By exposing Utah to the dangers of night-surfing and skydiving, Bodhi is clearly attempting to overpower him and be the dominant male. When it becomes clear to Bodhi that Utah is an FBI agent, rather than do the smart thing and go on the lam or turn himself in, he confronts Utah and begins a campaign against him, recruiting him against his will into one last Ex-Presidents bank robbery, but without letting him have a face mask, so that it looks like he's become an associate. Bodhi also kidnaps Tyler and uses her as ransom.

Bodhi eventually provokes the fascination he seeks from Utah when, after a death-defying leap from an airplane leaves Utah injured and unable to apprehend his man, Bodhi boasts, "I know, Johnny. I know you want me so bad it's like acid in your mouth. But not this time." This leads to a year-long, worldwide pursuit by Utah that eventually brings us to their final confrontation at Bells Beach, in which Utah is still under Bodhi's spell and eventually allows him to go and ride what we know will be the final wave. As Bodhi rides out toward certain death, Utah discards his FBI badge into the water.

Unlike the free-spirited Bodhi, *American Psycho*'s Patrick Bateman has become the embodiment of late capitalism and consumer culture's drastic influence on the male persona. Like his 1980s counterpart, the reptilian Gordon Gecko from Oliver Stone's 1987 film *Wall Street*, Bateman is detached, unfeeling, and uncaring toward the people around him. His only concern is himself and his outward appearance, physique, grooming products, daily care routine, expensive attire, music appreciation, and perceived social status. This outward obsession has left an internal void within Bateman; his delusions and fantasies begin to bleed into his reality.

An adaptation of Bret Easton Ellis's controversial 1991 novel, the film shows Bateman as far less sadistic than he is in the book. In Ellis's novel, Bateman indulges in drawn-out acts of torture, rape,

mutilation, cannibalism, and necrophilia, which are explained and dissected in graphic detail. The male interpretation (i.e., the male author's) of Bateman's behavior is to allow him to indulge in the most atrociously violent acts. The film version was adapted by Canadian film director Mary Harron, who made *I Shot Andy Warhol*, a biopic of the feminist activist and *SCUM Manifesto* author Valerie Solanas. Harron focuses instead on the narcissism and vanity of Bateman and his male colleagues, and leaves the acts of murderous violence and savagery mostly to the imagination of the audience (apart from one scene in which Bateman attacks his nemesis, Paul Allen — played by Jared Leto — with an ax).

By focusing on Bateman's petty concerns, Harron provides an account of male insecurity and anxiety in a world of consumerism and advertisements. One scene in particular exemplifies Bateman's obsessions. While waiting for a morning meeting to begin, Bateman and his colleagues compare their new business cards. Bateman, seemingly delighted with his new "bone"-colored and "Silian Rail"–typeset card, is then made delirious with jealousy over his colleague's far superior card: "Look at that subtle off-white coloring. The tasteful thickness of it. Oh my God, it even has a watermark." The scene demonstrates a man seething at the edge of sanity and triggered by the most inane situations. However, with most of the violent acts left to the imagination of the audience, it becomes far easier to understand that Bateman has perhaps imagined most of the atrocities he has committed. Toward the end of the film, Bateman pours out a confession to his lawyer over the telephone: "I don't want to leave anything out here — I guess I've killed maybe . . . 20 people . . . maybe 40! I have, uh . . . tapes of a lot of it. Some of the girls have seen the tapes — I even . . . I ate some of their brains and I tried to cook a little." Bateman's continuous rant about his exploits displays obvious panic as he thinks his time is up and the authorities are closing in, yet also uncertainty over how many acts of violence he believes he has committed. Without witnessing the

ordeals (unlike in the book, where every detail is explained), we have a sense that Bateman has simply lost his mind and is a victim of his own vulgar delusions. In many ways, Harron's film deals with the damaged male psyche in a much more effective and humorous way than the source material.

It's fitting that British actor Christian Bale would transfer Patrick Bateman's rich, egotistical capitalist to Christopher Nolan's reboot of the Batman franchise. Bruce Wayne's spoiled-rich-boy excursions into high-tech crime-fighting as Batman also reek of a delusional mind, one that is fighting other members of his gender who suffer from the same instabilities. What Bodhi and Bateman share is that their supposed wealth, good looks, knowledge, and social importance still leave them yearning for some form of violence and disorder to break the monotony of their privileged lives. In Bodhi's case, violent bank robbery is a justification for him and his comrades to be "against the system" and allow them to maintain their unstable spiritual journey, while completely detaching themselves from their vicious tendencies. However, Bodhi's absence of reality can not be broken even when he is unmasked by FBI agent Utah and every member of his gang is killed. This reveals a lack of empathy from Bodhi.

Bateman seems generally disconnected from the murderous crimes he commits, and instead his reality is fractured by moments when he feels his social standing or masculinity is in question — the business-card scene is an example of this. He finally breaks down when he realizes that he may have been found out, but his mind is so warped by the violent imagery that he cannot connect his real crimes, if any, to the ones he has played out in his head. Both characters go unpunished for their crimes, real or otherwise. Bodhi is allowed to go free and head into a surf that will no doubt kill him — thus, the responsibility for the deaths of his comrades goes unanswered and his masculinity will not be called into question. Bateman's manic confession to his lawyer is later presented as a vicious joke, thus leaving the nature of his crimes up for debate.

Bigelow and Harron's takes on male criminality are filtered through a lens of insecurity, jealousy, and a distorted view of reality. Although both of these men are open to violent and destructive behavior, a war is being waged within them that gives depth to the characters, a war that a male interpretation might choose to simply illustrate with excessive Stallone-style violence and stinging Schwarzenegger-style one-liners.

III

The kind of male companionship depicted in the buddy-movie genre has been a staple of American cinema for decades. While the lone male figure reveals existential turmoil and a sense of cool, silent detachment (see *Drive* or *Taxi Driver*, for example), having two male characters at the center of the drama allows for a dynamism and the revelations of personality that can only come via spoken or unspoken exchanges. For example, buddy movies such as 1969's *Butch Cassidy and the Sundance Kid*, the 1980 comedies *Stir Crazy* and *The Blues Brothers*, 1988's *Midnight Run*, and 1994's *Dumb and Dumber* all feature touching and humorous male interaction and, in some cases, good-natured rivalry. There is also an opportunity to convey a homoerotic subtext to films that feature a male twosome in the leads. Films such as *Pineapple Express* (2008), *I Love You, Man* (2009), *Swiss Army Man* (2016), and *Keanu* (2016) offer sweet-natured interactions and a sense of admiration and affection between the two leads is touching.

This is also apparent in two films by female directors that loosely fall into the buddy-movie genre: *Humpday* and *Old Joy*. Both narratives explore the revival of male friendships, yet there are moments in each film in which the relationship moves beyond simple friendship and comes closer to romance or a sexual encounter. However, it is not quite that simple, as the two films show not only the failure of male friendship, but the perceived failure of the male himself.

In the discussion above, I centered on female directorial interpretations of the fractured male psyche that lie within the spectrum of mainstream cinema, and showed that intense rivalry, combined with infatuation, can produce volatile homoerotic subtexts, most evidently between *Point Break*'s hero, Johnny Utah, and the film's villain, Bodhi. But it's also worth exploring the female perspective on the more subtle relationships between males that are not born out of psychotic tendencies, but come from genuine friendship. And it's best to turn to independent cinema to find these understated subtexts and explore a female take on male failure. Independent films can offer a safer and more open space to do this, as for the most part they are self-financed or funded by smaller studios or by Kickstarter campaigns that are not under any studio regulation or any pressure to compete in overseas markets that might turn their nose up at a hint of homosexuality.

Humpday and *Old Joy* both depict the narratives of once-close friends reacquainted after years of growing apart. While one has grown up to become a dependable partner and settle down, the other has never grown up and continues to inhabit an extended-adolescence mindset. When each of the friendships picks up again, it continues from the moment that the friends last saw one another, all those years back. That time before responsibilities, jobs, and marriage. In *Humpday*, Andrew (Joshua Leonard) is an artist who has been traveling around South America for the last few years. His attire of torn jeans, tatty jacket, an oversized backpack and his sporting of an unkempt beard signifies him as a roaming, free-spirited man. After being absent for 10 years, he crashes in on the homestead of his best friend Ben (Mark Duplass) at 2 in the morning. Like Andrew, *Old Joy*'s brash and opinionated Kurt (Will Oldham) has spent the intervening years wandering from place to place, crashing on friends' couches and avoiding the responsibility of adulthood.

When we first meet Kurt, he is pulling a wagon that contains what looks like an old, busted television set. His beard is wild,

and his denim shirt barely stretches over his protruding beer gut. Both Andrew and Kurt's behavior is impulsive, suggesting all the symptoms of a burnout. Too much booze, drugs, and partying have taken their toll on their aging frames. They have both been jumping from one spiritual, radical encounter to another, never quite finding the peace of mind and settlement they so obviously require. From Andrew and Kurt's perspective, it's as if nothing has changed, that their friends will simply accommodate their behavior as they once did. But in their absence, their friends have moved on, grown up, and now have adult responsibilities. *Humpday*'s Ben works a soulless desk job, is married to Anna (Alycia Delmore), and is in the first stages of planning a family with her. *Old Joy*'s timid and quiet Mark (Daniel London) is in a situation similar to Ben's. He is married to Tanya (Tanya Smith), who is due to give birth to their first child any day now.

From Ben and Mark's perspective, their friendships with Andrew and Kurt are a burden, yet in their presence, they revert to an adolescent mindset to prove something or regain a little of their lost youth. In Ben's case, he must prove to Andrew that he is not tied down and hasn't yet completely embraced his adulthood. During a party with a group of local hipsters that Andrew has connected with, the discussion turns to an upcoming porn film festival called HUMP! in which participants submit homemade porn and erotic films. Andrew boasts to his new friends that he is going to film himself having sex and enter the competition. Ben calls his bluff, yet Andrew rebuffs this by stating that he will have sex on film with Ben. The discussion then turns to how the idea of two heterosexual men engaging in full penetrative sex would be a brilliant artistic statement. Their unwillingness to back down and save face locks the two friends into a childish quarrel. This leads to an uncomfortably hilarious scene in a motel room where they attempt to film themselves with a cheap digital camcorder Ben has acquired. They strip down to their boxer shorts, share an awkward kiss, and discuss how they will secure and

maintain erections during intercourse. Neither is willing to admit that the scenario scares the hell out of him. Eventually, though, the two friends realize their stupidity. Ben begins to contemplate the damage he may have done to his relationship with Anna and returns home to make amends. The friends part ways. Andrew looks genuinely wounded as Ben gathers his things and leaves the room and, seemingly, their friendship behind.

Mark's situation is similar to Ben's. As fatherhood looms, a camping adventure with the freewheeling Kurt could be his last chance to experience a little carefree fun. On a whim of Kurt's, the two friends begin driving to Bagby Hot Springs in Mount Hood National Forest. After taking several wrong turns in the mountains and getting themselves lost, the pair decide at nightfall to set up camp down a dirt track and proceed to drink beer, smoke pot, and shoot cans with an air rifle. Kurt gets emotional at the detachment he perceives between himself and Mark, and his desperate need to reconnect overwhelms him. Mark reassures him that everything is fine and that their friendship is still intact and genuine.

Upon their arrival at the idyllic springs the next day, the unease between them seems to have passed. They fill up the bath with hot-spring water and soak in the tubs naked. As Mark relaxes in his tub, Kurt suddenly hovers over him. Kurt's shaky state of mind suddenly becomes a grave concern for Mark and the viewer. Does Kurt have some sort of homicidal tendency lurking beneath the veneer of fracturing spiritual calm? Thankfully not, but perhaps something else is on his mind. Kurt begins to tenderly massage Mark's shoulders and chest as he lies in his tub. At first, Mark is somewhat disturbed by the unsolicited touching. His upper body fights and shrinks from Kurt's hands. Eventually, though, he relaxes, closes his eyes, settles in, and allows Kurt to continue.

By the end of *Humpday* and *Old Joy*, both Ben and Mark have returned to their partners and resumed their adult lives. It is as if they have flirted with the possibility of an illicit affair. Andrew and

Kurt, on the other hand, are left alone and more detached than before, as if they were the jettisoned mistresses of lurid affairs. In the last scene of *Humpday*, Andrew sits on the bed in the motel room and rewinds the tape in the camcorder to watch back the footage of their brief and awkward encounter. He laughs to himself, yet it is clear he is saddened by the loss of this close friendship. Andrew packs his things and vacates the room and, we assume, leaves town for good.

The last few moments of *Old Joy* are as sad and lonely as any in modern cinema. Kurt aimlessly wanders the night-time streets of the city. He stops outside shop windows and peers in, he attempts to talk to a guy on the street but can't make the connection, he crosses the road and wanders back again, he searches around for a familiar or sympathetic face, but he finds nothing. He is utterly lost and alone.

Andrew and Kurt's imposition on their friends' lives is their last-ditch attempt to re-establish a connection that has long faded. The desperation is so intense that they both breach friendship and instigate a physical, homoerotic connection that is equally alluring and disturbing to Ben and Mark. It seems Andrew and Kurt can't be intimate without being sexual, a trait that leaves their friendships in tatters.

The films mentioned in this chapter's introduction as examples of the buddy-movie genre were all directed by men, but they are also older films. Male companionship in film has been replaced in more recent years by something a little more sinister, or more competitive, at the very least. The modern interpretation of male friendship in film is one that often features humiliation, intense rivalry, and betrayal. A few examples of this trend are *The Hangover* and its sequels (2009 onward), *21 & Over* (2013), and the film adaptation of the British television show *The Inbetweeners* and its sequel (2011 and 2014). While these films explore the insecurities of the male, they do it through the lens of gross-out humor, which, while funny, diminishes the overall impact.

What seems to have occurred in more recent years is the reinvention of the male-dominated buddy genre from a female casting perspective. Films such as *Ocean's 8*, *Hustlers*, *Booksmart*, *Blockers*, *Mistress America*, and the whole of the Pitch Perfect saga give female characters an opportunity to engage with each other.

Shelton and Reichardt's interpretation of male friendship is seen through the lens of male insecurity and a longing to turn the clock back on adulthood and return to a more carefree youth. It is also a more honest depiction. All four of the main characters are stunted adults who have failed to live up to the expectations of what it means to be male in modern society. They lack drive, ambition, or determination. They have let themselves go physically. Their politics are liberal enough, but they have failed to enact radical societal change. Though these characteristics are injected into the films for comedic purposes (two grown men kissing in their boxers as their bellies rub together is far funnier than if they both had toned physiques), it is also telling that the modern male has become the subject of much ridicule. We are a long way away from the ripped and slender bodies of the alpha males in *American Psycho* and *Point Break*. This version of masculinity has been unattainable for the vast majority of male audience members. In those two films, the male protagonists/antagonists are fit, confident, witty, and proud of their outward appearance. In *Humpday* and *Old Joy*, the lead characters have flabby beer guts, untoned muscle, unkempt hair, ill-fitting clothes, and defeated, sulking postures. This is the vision of masculinity we are left with. Their failure is complete when they are unable to recognize the difference between intimacy and friendship, and can barely love themselves, let alone another man.

IV

The above depictions of the fragile male mentality might seem firmly lodged in the world of fiction. The strange psychosis of Bodhi or Bateman could never attain such high levels of power

without a universal chorus of disdain from the population. At least one would hope. Andrew and Kurt have neither the desire nor the ambition to be in power, preferring to float along in life, while the man-children of *Bachelor Party* wouldn't have a hope in hell of forming a functional government (they can barely organize a bachelor party). But then, in 2016, Donald Trump was elected to one of the most powerful offices in the world and suddenly all bets were off. Many journalists and opinion writers at the time of the election results chimed in to the discourse to say that there was no precedent for this scenario, at least not in American democratic politics. Corruption, bankruptcy, double-dealing, alleged infidelities, and general grifting had followed Trump around like a bad smell for decades. Nixon had gotten busted and fled office. Clinton had been impeached. The call-out of creeps and rapists in all areas of life was reaching its zenith with the #TimesUp, #MeToo, and #AmINext movements. Trump was surely set to fail at his presidency, much like he had failed in other aspects of his life. Yet there had been a warning about how a Trumpian figure could emerge and take power, and strangely it had come 50 years prior to Trump's election victory.

Valerie Solanas's 1967 treatise the *SCUM Manifesto* was a damning critique of male dominance in American society. It denounced the male in extreme terms, calling for the end of the family unit and the male parental role, the dismantling of the male-led capitalist system, the end of traditional reproduction, the eventual destruction of all men (either by cold-blooded murder or by self-imposed annihilation), and a female-led utopia relying on automation and artificial reproduction.

Solanas and her *SCUM Manifesto* (an acronym for "Society for Cutting Up Men," although there is some dispute about this) toiled in obscurity until her infamous attempted murder of pop artist Andy Warhol in 1968 brought her to national attention and the *SCUM Manifesto* was widely published by Olympia Press. In

some respects, this has had a negative impact on the book. What might have become an important and influential text in mainstream feminism (perhaps with a few editorial overhauls) now had an air of notoriety, rawness, and extremism that was difficult to shake off. But the *SCUM Manifesto* is not a mess of incoherent anarchist ravings. Solanas had an astute intelligence matched with a troubled existence. Her hatred of men came from a dark episode of alleged sexual abuse at the hands of her father, and later violence at the hands of her alcoholic grandfather. She had a child at a young age, a boy named David, whose father was a married sailor. The child was put up for adoption and Solanas never saw him again. These events bleed directly into the *SCUM Manifesto*.

The twisted version of the male that Valerie Solanas presents in her book has become relevant in our own age. What was once written off as an extremist text on the fringes of feminist theory of the late 1960s could now be considered a primer in understanding the rise of toxic masculinity and the election of Donald Trump.

Trump's extraordinary election result in the face of numerous misogynistic, racist, and xenophobic comments and actions, before and during the primary and presidential campaigns, is a slap in the face of feminist progress, and of the race and gender equality that seemed to be pushing toward the socially established norm. What would have derailed a presidential contender in the past only seemed to advance Trump's agenda and play further to the premise that he was a political outsider who didn't play by the rules. For example, when an audio recording emerged of Trump making grossly lewd comments about grabbing women "by the pussy" as a seduction technique, it was dismissed as "locker-room talk"; a statement of apology was issued, and Trump continued his bizarre claim that "nobody has more respect for women than I do." Even in the aftermath of Hillary Clinton's campaign advert "Mirrors," which featured an audio collage of Trump's own derogatory language toward women, he stood by his claim. His misogynistic behavior should have been

enough to discourage any female voter from ticking the box marked "Trump" in the voting booth, yet according to exit polls conducted in the wake of the election, 53 percent of white women voted for Trump, a shocking statistic considering the decades of evidence that supports the notion that Trump devalues women or, at best, has little respect for them. When reading the *SCUM Manifesto* in light of Trump's 2016 victory, one could be forgiven for thinking that Trump ripped the more grotesque aspects of his personality directly from the text, taking the worst traits as a backhanded compliment and running with it.

Here, I want to re-evaluate the *SCUM Manifesto* and Valerie Solanas, who, in the wake of the 1968 shooting of Andy Warhol, her time spent in Elmhurst Hospital, and her diagnosis as a paranoid schizophrenic, has often been dismissed and discredited. Solanas deserves acknowledgment as a visionary, if somewhat extremist, thinker and writer, a cultural icon, and a worthy analyst of the male psyche, however. Her philosophies may have lessened as more mainstream feminist thinkers and ideas about patriarchy have come to the fore, but she offers a great understanding of male ego, rage, and privilege in regard to the presidency of Donald Trump and the males presented in modern cinema.

Not only can the *SCUM Manifesto* tell us more about the age of Trump-style masculinity, but it can also help us understand the many female voters, whom Solanas might refer to as "Daddy's Girls," that found Trump's message somehow appealing. One remarkable aspect of reading the *SCUM Manifesto* in the wake of Donald Trump's presidential victory is the descriptions of the male that seemingly envision Trump's own physique, actions, and mannerisms. This is the basic, surface reading of the manifesto, but is a way into the overall content of the book. Solanas could never have known the exact creature that would inhabit the White House 50 years after she wrote her manifesto, but she had a vivid idea of what type of male pushes himself toward ultimate power and dominance.

In one of her opening statements, Solanas claims that "The male is completely egocentric, trapped inside himself," and goes on to claim:

> He is a completely isolated unit, incapable of rapport with anyone. His responses are entirely visceral, not cerebral; his intelligence is a mere tool in the services of his drives and needs; he is incapable of mental passion, mental interaction; he is a half dead, unresponsive lump, incapable of giving or receiving pleasure or happiness; consequently, he is at best an utter bore, an inoffensive blob... [1]

The "isolated unit" that Solanas describes is important in understanding the nature of Trump. Trump has been a singular force for decades; his business dealings, books, and accumulated wealth have been viewed as an individualist victory with little input from others. The Trump Organization website boldly states that Trump "is the very definition of the American success story, continually setting the standards of excellence while expanding his interests in real estate, sports, and entertainment."[2] When Trump builds a hotel or casino, or authors a best-selling business book, it is taken as a given that he designed the building, or that the text came from his own pen. This is of course not the case. The hotels and skyscrapers are outsourced to a team of architects and designers, and are laid by construction workers, while his books are mostly ghostwritten by established journalists and authors, such as Tony Schwartz, who co-authored Trump's 1987 opus *The Art of the Deal* and, in fact, has claimed almost complete authorship of that book since. Trump's name is emblazoned across every product, as if it came from a single mind. This skewed positioning adds credence to Solanas's claim that the male is "completely egocentric," unwilling to share the limelight and taking credit for every victory and accomplishment himself, but unlikely to ever take the rap for bad decisions or gross outcomes. Later in the manifesto, Solanas further unpacks

this egocentricity, stating: "Isolation enables him to try and maintain his pretense of being an individual by becoming a 'rugged individualist,' a loner, equating non-cooperation and solitariness with individuality."[3] Trump has been noted to be a loose cannon when it comes to his presidential manner or following well-worn diplomatic protocol.

In a 2016 campaign debate with Democratic Party nominee Hillary Clinton, he refused to answer the question of whether he would concede defeat and acknowledge a Clinton presidency, stating: "I will keep you in suspense."[4] This played neatly to his stance as a firebrand and a political outsider who sees "non-cooperation" with perceived social norms as a positive anti-establishment trait. Trump also didn't follow the usual and established diplomatic protocol when contacting other world leaders after his election win, talking to the president of Taiwan on the telephone before contacting the leadership of China. This action caused the Chinese government to lodge an official complaint. Trump and his followers refused to concede the 2020 election and hand over the reins of power to victor Joe Biden.

Solanas claims that the male is "trapped in a twilight zone halfway between humans and apes, and is far worse off than the apes because, unlike the apes, he is capable of a large array of negative feelings — hate, jealousy, contempt, disgust, guilt, shame, doubt..."[5] These negative traits that the *SCUM* male processes were used by Trump to great success on the campaign trail and at his countless rallies.

Trump used his rallies to stir up resentment in his supporters toward those seeking immigrant and refugee status in the United States, toward religious minorities, and toward the political elite of Washington, D.C. He also turned them against any naysayer of his campaign and any political rival, however well-established or untouchable. At one point, Trump even dismissed the suffering and hardships of Republican Senator John McCain during his five-and-a-half years of imprisonment during the Vietnam War, claiming

that he was only perceived as a war hero because of his capture.[6] This negative attitude complements Solanas's idea that the male is "unable to relate, empathize or identify."[7] He can't see past his own self-importance, and he'll trounce anyone standing in his way to power. However, as Solanas explains, he'll also deflect his failings onto others and away from himself, using prejudice and resentment to further his cause: "The male needs scapegoats onto whom he can project his failings and inadequacies."[8] Trump continually used racism, xenophobia, sexism, and class prejudice to further himself, fire up his supporters, and distract attention away from his own scandals. The Covid-19 pandemic has been a gift horse for Trump, in that the failings of the economy and the hardships many have faced can be blamed on the "China virus," as he liked to continually call it. This framing wraps the pandemic in the type of xenophobia that his base laps up. To add to this, Solanas claims that "the male's chief delight in life . . . is in exposing others. It doesn't much matter what they're exposed as, so long as they're exposed."[9] Trump delighted in trying to expose Hillary Clinton's email scandal and seemed to be in a state of almost orgasmic elation when he brought three women who in the past had accused Bill Clinton of sexual misconduct to a campaign debate. Even when the previously mentioned video of Trump mouthing off about his seduction techniques surfaced, the apology video turned the attention to Bill Clinton's alleged sexual misconduct to deflect the accusations against him.

One of the few positive things that Solanas has to say about the *SCUM* man — and it's a backhanded compliment — also presciently applies to Trump: "It should be said, though, that the male has one glaring area of superiority over the female — public relations."[10] Indeed, Trump's whole persona is a public-relations nightmare or a riveting success, depending on how you view it. Comments and actions that would have destroyed most reputations only seemed to inflate his popularity and, one might add, his own ego. Trump played his political inexperience to his advantage, telling his supporters that

he was going to "drain the swamp" of Washington elitism and install some much-needed common sense. There was much alarm regarding Trump's thoughtless comments on war and conflict, and especially the horrific idea that as president he had a nuclear arsenal at his fingertips. The fact that his actual policies remained elusive (something he put down to not wanting to inform America's enemies of his intentions) was frightening. This is something that Solanas explains in damning terms: that the *SCUM* male uses war and conflict as a metaphor for his own manhood — that he weaponizes his genitals, so to speak. She explains: "The normal male's compensation for not being female, namely, getting his Big Gun off, is grossly inadequate, as he can get it off only a very limited number of times; so, he gets if off on a really massive scale, and proves to the entire world that he's a 'Man.'"[11]

During the Republican primaries, Trump's rival Senator Marco Rubio made a sly comment on the size of Trump's hands, implying that small hands equal small manhood. Trump took the issue up at his next rally, saying, "I guarantee you there's no problem, I guarantee it."[12] Trump wouldn't allow the comment to slide; he had to respond because his manhood was in question. Solanas talks about the sense of damage this could cause, stating that the male would "rather go out in a blaze of glory than to plod grimly on for fifty more years."[13] One might recall Hillary Clinton's criticism that Trump could be violently provoked by a simple tweet.

As mentioned, a strange occurrence in the 2016 U.S. elections was the huge turnout of female voters who supported Trump. There are many questions about why this happened, especially given that Trump had in the past used derogatory language and innuendo against women. There was also the matter of Trump's policies on reproductive rights and the intended overturning of *Roe v. Wade*; Trump stated he wanted to return the decision of abortion back to the individual states. While Solanas's manifesto is extremely critical of men, it also explores the idea that a certain type of female needs

to be eliminated for a fully fledged female revolution to flourish. Solanas refers to this type of woman as "Daddy's Girl," who is "always tense and fearful, uncool, unanalytical, lacking objectivity," and is happy to appraise "Daddy, and thereafter, other men, against a background of fear ('respect') and is not only unable to see the empty shell behind the façade, but accepts the male definition of himself as superior."[14]

However, if this is the case, and a certain group of women cannot unchain themselves from the *SCUM* male, then the blame cannot be fully placed on these so-called "Daddy's Girls." As Solanas continues:

> Having an obsessive desire to be admired by women, but no intrinsic worth, the male constructs a highly artificial society enabling him to appropriate the appearance of worth through money, prestige, "high" social class, degrees, professional position and knowledge.[15]

Money is something Trump has been immensely proud to brag about and splash out on numerous ventures: hotels, casinos, beauty pageants, wrestling events, reality-TV shows, golf courses, his own university, all in an attempt to gain wealth, prestige, social standing, and, as Solanas states, "masterfulness by the manipulation of money and everything controlled by money, in other words, of everything and everybody."[16]

Solanas's contempt for males is a defining characteristic of the manifesto, but is not the first call to action in the conflict she envisions. Solanas sees the conflict beginning with the SCUM movement's eradication of

> nice, passive, accepting, "cultivated," polite, dignified, subdued, dependent, scared, mindless, insecure, approval-seeking Daddy's Girls, who can't cope with the unknown, who want to hang back with the apes, who feel secure only with Big Daddy standing

by, with a big strong man to lean on and with a fat, hairy face in the White House.[17]

A *SCUM* male "in the White House"? Perhaps Solanas knew more than she was letting on.

The extremities of the *SCUM Manifesto* might be hard to swallow for most readers, and due to a sense of self-preservation, I can't fully endorse Solanas's notion and vision that the male needs to be violently eradicated from society. The natural degradation of the Y chromosome is already taking care of male eradication in a more balanced and humane way. Solanas called for a "cutting up" of men, but perhaps a better interpretation of her phrase would be the cutting out of men, while for women "dropping out is not the answer; fucking up is."[18] Solanas encourages males to drop out of society altogether and leave the world to women. That being said, there are moments in the manifesto that reach out further and make a male reader empathize with the plight of SCUM. Solanas eventually allows for some salient attempts at envisioning a utopia that could pave the way for a truly remarkable future. For example, she states eloquently:

Love can't flourish in a society based on money and meaningless work: it requires complete economic as well as personal freedom, leisure time and the opportunity to engage in intensely absorbing, emotionally satisfying activities which, when shared with those you respect, lead to deep friendship.[19]

She later envisions the first flourish of revolution using excited terminology:

A completely automated society can be accomplished very simply and quickly once there is a public demand for it. The blueprints for it are already in existence, and its construction

will take only a few weeks with millions of people working on it. Even though off the money system, everyone will be most happy to pitch in and get the automated society built; it will mark the beginning of a fantastic new era, and there will be a celebration atmosphere accompanying the construction.[20]

Both of these paragraphs mark a notably optimistic shift in tone from the main theme of the manifesto. Most importantly, Solanas doesn't hint at the eradication of men; in fact, in the last paragraph she uses the collective terms *public*, *people*, and *everyone*, allowing for a short glimpse of a SCUM revolution that transcends gender, race, class, and sexuality. Secondly, Solanas paints an optimistic expression of SCUM compatriots not as murderous anarchists, but as individuals ready and willing to construct an enlightened society where money is absent, work is minimal, love flourishes, and friendship reigns. This, in some respect, excites the mind of the reader, male or female. No real answers lie within the *SCUM Manifesto* that could be put into practice without enormous and wide-scale civil disobedience. The murder of millions is not a reasonable or acceptable approach. Yet, in the years since it was written, one thing has remained certain: societal structures are still built by and for the needs and wants of predominantly white cis males and is almost completely irrelevant to women. Solanas called this the "artificial society" in which the male appropriates "the appearance of worth through money, prestige, 'high' social class, degrees, professional position and knowledge and, by pushing as many other men as possible down professionally, socially, economically, and educationally."[21] Donald Trump and his cohorts in government represent what Solanas describes. And its artificiality is more potent than ever. This needs to change, and strangely enough it is men who need to enact this change; no instantaneous mass slaughter of the male will lead to a better society, but a shift in perspective on how one can order a diverse and just society that abandons the desires of the male eventually will succeed.

Men need to step up, yet simultaneously step aside and step down. We need women in every political office, big or small, leading in every aspect of our lives, not just in the areas where social norms have placed women in the past. We need women leading in areas of science, education, housing, and urban development, child development, energy, commerce, media, defense, and labor. And with the built-in male capitalist mechanism removed — because it will be down to males to remove it — these departments would be run for the benefit of everyone, not just corporations.

The "Daddy's Girl, ever eager for approval" will no longer need that approval, because approval from a male will no longer be wanted or required. The male that Solanas so unsparingly depicts is, believe it or not, a dwindling minority, and is in decline. It is in the endgame. Trump is the last gasp of a dying breed, the final revenge of toxic masculinity. We've hopefully hit the ceiling, with no room left above us. There is no question that hardship and injustice await in a post-Trumpian America. Solanas got a lot of things right, and for this she should be praised, but she got wrong a key component of revolutionary change. Society can't function with divisions in place, yet Solanas placed a massive gender division at the very core of her work. Trump, in a masculinist way, has done this as well, yet has gone even further, dividing people not only by gender, but by race, nation, sexual orientation, and class. Society's members function in solidarity with one another. And solidarity is critical for a better world.

The Watchlist

Point Break (1991)
American Psycho (2000)
Old Joy (2006)
Humpday (2009)
In the Company of Men (1997)
I Shot Andy Warhol (1996)

NORTHERN EXPOSURE

In the 2014 book *What Should We Be Worried About? Real Scenarios That Keep Scientists Up at Night*, the world's leading scientists across various fields of research and study discuss the possibility of humanity's decline or total obliteration. Included are many fire-and-brimstone scenarios such as incoming comets or asteroids, widespread pestilence, and natural disasters. Circumstances that, if they happened to occur, would be out of mankind's control. Most of the essays in the book concern the internet and its demise. In one essay titled "Living Without the Internet for a Couple of Weeks," scientist Daniel C. Dennett makes clear that "Goliath hasn't been knocked out yet, but thousands of Davids are busily learning what they need to know to contrive a trick that will even the playing field with a vengeance."[1]

In late November 2014, a group of "Davids" employed their tricky tactics and did severe and irreversible (at the very least in reputational terms) damage to one massive "Goliath." The hack attack by Guardians of Peace on Sony Pictures exposed a torrent of embarrassing emails that detailed squabbling movie executives and egotistical outbursts from some of Hollywood's biggest stars. The email exchanges read like the source material for a more devious draft screenplay of 1992's *The Player,* 1997's *Wag the Dog,* or 2008's *What Just Happened?* Basically, they showed Hollywood insiders going rogue and placing the film industry in a bad light.

The hack was in retaliation for the forthcoming release of Seth Rogen and James Franco's comedy film *The Interview,* which depicts

the gory assassination of North Korean Supreme Leader Kim Jong-un by a hapless television journalist (Franco) and his producer (Rogen). When the first trailer for *The Interview* was made available back in June 2014, North Korea complained to the United Nations to block the film's release. As reported in the *Guardian* newspaper, the North Korean government claimed the content of the film was an "undisguised sponsoring of terrorism as well as an act of war."[2] In many ways a fair comment from the North Koreans, who have been accused by the United States of similar depictions in their own media propaganda and of sponsoring terrorism in the past. Although North Korea denied knowledge of the attack, the FBI was adamant that, if nothing else, North Korea set the wheels in motion for the attack to take place.

American retaliation was on the cards. A month after the Sony hack, North Korea lost its entire internet connection. As most citizens of North Korea live without internet access, or, at best, filtered access, it was doubtful that many of them even realized what was occurring online. Did the U.S. government authorize this retaliation? This is still unknown, but it is this aspect that is perhaps the scariest notion of all. It signaled that nations could now engage in cyber warfare that would have a knock-on effect for us all. The landscape of war zones would change from vast deserts, fortified barracks, and abandoned cities to the digital realm. This would not, of course, be a deadly gunshot, but a disarming and disorientating blow to our everyday lives.

One frightening conclusion of *What Should We Be Worried About?* is the lack of any contingency plan for the downfall of the internet. Entire infrastructures rely on its flawless and continuous operation. The loss of internet service through hacking attacks or, as in the 2014 film *Transcendence*, a decision to simply disconnect from all power sources to survive would bring globalization to a standstill and make capitalist economies worthless.

Pulling the rug from underneath our aggressors means toppling the entire house. Much like the outcome of *Transcendence*, human-

kind would have to adapt and become self-sufficient, learning to survive in regional pacts that rely on the trade of local goods and services, growing food in communal gardens, and getting about on rickety bicycles. The lifestyle shift seen in *Transcendence* might be okay for the residents of Portland, Oregon, who already live this sustainable lifestyle (if the TV show *Portlandia* is to be fully believed), but for the rest of us who are reliant on "the net" the downfall would be considerable.

However, and in all honesty, the consequence of technological downfall seems tolerable compared with the result of following through to the other possibility: all-out global nuclear conflict. The hacking of Sony Entertainment might not seem like a doomsday scenario, but with the apparent backing of an armed and dangerous regime orchestrating the event, the situation suddenly becomes a profoundly serious and deadly concern. This whole scenario could be a swaying domino that will either steady itself or start a dramatic collapse. Either way, we will look back on the Sony hack with the knowledge that one silly comedy film did, or nearly did, bring about Armageddon.

II

One thing is noticeably clear about *The Interview*: you can't learn anything useful about North Korea from it. The country's ideology, history, and intended future are not discussed or explored. As in the 2004 film *Team America: World Police* or the 2012 remake of *Red Dawn*, the country and its government are the butt of most of the jokes or, as was the case with *Red Dawn*, the copy-and-pasted-in bad guys. I'm not in the business of defending the regime, but having some understanding of it is crucial. Two books draw a wide picture of life in North Korea and the regime's desires to maintain and succeed at any cost.

It's no coincidence that North Korea seems to exist as an almost real-time movie. The country comes across as a weird combination

of gangster films like *The Godfather* and *Once Upon a Time in America* and the old science-fiction adaptations of *1984* and *Brave New World*, played out over 70-plus years and with no end credits in sight. The Kim dynasty thus far includes Kim Il-sung, who ruled the nation from 1948 to 1994, his son Kim Jong-il, who assumed power in '94 and ruled until his death in 2011, and, since 2011, Jong-il's youngest son, Kim Jong-un. These three men are the main stars of the North Korean picture, prima donnas in the old Hollywood tradition, with every other North Korean citizen playing a supporting role to the egotistical narrative they have developed. It's the most elaborate and most expensive movie in history and it's still in production. Francis Ford Coppola, eat your heart out!

Unfortunately, the consequence of the Kim clan's absolute power is very real devastation. While the elite reside in the relative wealth and comfort of North Korea's capital city, Pyongyang, the rest of the country, or the "extras" in the North Korean movie experience, are left to fester in the abandoned soundstages of the country's poorer districts, run-down satellite cities, and derelict countryside.

Cinema was an early obsession of the country's second-generation dictator Kim Jong-il. Perhaps his real passion in life was to become a genuinely great movie director; in effect, he achieved this ambition tenfold, directing an entire nation, not on celluloid, but in his own reality. According to Paul Fischer's book *A Kim Jong-Il Production*, "He was the writer, director, and producer of the nation. He conceived his people's roles, their devotion, their values; he wrote their dialogue and forced it upon them; he mapped out their entire character arcs, from birth to death, splicing them out of the picture if they broke type."[3] In another life, and with any other materials, he'd have been called an auteur; instead, we know him and his clan as monsters.

While he secured his position in North Korea's elite structure, Kim Jong-il's first official position was leading North Korea's Orwellian-sounding Propaganda and Agitation Department, which incorporated the country's budding film industry, which was ulti-

mately used to promote the country's own brand of communist ideology, *Juche* (translated loosely as "self-reliance"), and to elevate his father, Kim Il-sung, to eternal godlike status. Jong-il authored a filmmaking manifesto entitled *On the Art of the Cinema*, a classic of North Korean literature, part gibberish, part genius. While the film productions that the North Koreans were churning out might have impressed and pushed the ideology on a domestic and, let's face it, captive audience, the aesthetics were stale elsewhere. Kim Jong-il was aware of this, and his obsession with gaining international recognition for artistic achievement led him to partake in an act of espionage worthy of a James Bond thriller.

Fischer's book tells the familiar and tragic consequences of the Korean War and the dividing of the nation into two opposing factions, the Chinese- and Soviet-backed North and the American-backed South. Rather than depict the events in some hard-boiled manner worthy of a Cold War thriller, Fischer instead lays out these dramas from the perspective of South Korea's most revered female actor and director, Choi Eun-hee, and the hotshot filmmaker Shin San-ok. When the dust had settled on the Korean peninsula, these two would team up as a potent creative force in South Korean cinema and become husband and wife.

Their fame was such that even the South's own dictatorial president, General Park Chung-hee, who had swept to power in a military coup d'état in 1961, wooed them to his cause. Choi and Shin were Angelina and Brad, or Will Smith and Jada Pinkett Smith, before the concept of a power-hungry transmedia duo was ever dreamed up. The rise, fall, rise, and fall again of Shin shows that as a film director he was as talented and yet as megalomaniacal and monstrous as Hollywood's own James Cameron. When Shin fell out of favor with the South Korean censors, and his relationship with Choi deteriorated, he traveled the world, trying to scrape together a film project.

Unknown to Shin at the time, his ex-wife Choi was already residing in relative luxury in North Korea, the victim of a horrific

kidnapping plot, and now a "guest" of Kim Jong-il, who was awaiting Shin's arrival and the reunification of the filmmaking powerhouse duo. When Shin did arrive, it was by force, another brutal kidnapping with the offer of relative luxury. Unlike Choi, Shin decided a life in the North was not for him; he tried to escape several times, once almost making it to the Chinese border, an escapade that makes the reader almost believe he could have made it out alive. Shin was recaptured a mere 10 miles from the border, and his punishment was exile to the notorious North Korean prison camps. Shin spent several years in appalling conditions, being virtually starved to death, forced to sit in discomfort for 16 hours a day, until eventually he began to realize working with the North was his only option.

When Shin and Choi agreed to lead the North Korean film units toward attaining artistic merit, the ruse also became a practice in earning the trust of Kim Jong-il and the cast of various "minders" who shadowed the pair constantly. Only with acute timing was an escape from their captors attempted, when they knew that they would be successful.

One can't help but sense that the whole of Kim Jong-il's life was shaped by the movies. As he was one of only a few citizens of North Korea allowed the privilege of viewing Western films, one might assume his entire persona was built from countless Hollywood movie archetypes, familiar to him yet utterly original to everybody else in the country. There are scenes in Fischer's book that bear striking similarities to classic moments of Western cinema. Take for example the chaotic parties thrown by Kim and his close associates. An obvious association would be *Entourage*, the television show that follows a spoiled Hollywood star and his group of debauched childhood friends as they spend, drink, snort, and fuck their way through Los Angeles. However, the belittling nature of Kim Jong-il toward his party guests instantly reminds the reader of Joe Pesci's maniacal Tommy DeVito from Martin Scorsese's *Goodfellas*, the rotten hood

who for his own amusement makes a teenage bartender dance by firing his gun at his feet, eventually killing him. This is prime Kim Jong-il, though in this twisted reality he was making everyone dance to his tune.

There can be no doubt that Shin and Choi suffered great hardships under the watchful eye of the North Korean state, Shin imprisoned for years, Choi unaware of why she was brought to North Korea, both taken from their friends and families. Eventually, though, they lived in relative comfort, headed up a film production company that placed artistic merit over ideological own goals, were able to travel outside of the country (with minders in tow) and screen their films at prestigious international film festivals, and, most importantly, had a direct line of contact to Kim Jong-il himself.

Fischer's book reads like a classic Hollywood tragedy, though in this case the protagonists are not the center point of the tragic events that take place. In this situation, the tragedy befalls the "extras," the people of North Korea, who are subjected to the deluded self-narrative and the absolute control of the Kim regime. Hooked up to a constant drip-feed of propaganda that tells them almost from the day they are born that they have nothing to envy of the outside world, that the workers' paradise created by the Kim dynasty provides everything they will ever need and more.

Hollywood is often called the "Dream Factory," and it certainly provides otherwise unattainable feats of the imagination. Yet aspiration is also to be found in Hollywood films. The North Korean model of film production is to crush aspiration, to never allow its people to prosper; it is a factory whose sole intention is to produce nightmares.

Fischer's book offers a fantasy incarnation of North Korean life from the top-tier perspective. At no point do we see or hear from the general populace, though we are fully aware of their existence.

My news feed is often set to prioritize stories that emerge from the DPRK. The slow trickle of internal news and rumor that comes

via China and South Korea's gossip bloggers, and from more serious academics, can last for months at a time and provoke bursts of laughter at the absurdity of some of the content. (The discovery of a unicorn lair was a howler.) Often, however, these trickles can erupt into a full-blown flood of reports that makes international headlines and evokes serious responses from diplomatic envoys the world over. These reports on North Korea can be as frightening as they are bizarre. Take for example the March 2013 nuclear posturing by the North toward its southern counterpart and the U.S. — it felt like it was ripped out of some outdated Cold War thriller. Yet the threat was real enough, and it continues to be the case.

The excursions by former NBA star Dennis Rodman to train the North Korean basketball team, and his budding bromance with North Korea's young leader, Kim Jong-un, seem like they should be the source material of some straight-to-DVD sports comedy.

However weird and funny these stories may seem, though, there is a real tragedy unfolding. In the months following the Rodman visit, major headlines reported that Kim Jong-un had ordered the execution of Jang Song-thaek, his uncle by marriage and, until Jang's public disgrace in the eyes of North Korea, a member of the ruling elite for decades. Then there was a news report that the North Korean government had ordered all North Korean males to adopt Kim Jong-un's rather tragic hairstyle. If a country could win a prize for weirdness, North Korea would be a winner year in, year out. What is truly shocking about North Korea is that after all its human rights abuses, its out-of-date political doctrine, its nuclear posturing, its cult of personality, and its ability to antagonize its neighbors and the world, seemingly without much repercussion, it still dares to exist, and in the aftermath of Donald Trump's presidency and his appraisal of the North Korean leader, it can do so as an almost legitimate country.

III

When President George W. Bush identified North Korea as part of, along with Iran and Iraq, the Axis of Evil, he reignited interest in the nation among academics, political commentators, and the general public alike, who all wished to delve further into this vague notion of evil. Thus began a publishing foray that has continued alongside the North's own development, ranging from sensationalist titles such as Michael Breen's *Kim Jong-Il: North Korea's Dear Leader* (Wiley, 2004) and Jasper Becker's *Rouge Regime: Kim Jong-Il and the Looming Threat of North Korea* (Oxford University Press, 2006) to the economic dissections of Victor Cha's *The Impossible State* (Bodley Head, 2012), explorations of the regime's propaganda machine in B. R. Myers's *The Cleanest Race* (Melville House, 2010), and the exposés of escapes from North Korea in Barbara Demick's *Nothing to Envy* (Spiegel & Grau, 2009) and Blaine Harden's *Escape From Camp 14* (Pan, 2012). In combination, these books offer a detailed picture of life and politics in North Korea, and frankly, they are pretty grim. Paul French's 2014 book *North Korea: State of Paranoia* is an attempt to decipher the country's past, present, and future in one digestible volume. Unlike some of its predecessors, its tone remains realistic and evades sensationalism; it portrays an honest picture of North Korea in all its aspects.

The book's opening chapter, entitled "An Ordinary Day in Pyongyang," is just that, a day in the life of the citizenry of North Korea's gleaming (at least on the surface) capital city Pyongyang. In the daily routine of the workers, we discover a life not too dissimilar to working-class life in early-20th-century Britain. Descriptions such as "Breakfast usually involves corn or maize porridge, possibly a boiled egg and sour yogurt, with perhaps powdered milk for children. After breakfast it is time for work"[4] could be lifted directly from George Orwell's *The Road to Wigan Pier* or Richard Hoggart's *The Uses of Literacy*. Though the conditions of the working class in 1930s

Britain were tough and demanding before the welfare state was built, they pale in comparison to those endured by workers in North Korea who are reliant on their own welfare state. French peels back the gloss that is projected by the regime of Pyongyang to reveal a far more normal city, one that is concerned with all the trivialities of modern existence. It's an opening that gives the reader a false sense of comfort. As the book progresses, French delves further to reveal the sinister mechanisms that hold the whole charade of North Korea together.

The Kim dynasty that has dominated the country since its inception is explored to great depth. First, French analyzes the path to power that Kim Il-sung walked, from his humble beginnings as a freedom fighter/thorn in the side of the post-war Japanese occupation of Korea, to his dictatorial apprenticeship under Stalin's Soviet guidance, and then to Russia's appointment of him as ruler of North Korea. What is striking is how much the historical narrative rubs against North Korean propaganda. All remnants of possible Russian involvement in the ascension to power of Kim Il-sung (and there are many) have been scrubbed, and a mythical, at times fantastical history has been implanted in the North Korean psyche. Kim Il-sung's heir, Kim Jong-il, has inherited the same delusion of grandeur. Kim Jong-il always came across as a spoiled rich kid, and French does not paint him in much different of a light. Kim Jong-il was busy laying the foundation of his father's legacy and the mythology of his own ascension for a decade before he officially took leadership in 1997. The revelations of his playboy tendencies, his huge Hollywood movie collection, and his love of expensive cognac come as no surprise, yet it's a testament to French that he doesn't wallow in sensationalism. Kim Jong-il's youngest son, Kim Jong-un, allows French to be somewhat more speculative about the direction he will take the country.

Recent news reports from North Korea seem to show a mellowing toward foreign investment and a more modern standard. However,

the Juche rhetoric (more of which in a moment) has not eased. If anything, the promotion of the country's political philosophy has been bolstered to justify the young heir's ascent to power. Despite Kim Il-sung's initial popularity with the people of North Korea and his later grandfatherly manner, French paints him as the real villain of the piece, the architect of his country's undoing. The egotism of one man has left in place a rigorous system in which no other citizen can prosper; to do so would be disloyal to and overshadow the Great Leader. Kim Il-sung took care of any possible threat to his leadership and his version of events through execution and imprisonment of naysayers and a regimented and inflexible state structure that infiltrates every aspect of daily life and thought. In doing this, he sowed the seeds of his country's most devastating problems, which hit seismic proportions after his death, when North Korea was struck by a famine. His own personal death toll is immeasurable.

The bulk of *State of Paranoia* is devoted to the economic decline that started during the 1970s and continued to a catastrophic conclusion during the mid-to-late 1990s, when the famine and related afflictions cost the lives of anywhere between 240,000 and 3.5 million North Koreans. True estimates are hard to pinpoint, as the North Korean media machine has often glossed over the crisis, outright lied, or presented "alternative facts" to the outside world. Although still in economic free fall, and reliant on external aid from China and Russia, North Korea has at least avoided having such devastation happen again, although, for the majority of those living outside the relative comfort of Pyongyang, hunger is still an everyday fact of life.

The chapters that make up the middle section of the book read like a comedy of bureaucratic errors, with no punch line. What striking overall realization comes from French's book is that the means to economic recovery and financial common sense have simply been bred out of the North Korean conscience over generations and replaced by doctrine. As it stands, there is no qualified

person within the party core, the educated class, or the common citizenry, for that matter, who could remedy the economic situation by applying even a rudimentary version of free-market economics or a shot at Soviet-style *perestroika* and *glasnost*. The country's dependence on Juche, the political philosophy of self-reliance authored by Kim Il-sung and Kim Jong-il, as the guiding principle in all matters, has not allowed any leeway in the management of the economy. To question the validity of Juche is simply not an option.

The subject of Juche, its origins, and its adaptation to North Korean life are also discussed at great length, offering a deep understanding of this often impenetrable and contradictory philosophy. In fact, for most of the book, Juche hangs like a specter over all aspects of life, politics, and military endeavor. And it's when French turns to the subject of North Korean militarism that the reader comes to grasp how the country's artillery has become such a powerful bargaining chip in the geopolitical arena. For a regime that has made some incredibly dumb policy decisions, the way it has played its aggressors and supporters against one another over its nuclear weapons development is extraordinary, and awfully close to genius. However, the fact that North Korea exists within the real world, and not in some Ian Fleming or Clive Cussler novel, chills the spine somewhat, given the very real threat of nuclear Armageddon. In the context of French's book there is a sense that North Korea is akin to the smart-ass kid in high school who is protected by the playground toughs, in this case Russia and China, but barely tolerated most of the time. This intolerance points toward French's closing speculation about how the next stage might play out.

In his conclusion, French proposes several scenarios that may befall North Korea, none of which are a desired outcome for the region. The dilemma of a mass exodus in which millions cross into China would, in French's view, cause a huge strain on aid and international goodwill. An internal military coup seems unlikely, with the higher echelons of the armed forces receiving the better end of the deal in

terms of wealth, rations, clothing, and quality of life. The only way French can see a military coup unfolding is if Kim Jong-un turns his back on the military elite, which would seem a foolish move. Although pockets of internal dissent no doubt exist throughout the country, there is no organized movement, no student army or working-class revolt that could influence mass change from within, as has been seen throughout the Arab world and most recently in Ukraine. North Korea doesn't much care about its appearance to the outside world, so any dissent would be brutally shut down by the regime.

The option that seems the most realistic is a military intervention from the West. A war with North Korea would probably be brief yet devastating. The loss of life on both sides would be astronomical, while the damage that North Korea could do in that short time, as it lashed out in all directions, could be catastrophic for the whole region, especially if it deployed its arsenal of nuclear weapons in a savage act of nihilism. The shaky foundations on which diplomacy with China and Russia is based would crumble, and another Cold War, if not an extremely Hot War, would be a distinct possibility. French acknowledges all of the above scenarios as possible outcomes.

But maybe what French and many other authors and readers of the hundreds of books about North Korean politics didn't envision was that a United States president would one day reach out, first with insults over Twitter, then with praise for the North Korean leadership, leading to a face-to-face meeting, and with it an offer of a noodle of legitimacy to the crumbling regime. Certainly, aligning himself with corruption even more abhorrent than his own was Trump's masterstroke. The long-term losses and gains of Donald Trump's attempt at diplomacy will play out over the coming years. One thing remains certain: the citizenry of North Korea will suffer no matter what happens.

The Watchlist

The Interview (2014)

Kimjongilia (2009)

Dennis Rodman's Big Bang in Pyongyang (2015)

Red Dawn (2012)

The Lovers and the Despot (2016)

Dear Pyongyang (2005)

THE MIDDLE WORD IN LIFE

Boomers love Dennis Hopper. This is evidenced by Hopper's double starring role in a 1998 Ford Cougar advert. In that TV spot, Hopper, in his early 60s, reconnects via the magic of technology with his iconic late-1960s role as Billy in *Easy Rider*, a film he also co-wrote and directed, and that inadvertently blew the musty old Hollywood movie standards out of the water for the fresh, youth-inspired New Hollywood. Hopper's middle-aged conformity met with his former hell-raiser persona for a nostalgic and short road trip. The advert was, as Leighton Ballett of Young & Rubicam, the advertising company responsible for it, explained, designed to appeal to boomers: "The Cougar is a car for people who once liked to race around but have grown up."[1] Hopper was the perfect embodiment of 1960s hippie ideals that had matured (or mutated) into a more sensible approach to life. In the advertisement, the older Hopper speeds away from his younger self, embracing his newfound conformity and leaving behind his radical, freewheeling version.

The advert is a neat reimaging of what could have occurred if Hopper's Billy had survived the end of *Easy Rider* and gone on to live his life in the aftermath of the 1960s. This actually did happen. Hopper and his wild-man persona were one and the same during the 1960s and 1970s. He eventually got himself clean of drugs and booze and went on to live much like the Cougar man in the advert. Hopper decommissioned his radical persona for respectability.

Reimagining and reinterpreting the past seems to be something that Hopper was deeply interested in. In many of the films he

directed or starred in, he often alluded or made direct connections to some element of his own past, even if it wasn't really there. For example, the character of Don Barnes in Hopper's third directorial film *Out of the Blue*, released in 1980, was often mooted by Hopper as an unofficial sequel to his *Easy Rider* character. In the 1990 film *Flashback*, Hopper's character, a former hippie radical named Huey Walker, berates two boomer males in a bar about how they've sold out their ideals, saying that it "takes more than going down to your local video store and renting *Easy Rider* to become a rebel." I've always found this line off-kilter. Here is Dennis Hopper, radical icon of the '60s, now older and clean-cut, referencing a film he directed and starred in and pointing at a pair of boomers and telling them *they* blew it.

II

One of Hopper's most revealing artistic statements and reinterpretations wasn't related to film as such, but was in his performed readings of British poet Rudyard Kipling's "If" that he dished out at various points in his career.

In Kipling's original 1895 poem, the voice of the narrator is that of a prudent father offering advice to his son on how to conduct himself as a man and remain focused in the grip of conflict. The conflict discussed in Kipling's poem is an external as well as an internal one. "If" can be interpreted in many ways. But Kipling's real inspiration for the poem was the British colonial politician and leader of the botched Jameson Raid of December 1895, Sir Leander Starr Jameson. The Jameson Raid was intended to trigger an uprising by the primarily British expatriate workers against the South African Republic government of Paul Kruger. The uprising never occurred, but the incident was a slow trigger for the Second Boer War of 1899 to 1902.

Hopper's interpretation of Kipling's "epic evocation of the British virtues of a 'stiff upper lip' and stoicism in the face of adversity"[2]

reimagines the poem as a declaration of creative intent. Hopper's free and fluid uses of the poem, and his own persona of 1960s hippie radical, strip away the father's authoritative voice, the iffy colonial overtones, and the stoicism of British virtues, and gives the poem the status of a manifesto to one's creativity and artistic life.

Hopper's first known recital of "If" came in 1971, during *The Johnny Cash Show*. Before Hopper stepped up to the stage, he commented to Cash and the audience that "*If* is the middle word in *life*," which offered a more thoughtful pretext to the performance than many in the audience might have expected.

Wearing his countercultural uniform of slim denim jeans, shirt, and jacket, matched with a cowboy hat and boots, Hopper read the poem under a solitary spotlight to the live audience. His reading was measured and calm and tailored to the mostly middle-class and straitlaced audience of *The Johnny Cash Show*.

In 1976, Hopper performed a more boisterous live rendition at the Warehouse in New Orleans as an opening act for Bob Dylan. His reading here was more forceful and wayward, perhaps reflective of the state of mind Hopper was in at the time. His on-stage performance was an extension of the photojournalist he played to crazed perfection in *Apocalypse Now*, which was in production at the time of the reading. The lines

If you can force your heart and nerve and sinew
To serve your turn long after they are gone,
And so hold on when there is nothing in you
Except the Will which says to them: 'Hold on!'[3]

are delivered with slow precision, and yet Hopper elaborately screamed them into the microphone. The audience whooped and cheered him on, giving the reading all the feels of a beat-poetry performance, or an early example of slam poetry. Again, before the performance of the poem began, Hopper commented to the

audience that "*If* is the middle word in *life* in the English language," emphasizing that the poem's statement is one of seizing the moment creatively, as opposed to an aggressive front.

During his hyper-performance as the photojournalist in *Apocalypse Now*, Hopper used a great deal of improvisation to project the erratic, war-torn mindset of his character. When the U.S. soldiers (led by Martin Sheen's Captain Benjamin Willard) arrive at the compound of Colonel Kurtz (played by Marlon Brando) to kill the rogue officer, they are greeted by the photojournalist, who attempts to explain and justify Kurtz's erratic and violent actions. In a hysterical monologue the photojournalist proclaims the genius of Kurtz by explaining his wayward philosophy:

> The man enlarged my mind. He's a poet warrior in the classic
> sense. I mean sometimes he'll... uh... well, you'll say "hello"
> to him, right? And he'll just walk right by you. He won't even
> notice you. And suddenly he'll grab you, and he'll throw you in
> a corner, and he'll say, "Do you know that *if* is the middle word
> in *life*? If you can keep your head when all about you are losing
> theirs and blaming it on you, if you can trust yourself when all
> men doubt you."

Here, Hopper employs Kipling's "If" in the contextual way it was originally written, praising the actions and guile of a strategic military officer.

Many years later, Hopper gave a more measured and sober reading of "If" for a 2003 German documentary entitled *Create (or Die)* that covered his life, work, and art. The reading dispenses with the earlier dramatics. With his distinguished gray hair and salt-and-pepper goatee, Hopper's appearance is closer to the Cougar man in the Ford advert; he is certainly more mature in body and mind. The performance lacks the theatrics of earlier readings, yet in the context of the documentary's subject matter — namely, his remarkable work

ethic and creative integrity — the use of "If" again becomes an artistic manifesto. However, the difference here is that the older Hopper is not making the declaration for future creative endeavors, but for his past ones.

Despite the odd colonial subtext of Kipling's poem, it's fitting that Hopper chose to use it as a way of clarifying his own creativity. Two stanzas stick out the most from the poem as a whole and relate to Hopper's life and creative work. At the time of the first reading of "If" on *The Johnny Cash Show*, Hopper had just released his second directorial film, *The Last Movie*. Despite the film's artistic accomplishment, the nonlinear narrative and experimental approach to visuals and sound were deemed too difficult for conventional cinema audiences. Two lines from Kipling's poem — "If you can meet with Triumph and Disaster/And treat those two impostors just the same"[4] — wonderfully reflect the triumph of *Easy Rider* and the perceived disaster of *The Last Movie*. *Easy Rider*'s success allowed Hopper creative control and final cut on *The Last Movie*. He decided to take the relatively straightforward screenplay by *Rebel Without a Cause* screenwriter Stewart Stern and produce a shocking and destabilizing artistic film. His triumph in artistic freedom was also his disaster in commercial terms. Yet, as the poem states, Hopper treated these results the same. He staunchly stood by his film to the very end. And the determination paid off. *The Last Movie* has continued to intrigue filmgoers, with a restored Blu-ray/DVD reissue in 2018 and a limited vinyl release of the film's soundtrack in 2020.

Hopper lived the artistic life. He filled his waking moments with all levels of creativity. Acting, directing, screenwriting, photography, sculpture, and even art collecting were methods to add artistic credence to his life. In a short 2007 documentary, Hopper explained:

> As an actor, I read a book called *Six Lessons in Acting* by Richard Boleslavsky, and in it he says, "Have you read the great literature, have you seen the great paintings, do you know the great sculp-

tures, do you know the music of your day?" So I went off to find paintings because I thought it would enhance my life as an actor.

Hopper's art collection was not just the accumulation of famous names for monetary gain, but an artistic act in itself. For Hopper, the ownership and custodianship of art was another phase in the creative process.

The last verse of Kipling's poem, in which he states, "If you can fill the unforgiving minute/With sixty seconds' worth of distance run,"[5] summarizes Dennis Hopper's artistic accomplishments. As spectators, we have an incredible amount of output to explore. His work in film is the most obvious point of entry, but Hopper's photographs, mostly taken in the 1960s, are brilliant documents of the era that show he had an amazing eye for capturing social and cultural events of importance. Even after his death, his artistic rediscovery is still ongoing, the full distance has yet to be run.

III

Dennis Hopper's "what if" moment came in 1986. After over a decade exiled from mainstream Hollywood, strung out on drugs, booze, and his own egoism, he returned clean and sober, older, yet triumphant, with three incredible performances in the can. In Tim Hunter's moody drama *River's Edge*, Hopper played troubled ex-biker turned pot dealer Feck, while in David Lynch's twisted neo-noir *Blue Velvet*, he played the psychotic crook Frank Booth. It was his turn, however, in the sports drama *Hoosiers*, as an alcoholic waster who finds redemption in coaching the local school basketball team, that garnered him a best-supporting-actor nomination at the following year's Oscars Awards ceremony. What these films hold in common is the deeply troubled nature of all three characters. Hopper deserved his nomination, but it had to be for *Hoosiers*, really, the most earnest of the three films. Hollywood seemingly couldn't

justify giving Hopper a nomination for his performances in *River's Edge* or *Blue Velvet*, even though both these films offered audiences much deeper character complexity; they were, perhaps, simply far too berserk to be given mainstream acclaim.

There are similarities between *River's Edge* and *Blue Velvet* that go beyond their being released in the same year. Both films take place in a small town, both films are about teenagers on the verge of adulthood and starting to take responsibility for their actions (though far from the John Hughes–inspired sensibilities). Both films even contain complaints about "warm beer." Drugs also play a crucial role in both films — Frank gets jacked up on nitrous oxide, while Layne, played to twitchy perfection by Crispin Glover, the leader of the group of teenage burnouts in *River's Edge*, is a speed freak. Feck enjoys a toke of strong weed. Parents are mostly absent from both films, and when they are present, they don't act in particularly parental ways. In *Hoosiers*, Hopper actually does portray a father, and although his characters are childless in *River's Edge* and *Blue Velvet*, in their strange way they become a father figure to the teen protagonists of each film.

But there is something more. Hopper's roles in *River's Edge* and *Blue Velvet* are unreservedly defined as supporting roles. He is not the main player, yet both films rely on his character for actions that move the narrative into a different space. In *Blue Velvet*, it is the arrival of Frank Booth that propels the film from a hokey teen-detective movie into a psychosexual noir. The film's male protagonist, Jeffery Beaumont, played by Kyle MacLachlan, suffers a savage loss of innocence at the hands of Frank, yet one which also marks his ascent to adulthood. The first time we see Frank is when he enters the apartment of Dorothy Vallens (played by Isabella Rossellini). Dorothy is Frank's obsession, and he has kidnapped her husband and young child in order to extract sexual favours from her. Jeffery is hiding naked in a closet, after being caught spying on her. He watches as Frank brutally assaults Dorothy. Frank is a vile bully who

gets his kicks from the grossest acts of sexual violence. Despite his small stature, Frank's menace is absolutely real to those around him. Watch the faces of his gang of goons when he berates them for not pouring his beer quickly enough — they look like scolded schoolkids. Or, when Jeffery bravely squares a punch right in Frank's face, their mouths gape open in absolute horror; they know things are about to get very, very "dark," as Frank would put it. Even his comrades are scared to death of him. Hopper once stated that in his opinion Frank was the most romantic leading man in modern cinema, willing to kidnap, beat, threaten, and even kill his rivals for the affection of the object of his desire. In this version, Frank is gripped by passion and unable to control his impulses.

Feck is also a small-town weirdo, though thankfully his oddities are tinged with eccentric humor that lightens an otherwise somber film. He wails on the saxophone, his one solid life companion is a blow-up sex doll called Elly, and he's convinced the police (or the IRS?) are after him, so he stays locked in his shabby little house. The local teens who populate the dreary town and buy his grass are never threatened by him, even when he pulls a gun on them. Much like Frank, Feck has also committed a crime of passion. He continually confesses to the teens that he "killed a girl once, it was no accident. Put a gun to the back of her head and blew her brains right out the front. I was in love..." Still, nobody bats an eyelid. When John, one of the teens, coldly strangles his girlfriend, Jamie, and leaves her naked body on the banks of the river, the teens group together to try and protect him. They are indifferent to the callous act of killing; none of them can muster the emotions required by the death of their friend. Feck offers his assistance, seeing something of himself in the teenager. He hides out with John, offering him comfort and friendship. In the end, it is Feck who pulls the trigger on John, putting him out of his misery and becoming the film's moral hero. Despite his eccentricities, Feck is a deeply sympathetic character.

Can the same be said of Frank Booth? Critic Charles Drazin, in

his book *Blue Velvet*, admitted: "I've grown rather fond of him...
I no longer think of Frank as evil. In the grip of evil maybe, but,
therefore, to be pitied."[6] After seeing *Blue Velvet* and recognizing
Hopper's artistic dedication, I've come around to Drazin's way of
thinking. What horrors must have befallen a young Frank Booth
to turn him into such a monster of a man? His acts are utterly
perverse, yet watch when he switches from the domineering "daddy"
to the pathetic "baby" in Dorothy's apartment. You sense that Frank
has never had anybody really love him in all his life. It is a neat
thread that Hopper wove between the characters of Feck and Frank;
both have committed awful crimes, yet thanks to Hopper's weighty
performances, we as an audience have the possibility of finding
within ourselves an ounce of pity for them.

IV

Blue Velvet's writer and director, David Lynch, much like Hopper, is
a person who expresses his creativity through forms and media other
than film. He has used painting, photography, sound, and sculpture
as artistic expressions. *David Lynch: The Art Life* is a documentary,
released in 2016, that explores this aspect of his life. Filmed over four
years by Jon Nguyen and funded via Kickstarter, the film exposes the
method and process of Lynch's artistic works and offers a portrait of
Lynch as someone who was, and still is, deeply alert to the possibility
of living the creative life.

The documentary is meditative in its approach. Mostly, we witness
Lynch working away quietly in his Hollywood Hills studio, wearing
his loose professorial slacks and his signature button-up shirt —
always done up to the top button — applying paints, fixing up
models, and twisting wire that will be incorporated into his finished
pieces. On occasion, we see old photos and 8mm footage of a young
Lynch larking around with his family and friends. Over top of all
this, Lynch narrates and reminisces on a childhood spent moving

from one place to another. Although his family was uprooted many times by his father's work as a research scientist, Lynch describes his childhood in idyllic terms: sunny days spent making wooden guns and playing cowboys on suburban streets.

He then talks of his introduction to art and artistic practice through friends and colleagues, and the prolific production of paintings he endured before he began to find his artistic mojo. He then laments his experiences of attending the School of the Museum of Fine Arts in Boston, Massachusetts, and the Pennsylvania Academy of the Fine Arts in Philadelphia during his late teens and early 20s — experiences that were equally frustrating and exhilarating to him.

The evolution of Lynch's work is vivid. He shifts from abstract painting to moving images quickly, spurred on by wishing to see his own artwork adopt movement and sound. His move to Los Angeles and his acceptance into the American Film Institute Conservatory were the turning point in Lynch's development as an artist: His live-action abstract films, 1968's *The Alphabet* and *The Grandmother*, produced in 1970, sent Lynch on the road to becoming the renowned filmmaker he is today.

Throughout *The Art Life*, Lynch recalls fragments of his early life that have inevitably bled into his artistic work. Perhaps most effectively, he recalls the moment he witnessed a naked, middle-aged woman walk across her lawn, bloodied and crying, while Lynch and his younger brother played in their suburban neighborhood. In the story he tells, the young Lynch wanted to help the woman, but he was too juvenile to understand the crisis, while his younger brother just began to sob at the sight. The juxtaposition of childhood innocence and the viciousness of the adult world is something Lynch would apply and explore in his film work. This scene from Lynch's childhood would play out later in *Blue Velvet*, when Dorothy Vallens stumbles naked and bruised across Jeffery's suburban lawn. This is just one example from Lynch's life that bled into art.

The film is also gorgeously shot and edited. Frames of a quiet, thoughtful, and aging Lynch sipping coffee and surrounded by

clouds of cigarette smoke illuminated by sunlight are mesmerizing. During these moments of reflection, the layers of Lynch begin to peel back to reveal something very human and even very fragile — something that is mostly absent from his public persona as an avant-garde filmmaker. No other voice is included in the film, only Lynch tells his story, and every frame has either him or a product of his artistic work in it.

The movie concludes with Lynch recalling his work on his debut 1977 film, *Eraserhead*, a production period that would last over half a decade and see Lynch experience early fatherhood and divorce from his then wife, Peggy. While personal triumph and trauma are left off the agenda, this period in Lynch's life was transitional in terms of his art and his foray into filmmaking. *Eraserhead* could be seen as the accumulation of artistic knowledge that Lynch had assembled during his formative years, laid bare. It's clear that Lynch recalls *Eraserhead* and indeed the time of its production as the purest embodiment of his art, since the freedom that he was allowed to craft his film would rarely be replicated in future film productions, especially when he began to be embraced by Hollywood and became responsible for million-dollar budgets and the production of a commercial commodity.

During the making of *Eraserhead*, Lynch experienced barely any interference at all from AFI professors, and certainly no studio executives were knocking down his door. This allowed Lynch to strive, to fail, and ultimately to learn the language of film and incorporate his artistic background without dilution. Though it's not as if Lynch has made many compromises since becoming a filmmaker. His directorial work has remained daring, abstract, strident, frightening, and life-affirming, and it is to his credit that Lynch can produce abstract fever dreams that play in movie theaters and are syndicated for television.

Those disappointed that the documentary concludes just as the directorial work begins, leaving works such as *Blue Velvet*, the 1992 television series *Twin Peaks*, and 2001's *Mulholland Drive* unexplored

and unmentioned, should take comfort in the fact that the film endeavors to explore and connect the process of the early artworks with Lynch's contemporary works of cinema. It connects the younger impressionable Lynch with his older, wiser self.

It could be said that in David Lynch and Dennis Hopper's worlds the methods of creativity and artistic integrity can be applied to any medium. Be it painting, sculpture, photography, musical composition, or film, the places where the work comes from, the memories and experiences gained in life, are the same. Art is life and vice versa. Lynch and Hopper's lives are examples of constructing a truly inspired, transcendent, and artistic existence. As Hopper continually reminded us, "If," the title of the poem he loved to recite so much, is the middle word in *life*, and it can be applied to both Lynch and Hopper as the continuous possibility of what-ifs.

The Watchlist

Easy Rider (1969)

The Last Movie (1971)

Out of the Blue (1980)

River's Edge (1986)

Blue Velvet (1986)

Hoosiers (1986)

Eraserhead (1977)

Along for the Ride (2016)

Dennis Hopper: Uneasy Rider (2016)

The Short Films of David Lynch (2002)

Meditation, Creativity, Peace (2012)

David Lynch: The Art Life (2016)

BEING NICOLAS CAGE

Around halfway through *Mandy*, the sophomore 2018 feature film from Italian-Canadian director Panos Cosmatos, the reclusive Caruthers, played by the legendary character actor Bill Duke, explains to Nicolas Cage's vengeful Red Miller that the people he intends to hunt down and kill for brutally murdering his girlfriend have had their minds warped and twisted by some powerful LSD. There is no humanity in these sickened souls.

The audience member might be thinking, as this scene plays out and Caruthers gives us the only tidbit of exposition the film offers, that the ticket purchased from the kiosk to watch *Mandy* was also laced with some bad acid. If this was the case, it has made for a much more thrilling experience.

Mandy exists as a hallucinatory trip, and one that's worth taking and experiencing in all its lurid and lucid glory. The action takes place in 1983 in the Pacific Northwest of the U.S., which seems devoid of people, at least normal people anyway. But we know this is no alternate reality, however much *Mandy* believes in the supernatural or the otherworldly. President Ronald Reagan appears on the radio, rallying against drugs and pornography. If *Mandy* had been released at the time of Reagan, the Moral Majority would have flipped out at its bent vision of religion and God. Still, the woods, mountains, and lakes are bathed in a fog of dreamy light and aura that offers a sense that weirdness is a norm in these parts of the country.

Red and his girlfriend, Mandy Bloom, played by Andrea Riseborough, live in a rural retreat, a secluded cabin by a place called Crystal

Lake. Red works as a lumberjack, while Mandy mostly hangs around the house, drawing and reading wild novels of science-fiction and fantasy, and as we later learn works in a local roadside store. Mandy is a doomed character. She seems to sense this doom is coming and carries with her the knowledge that she will suffer an inevitably gruesome death. A scar under her eye hangs like a permanent streak from a lifetime of cried tears.

A freakish cult known as the Children of the New Dawn travels through Crystal Lake, and when their alluring leader, Jeremiah Sand, played to wicked and perverted perfection by Linus Roache, spots Mandy as she walks on the roadside, he becomes instantly intrigued and obsessed with her. He orders his creepy minions to kidnap and bring her before him to be initiated into his cult as a servant and witness to his greatness.

Up to this point, the film has unfolded at a slow and delicate pace. Conversations between characters have hung in the air and contributed nothing to the direction of the narrative except to act as backdrops for the film's genuinely gorgeous use of color and cinematography. But the summoning of a weird cohort of mutated bikers — think the minions of Clive Barker's 1987 horror movie *Hellraiser*, but on wheels — by the cult's henchmen to kidnap Mandy and dish out a beating to Red begins the film's ascent toward its gonzo high. These biker freaks are the same ones that Caruthers speaks about. Mandy is brought before Jeremiah. Dressed in his cult-leader robes, he plays Mandy a corny folk recording of his own making. It turns out that Jeremiah was once a promising singer-songwriter before seeing other avenues unfold. Sound familiar?

Although succumbing to the bad acid that she is given by the converts (and a giant wasp sting), Mandy laughs in Jeremiah's face (and at his tiny flaccid penis) and rejects his cult and his sexual advances. Jeremiah runs out of the room, humiliated. The cult members decide to burn Mandy alive for her insolence, and in front of Red. The scene is genuinely disturbing as the bagged-up body of

Mandy sways and writhes as the flames take hold. The cult members also leave Red to die. Red manages to free himself by allowing the wire that binds his wrists to cut into his flesh, and once he's crawled back to the house he stares at the television as a creepy (though also very funny) commercial for Goblin Macaroni and Cheese plays on the screen. His life has fallen apart, yet he still can't pull away from a good commercial spot with a cracking jingle.

He then necks a bottle of vodka he finds in the bathroom and pours it over his wounds to cleanse the broken skin. His soul, however, is shattered beyond repair. This scene in the bathroom is a hard watch, though not for the reasons you might think. From the point of view of a single camera and a fixed wide shot, we watch in gruesome voyeuristic detail as Red moves from sobbing to shouting to screaming and back in only a matter of seconds. The scene is fraught with emotion, yet it is also played out with Cage wearing a tiger-emblazoned T-shirt and a pair of soiled tight, white underpants. Any other actor might have found the nexus of emotion and seriousness in the character's situation difficult to play straight, but with Cage as Red, it is played out with delirious lunacy.

We enter the half of the film in which Red seeks revenge on those who have wronged him. He calls on an old friend, the afore-mentioned Caruthers, who loads him up with a crossbow and an assortment of swords and blades.

Unlike the ethereal first half of the film, which moves at a snail's pace, the last half shifts along briskly and features some bloody horror tropes that are reminiscent of the Hellraiser franchise and Sam Raimi's Evil Dead trilogy, especially in the chainsaw duel between Red and a Children of the New Dawn thug, which pulls heavily from Raimi's 1992 *Army of Darkness* and, of course, Dennis Hopper's maniac avenger in Tobe Hooper's 1986 sequel *The Texas Chainsaw Massacre 2*.

Red is victorious, and his revenge against Jeremiah is complete when he tracks the leader down to his church and crushes his skull

with his bare hands. With his mission over, Red drives away and imagines Mandy sitting beside him in the passenger seat. The maniacal grin on Red's blood-soaked face indicates that his mind has fully gone to the dogs.

Mandy is a revenge caper, but its exquisite palette of color and trippy use of lens flare take it far beyond the B-movie shock horror it might have become. The lens flare in *Mandy* was created by cinematographer Benjamin Loeb aiming small LED lights into the barrel of the lens; the aesthetic is truly pleasing and immersive, conjuring a kind of hypnosis that draws the viewer in slowly and subtly. The trashing violence and destabilizing, sometimes comedic performance from Cage shock the viewer out of the fever dream for a moment, but the pauses of calm bring you back in easily.

Nonetheless, there is an otherworldly quality to *Mandy* that grounds it in the weird sci-fi novels that the character of Mandy reads and the heavy-metal genre influences that bestow imagery that seems ripped from the lyric sheets and album covers of bands like Iron Maiden, Testament, and '80s-era Ozzy Osbourne. Reviewers have commented on the idea that the film is akin to an Iron Maiden record sleeve come to life. I'd like to picture a more modern incarnation, such as Aussie band King Gizzard and the Lizard Wizard's recent concept records taking on a life of their own. King Crimson's beautiful song "Starless" opens the film, along with a title card of the last statement from death-row inmate Douglas Roberts: "When I die, bury me deep, lay two speakers at my feet, put some headphones on my head and rock and roll me when I'm dead."

The mutant biker gang might've added to the supernatural quality. When they are first summoned to do the dirty work of the cult members, they arrive in a red mist of dew and exhaust fumes. They appear to be from another dimension. When Red sets out on his killing spree, he invades the gang's domain. Except their domain is an abandoned house with discarded takeaway boxes and beer bottles littering the floors and tables. One gang member sits watching tele-

vision and admiring the rhythms of '70s softcore pornography. The bikers are human but so perverse and drug-addled that their form no longer seems familiar. Their biker leathers seem fused to their skin. They are an odd bunch of freaks.

Speaking of odd, let's take a moment to appreciate Nicolas Cage's wild, feral, and overblown performance. Cage employs his most riotous tendencies here. We've seen only glimpses of this madness in films such as Patrick Lussier's 2011 3D extravaganza *Drive Angry*, Neil LaBute's bizarro 2006 take on *The Wicker Man*, Brian Taylor's 2017 comedy-horror *Mom and Dad*, and Paul Schrader's 2016 film *Dog Eat Dog*, but in *Mandy* we see it come to absolute fruition, and it's glorious. Cage is wrathful and yet incorporates intricate moments of subtle humor to elevate the insanity. Take for example the moment Red brutally dispatches a member of the mutant biker gang. He slashes away at his enemy and, after coming out victorious, scoops a wad of cocaine up in his hand and gleefully snorts the lot. The performance is pure gonzo theatrics. Does it steal the film away from his co-stars and the importance of the narrative? Yes, no, and maybe, but also who cares? Everyone else in this film seems happy to bow out and let Cage take the reins; so should the audience.

It is also worth noting that Red has very few lines of dialogue. His conversations with Mandy mostly have him sleepily responding, while the conveying of emotion and his hack-and-slash revenge trip are mostly a bunch of hoots, groans, laughs, and cries. He's given a few off-kilter one-liners ("You ripped my favorite shirt!"), and any monologue is a stunted and jilted mess of incoherence.

There is another character in the film that you won't find in the casting credits: the soundtrack. The last film-score entry in composer Jóhann Jóhannsson's discography is a fitting, though sad, end to a career that placed the soundtrack back in its rightful place as a vital component of a film's aura. The music used in *Mandy* is a symphony of simmering, ethereal synth and booming, decaying electric guitar. It literally shakes the screen. It's a masterpiece that plays brilliantly by itself, yet take the soundtrack away from the film

and suddenly *Mandy* loses its unearthly quality. The soundtrack is a solid movement that pushes and prods the emotion within the film. If not accompanied by the film, it's best experienced alone and in absolute darkness with a decent set of headphones and the volume set way up.

Mandy is a highly effective movie because of many factors: Cage's performance, the outstanding soundtrack, the eeriness and dread of the first half, and the rage and madness of the second half. Yet, as a whole, the film clearly belongs to director Panos Cosmatos. He has created a vision that, while inspired by grimy VHS nastiness and late-night sci-fi oddities, is truly singular. Cosmatos's masterful approach aligns him with Kubrick and Lynch in delivering perfectly believable and fully realized worlds and characters that operate within their own laws of physics.

II

Mandy might very well be the accumulation of Cage's more operatic tendencies as an actor, but Lindsay Gibb's book *National Treasure* defines the entire existence of Cage as a cultural institution, taking in his entire film catalogue and his life as a whole. It is a fair and required assessment. Cage has been a prominent force in film for decades, starting out as a young actor in the 1980s under the guidance of his uncle Francis Ford Coppola in his directorial films *The Outsiders*, *Rumble Fish*, *The Cotton Club*, and *Peggy Sue Got Married*. He made a name for himself as a credible, though gonzo, leading man in *Raising Arizona*, *Moonstruck*, and David Lynch's *Wild at Heart*, and won an Oscar for best actor for his portrayal of a suicidal drunk hitting the skids in Mike Figgis's *Leaving Las Vegas*. He then turned macho action man during his mid-1990s renaissance with performances in films such as *Con Air* and *Face/Off*. Cage's early career could be seen as a lesson in diversity and guile.

However, since he starred in 2006's remake of *The Wicker Man*, Cage has been playing a patience-testing game with audiences by

prominently providing off-kilter performances in schlock supernatural action flicks such as *Drive Angry*, *Ghost Rider*, and *Knowing*, turning up in crime dramas such as *Seeking Justice* and *Stolen*, dressing up in hokey, fantastical duds such as *Season of the Witch* and *Outcast*, and lending his vocal talents to a bunch of animated kids' movies, the best being *Astro Boy* and *The Croods*. This isn't to paint Cage's later career as a farce. The films themselves may not be of a high caliber, but the performances are always worth witnessing. He has on occasion over the past decade pulled magnificent and seemingly effortless performances out of the bag. His role in Werner Herzog's *Bad Lieutenant: Port of Call New Orleans* was a masterclass in stunted rage. His quiet turn as the title character in 2013's *Joe* proved that subtlety does still exist in his arsenal of acting chops. Cage's twisted turn as the violent superhero Big Daddy in 2010's *Kick-Ass* mixed crazed overperformance with quiet tender moments.

The book *National Treasure* makes for an accomplished case study in Cage's dual status as a cult actor who appears in independent films and an A-list celebrity who stars in mega-budget blockbusters and has his life splashed across gossip magazines. It is this duality that occupies the first half of the book. Cage's deftness as a fine character actor in one instance and his performative and overreaching style in another has meant there is confusion about his work. Therefore, as Gibb explains in her introduction, "the general, easy consensus was that Nicolas Cage sucked. He chose bad film roles. He was a straight-to-video-caliber actor."[1] It's easy to pigeonhole Cage as a "bad actor" when the majority of his performances are destabilizing, quirky, and bordering on insanity, but, as Gibb continues, it is this facet that makes Cage "the best — and, more importantly, most interesting — actor in America" and one whose "back catalog is ripe for re-evaluation by film and culture writers."[2] I, for one, can't disagree with this assessment. Every time a new, usually straight-to-streaming film pops up on Netflix that stars Cage, I'm hooked in, because no matter the content of the narrative or the other actors involved, Cage will provide at the very least an "interesting" turn.

As Gibb further explains, Cage "refuses to be reduced to an either/ or proposition and instead embraces the contradiction,"[3] that of his own weird persona.

Gibb uses films such as *Face/Off* and *Adaptation* as further case studies in this strange duality. In both films, Cage provides a dual performance. In *Face/Off* he plays criminal mastermind Castor Troy, and then must embody the character of Sean Archer, the cop chasing him down as the two emissaries switch lives. Within one film we see Cage's contradiction. Castor Troy is the manic super freak that Cage embodies in films like *Vampire's Kiss* and *Raising Arizona*, while his performance as Sean Archer is more quiet, sensitive, confused, and vulnerable.

In *Adaptation*, Cage portrays real-life screenwriter Charlie Kaufman as well as Kaufman's fictional twin brother, Donald. Again, the duality of Cage emerges. Charlie is the artistic writer trying to adapt a best-selling novel about orchids to the big screen, while Donald writes a lowbrow script with high-octane car chases, violence, and sex. It is this strange and uneasy balancing act between the two versions of Nicolas Cage that has led to his perceived unreliability as a credible actor, and is why most critics and pop-culture junkies dislike or discredit him. Gibb explains that "we lash out at Cage because we're frustrated that he refuses to meet our expectations."[4] And this is absolutely true of him. We've seen his greatness, we know what he's capable of; Cage knows it too, but giving us subdued realism is not in his interest as an actor. In fact, his persona doesn't allow for it, as Gibb unpacks further by pointing out that Cage is noted for his "sleepy-yet-expressive eyes and the cartoonish malleability of his face. He uses these assets, along with his lanky frame and highly controlled physicality, to combine opera and silent film-style acting, using exaggerated movement and emotions to create characters that keep audiences guessing."[5]

And there is often a good reason for these hyperrealist performances. Cage wants the audience to know and understand that movies need not represent reality and that weird and eerie things

can occur in the dreamscapes of cinema. Gibb uses the disturbing rape scene in *Vampire's Kiss* as a prime example. At this point in the film, Cage's performance has become so destabilizing and bizarre that "the audience can handle the disturbing action because there is no doubt that these are actors, and this is a movie. The critical distance allows us to appreciate the performance without enjoying what the character is doing."[6] Sometimes, only for a moment, Cage shakes us out of the narrative by screeching out a wild yell in *Face/Off*, pulling an Elvis-style hip shake in *Wild at Heart*, or, as pointed out in the text of *National Treasure*, shaving, which Gibb counts nine instances of. But these little nuances are enough for us to realize we are watching an actor's performance.

The next part of the book moves away from Cage's film work and into the arena of his life and his status as a living internet meme, arguing that in some respects life imitates art: "As a famous actor, he constantly exists in unnatural situations. It might be playing a guy who thinks he's a vampire or a man who is turning into a flaming skull, or playing himself in the midst of his stardom."[7] Nicolas Cage plays eccentricity in his life and on-screen, and therefore he has become an internet meme. There is no context to his performances in his movies or his public life, and any situation the internet can place him in makes total sense because he has placed his image in so many bizarre situations. Gibb explains that Cage "has managed to position himself in so many different settings across his career that we want to put him in rocket boots holding a keytar next to a basket of kittens."[8] Yes, that is how weird and funny these memes can get, but they're nothing in comparison to Cage's turn in a set of Japanese pachinko television adverts.

Although Cage is not the manipulator of his own image, he is in some respects the architect of its creation. He has invited us to interpret him, and you get the impression that he is happy with the results. As his performances have broken through the narrative of films, Cage has also moved beyond the idea of being just an actor

in a movie. Gibb explains that "bringing Cage outside of his movies and into other forms of media shows that Cage's relevance to us goes beyond his own creations."[9]

The text concludes by stating that "if art is fundamentally about generating a reaction, then Cage has been more successful than most actors."[10] This is undoubtedly true. Critics and audiences can be full of praise or deeply unfavorable to Cage. There is rarely a middle ground. Recent films that Cage has starred in can be poorly directed, shoddily edited, badly scripted, yet Cage's performance is always noted in either the positive or the negative for its utter lunacy and weird nuances. Of late, Cage has set foot in the revitalized B-movie arena with the aforementioned *Mandy,* which teeters on the edge of B-movie and art-house film, but also with 2018's *Mom and Dad,* 2019's *Color Out of Space,* and most recently *Willy's Wonderland* and *Prisoners of the Ghostland.* Cage brings his own version of insanity to movies that might have gone straight to streaming at best.

It has become an anticipated trait and it must be commented on. "Cage," as the text concludes, "has never been afraid to look like a failure. He doesn't want to be cool; he wants to be creative."[11] It is this fearlessness that is Cage's true claim to genius. He has allowed for the audience's awareness that performance is everything and that the worlds created within film do not require realism but a version of hyperreality that transcends real life.

National Treasure raises the points of Cage's genius in a convincing manner, but it is still up to the reader and the viewer of Cage's work to embrace the madness for what it is: an intensive artistic experiment in merging art and life. Cage may or may not be the greatest actor, but he should be praised for being, at the very least, an original one.

The Watchlist

Mandy (2018)

Color Out of Space (2019)

Vampire's Kiss (1989)

The Wicker Man (2006)

Bad Lieutenant: Port of Call New Orleans (2009)

Joe (2013)

ALL-AMERICAN TRAGEDY

In 1999, the first *American Pie* movie gave audiences an honest perspective on high-school life. With its fresh-faced cast of young, wholesome, and handsome male and female leads, it dressed the late-'90s American teenager in a positivity that was not necessarily present in some of the more shoegazing high-school dramas of the '80s and '90s. *American Pie* offered flawed yet believable characters and situations of humiliation and expectation that every male teenager in America and beyond faces at some point in his young life.

The film's premise centers around close friends Jim Levenstein (Jason Biggs), Chris Ostreicher (Chris Klein), Kevin Myers (Thomas Ian Nicholas), and Paul Finch (Eddie Kaye Thomas) making a pact to lose their virginity on the night of their prom. Although this pact might seem puerile at first, the groups' ethics are in fact fairly sound. More sinister teenage films of the era explore the territory of trickery or manipulation of the female sex, as, to horrid effect, in the Bret Easton Ellis adaptation *The Rules of Attraction* (2002). But to achieve their sexual goals, the group court the objects of their desire with the full intention of offering as much sexual pleasure and satisfaction as they can muster to their potential partners, hence the introduction of *The Book of Love*, a concise sexual encyclopedia gathered by former students that informs Kevin on how to perform satisfactory oral sex on his girlfriend, Vicky. Compared with other teen comedies of the previous decade, *American Pie* is wholesomely woke, with the male leads often being the butt of the sexual-humiliation jokes and the female characters taking the lead in the courtship.

Jim, for example, is perhaps the horniest and most humiliated of the group. His first sexual encounter, which is met with a double premature ejaculation, is also broadcast across a rudimentary version of the internet, while, in another sticky situation, his dad walks in on him humping a warm apple pie to get off. *American Pie* has an altogether uncommon and refreshing approach that also allows the female leads investment and control of their sexuality, while the males stumble and trip pathetically around them.

American Pie's reputation was diminished somewhat by its sequels, which for the most part shed the original cast and began to rely heavily on the gross-out humor of the franchise's most obscene character, lacrosse jock Steve Stifler (Seann William Scott).

In the original film, Stifler hung on the periphery of the group, making crude jokes and berating the others in memorable put-downs, such as "Why don't you guys locate your dicks, remove the shrink wrap, and fucking use them!" After the initial three films of the franchise, *American Pie* regressed into straight-to-DVD spin-offs that only featured Jim's dad (played by the always excellent Eugene Levy) as a recurring character from the original movies. With the release of *American Reunion* in 2012, the franchise came full circle and featured the still fresh-faced original cast, now not as hopeful teens, but as disillusioned grown-ups facing the realities of modern adulthood in the capitalist hellscape of jobs and the responsibility that comes with it.

One of the interesting aspects of the first *American Pie* film is how sex, from the male perspective, is portrayed as something special. The male leads see the loss of virginity as sacred, and not to be rushed. Only 10 years later, this characteristic is absent from most films of a similar genre. The most obvious example is the 2009 Tucker Max adaptation *I Hope They Serve Beer in Hell*, which presents male relationships with females as strictly sexual and vulgar. But it can also be found in films such as *The Inbetweeners* (2011), though the lads in that film do learn a few lessons, and the sequel is largely about one of the gang desperately trying to win the affections of a girl.

Of course, as with real-life situations, there are always some humiliating aspects of first-time sexual encounters, but these are played out for laughs in *American Pie* and without the degradation of females seen in other films of a similar genre. For example, Jim, seemingly untouchable after his humiliating internet episode, asks out the seemingly nerdy and overtalkative flutist with the school band, Michelle (Alyson Hannigan), on the basis that she appears to be the only girl who did not witness the live stream. However, Michelle does know about Jim's online performance, did indeed witness it, and instigates a dominating role in her sexual seduction of Jim, having identified him as a "sure thing." He is used by Michelle for what we suspect was a very rough and dominating one-night stand.

The next day, Jim wakes in bed alone; Michelle has left, but he has lost his virginity. While both Kevin and Finch do lose their virginity on the night of the prom, Kevin to his girlfriend Vicky (Tara Reid) and Finch to Stifler's mom (Jennifer Coolidge), it is the character of Chris Ostreicher who remains a virgin. This is an interesting twist. Out of the group, Ostreicher appears the most likely to have already lost or to soon lose his virginity. He is a popular lacrosse player, handsome, well-built, and carries a quiet charm. In theory, his jock status would get him any girl he wished. He is, up to prom night anyway, the most sexually experienced member of the gang. Yet he has an emotional depth not often found in his peer group. His courting of Heather (Mena Suvari), an intelligent choirgirl, requires him to try and engage intellectually with her, and the courtship between them is sweet-natured, apart from when Stifler is around making his lewd comments. Ostreicher joins the school choir, and although initially he does so because he sees the choir group as an "untapped resource" for scoring with girls, at the end of the film he quits his big lacrosse game to take part in a singing competition. Chris and Heather spend prom night together in a romantic tryst but do not have sex.

Although his original role was secondary as a popular and rich jock, Steve Stifler became more of a fixture as the franchise progressed

to a trilogy of films. The direct-to-DVD movies even featured his younger brother and, later, his cousin in the lead roles (*Band Camp* and *The Naked Mile*, respectively). With his affluent background and domineering role in the social functions of the school environment, it seemed like Steve Stifler was destined for success. In the opening scenes of *American Reunion,* a sharp-suited and clearly still arrogant Stifler is seen parading through an upscale investment firm, calling the shots like a tyrannical boss. However, it turns out Stifler is just a temporary worker and is, in fact, subject to much ridicule from his cruel boss. This interesting misfortune for Stifler is relevant to today's minimal job market in the modern, neoliberalized West. The increasingly popular intern model of being paid very little (if anything at all) for the privilege of on-the-job education has snared a whole generation of young people willing to aggressively compete for a prized position within a company.

Another member of the original cast that seemed likely to achieve success in adulthood was Paul Finch. Though perhaps the least popular of the group, due to his obvious eccentricities and social awkwardness (leaving the school grounds daily during lunch breaks to take a bathroom break at home), Finch demonstrates heightened intelligence and a world-weary sophistication. Therefore, when we are reacquainted with Finch in *American Reunion* and learn that he has been traveling the world, it initially comes as no surprise. However, later in the film Finch is arrested for stealing a motorcycle. At the reunion party, Finch admits that he has not traveled the world at all, and is, in fact, an assistant manager for the stationery franchise Staples, and that the motorcycle was his store manager's, which he stole for not having received a pay raise.

The other boys in the group seem to have fared better in their careers than Finch and Stifler (being mortal enemies after Finch's sexual encounter with Stifler's mom — it is fitting that these two would be lumped together as the least successful of the group). Chris Ostreicher, now an NFL sportscaster living in Los Angeles with his promiscuous supermodel girlfriend, is perhaps the most financially

successful, though catching his appearance on television makes him recoil in horror as he begins to realize his Z-list-celebrity lifestyle is overshadowing his career as a respected sports commentator. When he reconnects with Heather, Ostreicher decides to break up with his girlfriend and remain in town with Heather, no doubt to reconsider his future and the errors he has made.

Kevin has become a work-from-home architect and is happily married, although the feelings he maintains for Vicky remain complex. Jim and Michelle, meanwhile, struggle to balance their work and family life and sustain the sexual relationship that forged their union in the first film.

The four main American Pie films provide a convincing trajectory of the journey into adulthood and the complications faced with relationships and work in modern America. In times of economic downturn, even those we perceive as intelligent, popular, and wealthy (Finch and Stifler) are faced with lesser options, as companies strive to scrape together profit in an increasingly unprofitable environment. Even the most successful of the group, Chris Ostreicher, has supplemented his former sports career by gaining celebrity status, as most young adults wish to achieve in our time of oversaturated media outlets and social media.

What *American Reunion* evokes is a longing for youth and simpler times. In the generation that has passed into adulthood since 9/11, life for young people in America has become ever more precarious and directionless. Jobs have vanished, relationships have migrated online and do not hold the same currency, education has been singled out for the advantaged, politics has become disengaged, and responsibility has evaporated. The original film saw the seeds of this failure being sown; the reunion is the realization of this failure. The trajectory perfectly aligns with the generational betrayals felt by older millennials and the current Gen Z.

The Watchlist

American Pie (1999)
American Pie 2 (2001)
American Wedding (2003)
American Reunion (2012)

THE OPENING LINE

We were somewhere around Barstow on the edge of the desert when the drugs began to take hold.[1]

This is the first sentence of Hunter S. Thompson's 1971 book *Fear and Loathing in Las Vegas: A Savage Journey to the Heart of the American Dream*, a book which, give or take a few missed opportunities, I have endeavored to read once a year since first picking it up sometime in my late teens. As I'm now heading, rattling and aching, toward middle age, the book is one of only a handful that have stayed with me, and on every read I discover a new angle or interpretation that expands its meaning.

Fear and Loathing holds an almost mythic quality in its mix of gonzo reportage, drug frenzies, and soulful meditation on the '60s generation of America. It reflects the loss of a utopia and chronicles its spiral into violence and mass-cultural sellout, much in the same way Dennis Hopper's 1969 film *Easy Rider*, which came on the cusp of a new decade, pointed toward a shedding of the '60s vision of the American Dream and replaced it with a rendering of an overbearing capitalist interpretation that was obsessed with status and wealth. Both works paint a grim picture of what it was like to live in those transitional times. *Fear and Loathing in Las Vegas* gets us over the line into the 1970s and points us through the door.

However, before *Fear and Loathing in Las Vegas* even delves into this strange schism, it is those opening lines that draw the reader in. With re-read upon re-read, I fully expect those lines, yet I am

always utterly surprised when they appear at the top of the page. I savor them every time I read the book, before diving headfirst into the collision of overreaching madness, laugh-out-loud hysteria, and aching beauty that follows.

To me, those 18 words do more than state simple geography and the impending drug wave that will grip the two strange individuals of Thompson's alter ego and narrator, Raoul Duke, and his Samoan companion, Dr. Gonzo, a thinly disguised Oscar Zeta Acosta, whose exploits the book will revel in.

They scream like a declaration of intent, a manifesto. It's as if the reader has just jumped into an already unfolding narrative, maybe one that has been unfolding for years, and has missed some important specifics; the narrator bawls the only feasible line he can fathom that will inform the reader of what they have missed and where they are now. The introduction of the young hitchhiker on Page 5 of the book will allow for a brief interlude of calm recollection. It is here that Duke will conveniently fill in the exposition about the imperative assignment given to him 24 hours previously to cover the Mint 400 motorcycle race, an assignment that has been interpreted by the two protagonists as the pursuit of the American Dream.

The "edge of the desert" marks a geographic point. As they hurtle down a lonely highway on the outskirts of Las Vegas, they are very much in the desolate desert. But another reading of this could be that the "edge" is not only that of a desert, but of Duke and Gonzo's sanity and normality as they enter the nightmarish neon hell that is Las Vegas and tip over the boundary into sudden and absolute madness. After this first sentence, the narrative takes a sudden and distressing turn.

As the opening line indicates, the drugs "take hold" and all notions of the real and unreal are blurred into one long stretch of drug paranoia that persists throughout the narrative. These are not the drugs of the '60s that promoted an expansion of the mind, a state of human comradeship, and a loving buzz. Sure, there is plenty

of grass and LSD, but the items in Duke and Gonzo's possession are dangerous narcotics including cocaine, ether, and mescaline, which, taken together, are a brain-frying cocktail designed to trigger insanity and despair.

The first sentence is the only statement that, as far as the reader can tell, is factual. After all, the next line reads: "I remember saying something like 'I feel a bit lightheaded; maybe you should drive...' And suddenly there was a terrible roar all around us and the sky was full of what looked like huge bats, all swooping and screeching and diving around the car..." Not only does this sentence begin the book's long episode of hallucinations and delirium that Duke will experience in his travels around Las Vegas's purgatorial casinos, it also indicates, by the line "I remember," that this text is written after the events have already occurred. Maybe days, perhaps weeks, possibly even years have passed; therefore, what lies ahead in the book cannot be presumed as a factual account, but rather a strung-together fragment of events that linger like broken reels of film and audio in Thompson's hazy mind.

The original book jacket of *Fear and Loathing in Las Vegas* illustrated the coarse nature of the text via a grotesque caricature by English illustrator Ralph Steadman. The image is of Duke and Gonzo spewing and sweating their way across the desert toward the pristine outer shell of Las Vegas, a gleaming palace wall that hides behind it as much debauchery and sin as Duke and Gonzo can muster in themselves. It reminds me of Dorothy, Toto, the Tin Man, the Scarecrow, and the Cowardly Lion, all dancing toward Oz's Emerald City. The image perfectly captures the opening salvo of the book, even though the road, the car, the speed at which they are traveling, the peacock-colored attire they have adorned themselves in, have yet to be revealed; as the reader, we understand from the cover art that these lines are being drawn from a high-speed, Technicolor shot across the hot desert, not a stationary situation.

When film director Terry Gilliam adapted the book for the big screen in 1998, he must have had the same sequence running in his head as the reader did. As Johnny Depp's booming narration of the opening line unfolds, the Great Red Shark zooms past along the boiling desert highway. In terms of adaptation, *Fear and Loathing in Las Vegas* the film is unusually loyal to the source material. Its story is followed almost page-for-page, except for a few minor twists, omissions, and adjustments for narrative purposes. While, for me, the film never fully catches the verve and intensity of the original book, it does come close to the 1971 Stanley Kubrick adaptation of Anthony Burgess's highly controversial 1962 novel *A Clockwork Orange*. Kubrick remained loyal to Burgess's wickedly violent text and incorporated the book's strange Nadsat slang into the dialogue and voice-over to present a very realistic portrayal of a future England under authoritarianism. Thompson's fragmented narratives are still simply too loose and wild to condition to a two-hour linear framework. The fate of Thompson's screen adaptation also befell 1980's *Where the Buffalo Roam*, directed by Art Linson, which starred the Bill Murray as a note-perfect Duke/Thompson, but in a film that tried to pull too many of Thompson's gonzo experiences together and made for a fragmentary viewing experience. Even the film adaptation of Thompson's relatively straightforward early fictional work *The Rum Diary*, directed by Bruce Robinson and released in 2011, failed to translate its youthful vigor and sexiness to the big screen. The short seconds that fill the first scene of Gilliam's *Fear and Loathing* adaptation are almost perfect synchronicity, and if what follows doesn't manage to sustain the power of the opening shot, it still offers the same eyes-wide adrenaline rush as reading the lines.

With *Fear and Loathing*, a book crammed full of memorable phrases, howlers, screamers, scenes, and sentences, it's the opening lines that clearly define the entire book and its cultural documentation. I will continue to revisit *Fear and Loathing in Las Vegas* for many years to come and revel in its sheer lunacy, and I will continue to relish those opening lines

The Watchlist

Fear and Loathing in Las Vegas (1998)

The Rum Diary (2011)

Where the Buffalo Roam (1980)

Buy the Ticket, Take the Ride: Hunter S. Thompson on Film (2006)

A Clockwork Orange (1971)

CRYING AT ROBOTS

I've cried so many times at films that it's impossible to say anymore what sets me off. Certainly, I'll be affected if I see other people crying either within the film narrative or among the company I'm watching a film with. Happy endings that are not overly saccharine will work to set tears rolling. Movies with talking dogs floor me every time. One cinematic figure is always able to create a trembling lip and a twitch in my eye: the robot. Although in most cases the robot is devoid of any real feelings — its responses are based on a configuration of predetermined code — its plight is somehow more profound than any of the human characters involved.

There are some obvious encounters with robots that are meant to engage the audience on an emotional level. Think about Arnold Schwarzenegger's T-800 cyborg in 1991's *Terminator 2: Judgment Day* as he bids a final farewell (at least, in 1991 we thought it was final) to the young John Connor (Edward Furlong). The T-800 has fulfilled his mission to protect Connor and has also played a father-figure role to the boy as they fought for their survival as well as that of mankind. Knowing that the apocalyptic future could still occur if he lives, the T-800 slowly descends into a pit of molten metal to destroy the computer chip that rests inside his metallic skull — the last piece of hardware linked to this unwanted future. The music swells to a thundering beat and John Connor weeps for his sacrificial robot. Or how about Rutger Hauer as the violent yet deep-thinking Nexus-6 replicant Roy Batty in Ridley Scott's *Blade Runner* (1982)? In Batty's final moments, he recounts his exis-

tence in a profound, quasi-Shakespearean monologue that seems to stretch across time and space. It makes his death an emotional roller-coaster for the viewer.

The robots I discuss in this chapter stem from my own cinematic encounters and subsequent explicit emotional responses to intense and mournful cinematic scenes that feature a robot, android, cyborg, or something that may seem robotic in its nature. Some of these choices might not seem like profound encounters to the film theorist, but for me personally, they have become the most ingrained experiences in memory.

The first tear I shed for an artificial intelligence machine was for Johnny Five, the personable, nasal-voiced, U.S. military robot that starred in 1986's *Short Circuit*. I discussed Five in an earlier chapter and in a way it's funny to see him crop up again. In case you skipped it, I'll offer a brief synopsis again. Five is part of a collection of robots designed by NOVA Laboratory scientist Newton Crosby (Steve Guttenberg) and his partner Ben Jahrvi (Fisher Stevens) for proposed peaceful purposes, but the program is hijacked by the U.S. military, who see the robots as advancing their arsenal in the dying days of the Cold War. During a demonstration of the robot's ruthlessness, Five is blasted by a bolt of lightning that fries his circuits, wipes his memory, yet somehow bestows upon him a rudimentary consciousness. Through a series of blunders, Five escapes the military compound. While lost and uncertain of his purpose, he stumbles upon Stephanie Speck (Ally Sheedy), who believes he might be some kind of alien life-form. To make him stick around, she offers Five books to read, which he consumes in a matter of seconds, and lets him watch television shows to satisfy his need for "input."

Johnny Five begins to develop an individual, yet very child-like, personality and begins his journey of self-discovery and awareness as a sentient being. He even christens himself Johnny Five after hearing the 1986 El DeBarge song "Who's Johnny" on the radio.

Seeing independence and self-awareness as a glitch in his original programming, the military tracks Five down and attacks him with an assortment of guns and missiles. Being the cunning robot that he is, he assembles a decoy replica from spare parts, which the military pounds with weaponry and blows to smithereens. As Newton and Stephanie tearfully drive away from the scene of carnage, Johnny Five suddenly appears in the back of the van, much to their amazement, and they instantly declare they will go and live on Newton's 40 acres of secluded land and raise Johnny as their own.

It took years for me to finally sit through the final scene in which Johnny Five appears to be decimated without bursting into tears. Even with the knowledge that it was a decoy, I couldn't handle the emotional trauma and maybe even convinced myself that Five had sent another self-aware robot to his doom. To see the life and development of Five cut short in a blaze of missiles and bullets was too much. I fast-forwarded over this scene and breathed a sigh of relief that Five survived.

And maybe it would have been best to have left it there. But, two years later, I was even more heartbroken by a scene in the 1988 sequel, *Short Circuit 2*, in which Five is brutally beaten by thugs who have exploited his naivety to help rob a bank vault. Five is so violently attacked that he leaks a fluid that looks a lot like blood. When he is smashed by an iron crowbar, the fluid splatters on his assailant's clothing in gory detail. During the brutal attack, Five pleads with his assailants to stop. He is eventually found wandering a back alley cradling a broken arm, one eye hanging loose, and unable to communicate. As Five's "blood" flowed, so did my tears at seeing such an innocent be so savagely beat up.

Short Circuit began something of an empathetic trend. Robots, especially those with ambitions to be human, or to adopt human traits, continued to make an emotional connection with me. It's not by coincidence, I'm sure. Filmmakers have long used robotic characters to explore the nuances of human behavior. To achieve this,

they have bestowed human trace elements. For example, a human-like voice, a human-like face, a human-like body. Maybe not all of these exist in the same robotic figure, but certainly one or another. For example, HAL 9000 from *2001: A Space Odyssey* (1968) is a red light affixed to a space station wall, yet his voice (by Douglas Rain) is that of a calm and collected human male who engages with the crew in activities such as chess and philosophy.

I recall witnessing Lieutenant Commander Data, played by Brent Spiner, the android who steered the USS *Enterprise* in all seven seasons of *Star Trek: The Next Generation*, stumble and fall, yet continually pull himself up, in his quest to achieve humanity. His response to most situations was tinged with a childlike curiosity. His mannerisms could also be described as animal-like as he copped an inquisitive ear at a new or strange turn of phrase. Data encountering the deadly Borg, intervening in an alien squabble, discovering a new gaseous cloud in space and even sexual relationships, were all greeted with the same enthusiasm and wonderment.

When Data finally bites the bullet in the ultimately disappointing 2002 film *Star Trek: Nemesis*, the emotional gut-punch is still felt because we have followed his journey of discovery through all seven seasons of the *Next Generation* TV show and the three TNG feature films. Data's desire to be human, or at least experience human emotions, leads him to sacrifice himself to save those who have assisted his development toward humanity.

In a similar response to Spock's death in 1982's *Star Trek II: The Wrath of Khan*, it is the warm fatherly/brotherly relationship between Data and Patrick Stewart's Captain Jean-Luc Picard that ultimately sets the tears rolling. From Picard's perspective, he has lost not only a friend and colleague but also a son or brother, for it was Picard who set the chain of Data's development in motion by continually encouraging his evolution and placing him in situations where he gained knowledge and experience, just like any good parental figure.

South African film director Neill Blomkamp's 2015 film *Chappie* explored a premise similar to *Short Circuit*'s. A state-of-the-art Johannesburg police robot is stolen by its inventor and given a set of new programming and directives that offers him the ability to think and feel for himself. The initial response to the world from the robot Chappie is that of a curious, yet cautious, child. *Chappie*'s promotional trailer alone was enough to give me those spine-tingling shivers that are the usual precursor to full-on tears. One trailer shows the character of Chappie being hounded by a gang of Joburg thugs and then being gunned down by the military. This small taster of the film was enough for me to know that however disappointing *Chappie* might be, the robot character would produce the same tear-stained cheeks as the rest of them.

The above robots have all been in possession of some sort of physical human trait. Despite not being strictly humanoid, Johnny Five has a recognizable mouth and eyes, and a human voice. His "mouth," in fact, is a little LED pad that lights up as he talks. Data is instantly recognizable as humanoid; only his pasty white skin, yellow eyes, and stiff demeanor single him out as different from his crewmates. Chappie and his legion of police robots look menacing with their hard-worn exteriors, blinking lights, and big guns, but once taken out of this context, Chappie himself appears cute. His pointy bunny ears stick up as a reaction to new encounters and bear a resemblance to those of a little happy puppy who's just learned he's going "walkies."

Part of my reaction to these robots is their similarity to human beings. I sided with their cause because I saw humankind's struggles reflected in their desire for acceptance. At least, this is what I thought. Imagine my surprise when a lump developed in my throat during Christopher Nolan's 2014 sci-fi epic *Interstellar*. Many aspects of the film could certainly produce a few tears, but the two lumbering monolithic robots, TARS and CASE, do not seem obvious contenders. Their appearance is akin to that of VHS

cassettes bumbling around the landscapes of the newly discovered worlds they encounter. Nevertheless, CASE's heroics on Miller's Planet, in which he saves Dr. Amelia Brand (Anne Hathaway) from an immense tidal wave, stirred something inside me. Later, when TARS and Matthew McConaughey's Joseph Cooper sacrificed themselves to allow Brand to traverse the gigantic wormhole that may lead to humankind's very survival, the scene overwhelmed me, more so than any other of the human-based emotional scenes that are dotted throughout *Interstellar*. I silently sobbed, desperately trying to hide my tears from the friends whom I'd accompanied to the movie theater and the two chatty teenagers sitting behind us. TARS acknowledged his fate with dignity and humor. The humans in *Interstellar* were an emotional letdown.

As mentioned above, my initial and long-held reasoning for empathizing with robots was their similarity to human beings, whether a physical resemblance or a metaphorical one. Or maybe my connection with them was founded on some class-based solidarity. After all, most of these robots are designed as grunts. They are created to perform a thankless task or replace a human in the field of conflict. *Interstellar* changed this perception. It is not their similarity to humans that causes this reaction, but rather their differences from us, I've come to realize.

In some respects, these robots face adversity and peril in a more dignified and noble manner than any of their human co-stars. In *Short Circuit*, Johnny Five is supposedly blown to pieces by a military unit that unleashes its full arsenal of weaponry on the hapless robot. Yet he takes no revenge; instead, he uses his cunning to construct a replica that fools the military into drawing their fire away while he escapes with the two humans who have shown him compassion. In *Short Circuit 2*, Five is berated in the streets, vandalized by some street toughs, and eventually beaten to a scrap-metal pulp. Yet he shrugs off the criticism and believes the street toughs have decorated him, and when he finally catches up with his assailants, he

lets the police take them into custody. Justice is served. Despite all the setbacks, he willingly becomes an American citizen (along with his co-creator Ben Jahrvi) and takes pride in a country that has consistently inflicted harm upon him.

By contrast, Data has been accepted into the social functions of his Starfleet crewmates. He is considered equal in every way. That is not to say he doesn't face some hardships or some forms of conflict in his encounters with other people and aliens. He is often called upon by his superiors to place himself in situations no human would venture. His superhuman strength means he is the first choice for risky missions to other worlds, and he often becomes the protector and savior of his crewmates in peril.

Chappie is initially created for the sole purpose of protecting law-abiding citizens and dishing out punishment to those who would break that law. He and his legion patrol the dangerous streets of Johannesburg as if they were an occupying military unit.

TARS and CASE are former U.S. Marine Corps robots that are given a new, ultimately more dangerous purpose of traversing time and space to find a planet suitable for human occupation after Earth's resources have been exhausted.

These robots were created to serve humanity, in most cases, in the context of aggression and warfare. Only Data has been created with peaceful intentions in mind and with the ability to exceed his programming independently, yet he is often called upon by his crewmates to end disputes and aggressively impose order. Johnny Five, Chappie, TARS, and CASE exceed their original military programming, but through some kind of reprogramming event that wipes their aggressive protocols. They learn to be peaceful and protective, and in effect become the better angels of our nature, replacing the violence that is programmed (or inherent) in them with resolve and self-sacrifice no member of humanity can muster.

My teary-eyed response to robots is not necessarily based on seeing them come to psychical harm or be the victim of disrespect

or verbal abuse — though this is a factor, of course. It is based on the fact that our own creations have exceeded us and bettered our own human nature, showing us up for being the cruel, manipulative creatures we are.

When I cry for robots, I'm really crying for a version of humanity that doesn't exist and perhaps never has or ever will.

II

Perhaps there are no robots to cry harder for than the droids of the Star Wars universe. Their presence has become integral to the narrative of each film, as well as the whole story arc of the Skywalker saga. They fight personal hardships, feel sadness, remorse, jubilation, humor, and fear, and stir companionship within their kind, while eliciting friendship with their human (or alien) masters. The droids take all shapes and forms, from humanoid service or protocol droids to small, ball-shaped rollers. Every droid has a personality trait that distinguishes it. It can't just be something inputted in the programming. These droids learn and are stunning examples of artificial intelligence.

But we must question how or why we feel for them the way we do. Their resemblance to humans is only really captured by C-3PO, in his fixed nervous expression and mannerisms. The droids R2-D2 and BB-8 have no human features and communicate in unhuman toots, whistles, and beeps.

In the book *I Am a Strange Loop*, Douglas Hofstadter talks about the feelings we have toward robots that we identify as having conscience. He uses the examples of C-3PO and R2-D2 to illustrate this. Hofstadter comments that "we are easily able to imagine a thinking, feeling entity made of cold, rigid, unfleshlike stuff,"[1] and when it comes to the two droids, it is hard to disagree with this assessment. Despite R2-D2 only communicating in beeps and whistles and looking like a large rolling trash can, and C-3PO

having the manner of a gold-plated, uptight, and cowardly butler, we the viewers are never in doubt that they are as switched on to consciousness as Luke Skywalker and Princess Leia or any of the other human characters of the Star Wars universe. Hofstadter then goes on to discuss the "squadron of hundreds of uniformly marching robots,"[2] presumably the Trade Federation Droid Army that invades the planet Naboo in the 1999 Prequel film *The Phantom Menace* and is featured in the climactic battle in the 2002 follow-up, *Attack of the Clones*. These droids are completely disposable. We don't attribute any consciousness to them, and their countless deaths at the hands of the Jedi have no impact on us. To emphasize this, we see the mass production of these droids in *Attack of the Clones*. They are welded together by other machines on a massive assembly line. C-3PO, on the other hand, was painstakingly constructed by a young Anakin Skywalker, while R2-D2, a repair droid that one assumes must have countless counterparts scattered across the galaxy, still resonates with a distinct and wise personality, and his plating, a distinctive white and blue, looks like no other.

The Separatist battle droids' eventual sacrifice to the Separatist cause is neither commented on nor mourned in any way. Apart from maybe a larger CPU, there is little difference between a nameless Separatist droid soldier and C-3PO, yet when watching *A New Hope* we feel fear, or maybe apprehension, for C-3PO and R2-D2 when they are in peril. Think back to that very first scene of *A New Hope* in which Princess Leia's ship is being rocked by blasters from Darth Vader's Imperial Star Destroyer. C-3PO and R2-D2 are the first characters who speak to us, and we follow their escape from the captured ship to the desert planet Tatooine, which in turn sets the whole saga in motion. We're with them every step of the way and root for their victories and fear for their safety throughout the saga.

And it continues with other droid characters of Star Wars as they place themselves in harm's way to allow their human masters to escape or complete an important mission. In 2016's *Rogue One: A*

Star Wars Story, the reprogrammed Imperial security droid K-2SO, while being physically imposing and bitingly sarcastic, is actually the most humanistic and naturalistic character, something most film critics pointed out in their appraisal of *Rogue One* and particularly Alan Tudyk's voice and motion capture for the droid. One critic pointed out that while "the direction of the actors [is] so methodical, as to render these artists nearly robotic and synthetic,"[3] Tudyk's K-2SO is "the one character with any inner identity."[4] Even within a sci-fi/fantasy setting, the idea that a robot could be more human and generate more sympathy than the "human" actors is startling.

III

A few decades ago, I chanced upon a science-fiction film being shown on television. I was very young at the time, maybe 10 or 11 years old. Most of the major plot details, the actors who starred in the film, any lines of dialogue spoken, even the title, have been erased from my mind, all of it except the film's very last scene. The narrative details I can string together are as follows. A nerdy, socially awkward scientist creates an artificially intelligent android that resembles him. The android is designed for space exploration. The android turns into a national sensation and instantly becomes more popular than the scientist who designed him. Instead of sending the android into space, the scientist switches places with him and blasts off on the mission to explore the cosmos. When asked by mission control if he is afraid to be alone in space, he responds that he is not because, "you see, I'm not very good with people." This final moment of the film floored me, and to this day it still resonates. It's difficult to fully explain why, but the premise of a human being blasting off into space alone has haunted me for years and filled me with deep, unfathomable melancholia that is not just unique to this forgotten film, but to almost all films and television shows that deal in human loneliness and the vastness of space.

A while ago I made the decision to exercise some internet research skills (in this case, by entering some search terms into Google) to try and track down the film that has haunted me all these years. I had tried a few years before, even going so far as to ask an apparent authority on science-fiction films and space literature; with my rather shaky description of the film, he unsurprisingly drew a blank. I was hoping that at this point the internet had caught up on what I assumed was an obscure early-'80s sci-fi curio. With the last line of dialogue still rattling around my head and, as detailed above, a loose description of the plot, I set about putting my mind to rest.

It turned out the internet had caught up. I managed to find the film within about 10 minutes of searching. The film in question was titled *Making Mr. Right*, a 1987 romantic comedy with only a hint of science fiction. The film starred a young John Malkovich, who at this point had yet to become a household name through films such as *Dangerous Liaisons* (1988) and *In the Line of Fire* (1993). Malkovich's dual role as the awkward professor Dr. Jeff Peters and the childlike android Ulysses showed that he had great capacity. His physicality as Ulysses is at times comedic, innocent, and open, while the more subdued Dr. Peters is cynical, closed-off, and stiff; they both, however, share a unique social awkwardness. It was no wonder the prominent film professor was unable to locate the movie in his sci-fi library; *Making Mr. Right* is no sci-fi oddity, and would have been well off his radar. The film is very much in the vein of mid-'80s/early-'90s sci-fi/comedy films such as *My Science Project* (1985), *Weird Science* (1985), *Earth Girls Are Easy* (1988), and *Encino Man* (1992) — films that are bright and brash in design, incorporate pop music, contain zany characters with sarcastic quips and sexist comments, and have an extremely limited understanding of actual science.

Making Mr. Right is only slightly more "mature" than the films listed above. For a start, it contains a sweet romance between the android Ulysses and Frankie Stone (Ann Magnuson), a brash young

public-relations executive employed to humanize the android and to make the Ulysses space project palatable to the public, the U.S. Congress, and potential private investors. However, the more time Frankie spends with Ulysses, the more she becomes convinced he is the perfect romantic partner. Unlike the other men in her life, Ulysses is sweet-natured, sensitive to her needs, and, as she discovers, well-endowed and, as such, capable of a physical relationship. Meanwhile, Ulysses begins to develop intense feelings for her that are counter to his imposed programming and purpose.

After a quick search on YouTube, I found a streaming version of the film. To avoid copyright infringement, the user (who I will not name, but thanks for uploading!) had chopped the film into 10-minute sections. As I watched the narrative unfold, I began to suspect that I must have originally caught only the last few moments of the film. *Making Mr. Right* seemed to be far removed from the narrative I had envisioned in my head. This suspicion was soon disproved as parts of the film became familiar. For example, an early scene in which the Ulysses android is practicing walking in a padded room was recognizable for its Charlie Chaplin–like physicality. Ulysses charges around the room like a sugared-up toddler, banging into the walls and trying again and again to comprehend the act of walking. Upon learning it was John Malkovich who was in the dual role, it suddenly dawned on me that it had always been him in my memory, speaking those haunting last lines of the film. For some inexplicable reason this had never clicked, even after repeated viewings of *Being John Malkovich* (1999), *Ripley's Game* (2002), and *Red* (2010).

As *Making Mr. Right* played out, I wondered if my memory of even the last moments of the film were constructed from fragments of other films. There seemed to be no buildup toward what I recalled as such an astonishing ending. The film continued to be goofy and almost impossible to comprehend in the way I thought I'd remembered it. Finally, the ending approached. Ulysses confesses to Dr. Peters that he is in love with Frankie and has lost interest in

space exploration. A press conference is arranged in which Ulysses is introduced to the world. He is asked numerous questions by the press, who all are amazed by his superior intellect. He becomes a worldwide phenomenon, adored by kids and adults, and the program becomes enormously funded by Congress. As previously discussed, by the end of the film Ulysses and Dr. Peters have switched places, and this does occur as I had remembered. Ulysses visits Frankie's house dressed up as Dr. Peters, and when she realizes it is him, they share a passionate union. Unbeknownst to anyone else, Dr. Peters blasts off into space, excited by the prospect of exploring the cosmos alone. It now becomes clear that Dr. Peters was playing the role of Ulysses during the press conference. His cold and calculating responses to the press were not those of an android, but of a man alienated from other people.

What is interesting is that even at a young age my brain had somehow constructed an entirely different, perhaps even more exciting, narrative arc than the one played out in *Making Mr. Right*. Granted, it has been many years since I originally saw the movie on television, and in this format all kinds of factors, from advertisements spliced into the film at half-hour intervals to trips to the kitchen to grab a snack, can disrupt and change the narrative flow. However, the romantic-comedy angle that is prominent in *Making Mr. Right* did not feature in my mind at all, possibly because my adolescent brain was simply not interested in such things yet. It came as something of a surprise that the film was a simplistic romantic comedy. In my head, *Making Mr. Right*, or possibly *The Melancholic Android*, as I'm sure I had named the film in absence of an actual title, was a serious science-fiction film in the mold of *2001: A Space Odyssey*, *Solaris* (1972), or even *Interstellar*. As I got older, I convinced myself that *Making Mr. Right* examined deep questions about human relationships with artificial intelligence. Yet it turns out that the only relationship explored in *Making Mr. Right* is a romantic one that leads to sexual gratification. In a way, I (or, in this

case, my brain) tricked myself into thinking that *Making Mr. Right* was a more profound experience than it was.

This isn't the first time this has happened, and it's unlikely it will be the last. Films, books, television shows, comics, any media that has become a part of oneself, are often interpreted differently at different times in life. As a kid, I wanted to be Superman or Luke Skywalker, yet I now feel I have more in common with the bumbling Clark Kent or the hapless C-3PO. Perspectives change all the time. It is unlikely I'll ever again watch *Making Mr. Right*, yet despite that, I now know that last moment, when Dr. Peters is heading toward the unknown cosmos alone and content, still feels the same and will still resonate with me for the rest of my life. It is a deception, a false hope, I am happy to believe in.

The Watchlist

Terminator 2: Judgment Day (1991)

WALL-E (2008)

Short Circuit (1986)

Short Circuit 2 (1988)

Chappie (2015)

Interstellar (2014)

Blade Runner (1982)

Making Mr. Right (1987)

Star Trek: Nemesis (2002)

Solo: A Star Wars Story (2018)

Rogue One: A Star Wars Story (2016)

THE SLOW DISSOLVE

Much of this book has concerned itself with film and has included surrounding texts to help delve further into what I believe (if you haven't guessed by now) is the cultural significance of the medium. I want to deviate slightly from the filmic aspect of the text and comment on the technological nature of social media and what it has done to our societies on both a positive and negative front. Although we're leaving the realm of film behind, I think the arrival at the subject of social media and the internet is fitting in this sense and for a book titled *Screen Captures*. Our lives are now being fully captured by screens. Social media is the new movie experience. People no longer desire to act in films as fictional characters when they can act as themselves, or as a hyperreal version of themselves, in so-called real life and see it captured instantaneously.

In the 1998 book *Life: The Movie: How Entertainment Conquered Reality*, Neal Gabler commented on the idea of life becoming the subject of film, stating that "life would be the biggest, most entertaining, most realistic movie of all, one that would play twenty-four hours a day, 365 days a year, and feature a cast of billions."[1] To this effect, and even before the rapid rise of the internet, Gabler noted that we had already cast ourselves within our own mini-productions. Life was a performance even back then. Yet, at the time of the book's release in the late 1990s, the audience was minuscule. Web 2.0, the internet experience we know today, was still years away. Social media, to the extent we see it today, barely existed.

But our real life isn't very real at all. The recent rise of social media places its users at the center and encourages the mining of so-called real life to create content. But with this desire to create content, are users more preoccupied with this matter than with the leading of an actual normal existence? Can the two things even co-exist?

In the 1963 play *The Milk Train Doesn't Stop Here Anymore*, Tennessee Williams asked, "Has it ever struck you that life is all memory, except for the one present moment that goes by you so quick you hardly catch it going?"[2] This question was no doubt profound for the early 1960s, when the play was written and originally performed. All life was a memory. In the early '60s, recording moments of one's life could only be done by the still photograph or the 8mm or 16mm film reel of the chunky home-movie camera. And even these methods were costly and would fade over time. The capture was never instantaneous as such, the "one present moment" still slipped into the past while you waited for the Polaroid to come to life or for the pharmacy to develop the photographic film when you returned home from holiday. Now footage and photographs are viewable in an instant.

Williams's question has little relevance to our current culture, where memory is so easily captured in the present moment. But it is one that we should meditate on to better understand our situation. Today, moments and memories can be captured in a few seconds, uploaded to a social-media site such as Twitter, Snapchat, Instagram, Facebook, or TikTok, and shared around the world in minutes. In fact, the act of sharing becomes almost a part of the initially captured moment. This isn't really a new development. We've been here since the early incarnations of social media. We all wanted to be internet sensations when sites such as Myspace launched in the early 2000s. Some users did find stardom. Talented young musicians, artists, and filmmakers were able to skip the middlemen of record companies and film production houses and direct Myspace users to their creative endeavors online. Myspace allowed us to display

our creative sides and creative moments in almost real time. But it never breached the level of personal capture that we're seeing today. At that time, there always seemed to be a barrier we were unwilling or unable to cross.

We have entered a time when every second of every day of our lives is a moment to record, upload, and share. Apps such as TikTok, which has spread like wildfire to almost two billion downloads at the time of writing, capture a user's moments in three-second, one-minute, or three-minute bursts. Recorded moments or scenes from daily life can be uploaded instantly and shared among the app's users, and then shared beyond the platform to other social-media sites such as Instagram, Twitter, and Facebook. Most of the content is users miming and dancing to a range of popular songs and performing comedic skits and memes. There is little prep or staging of the content. Most of it is filmed in and around users' regular homes, schools, or neighborhoods. It is a fun, inclusive, and supposedly unfiltered way of creating and sharing. Most of the popular users of TikTok are ordinary folk who have an air of authenticity to the way they use it.

Like most social-media apps, TikTok has its stars and viral sensations. These users, like gamers on YouTube or comedic pranksters on Vine, have commodified and monetized their unexpected popularity, earning millions in advertising collaborations and book and TV deals, and selling what appears to be an authentic lifestyle to their millions of followers. TikTok's most famous stars include dancers Charli D'Amelio (100 million followers), her sister Dixie D'Amelio (46.3 million), and Addison Rae (70 million). They have all conquered TikTok in the space of a year, quit school, and moved themselves and their families to Los Angeles to, as Rae stated, "pursue TikTok."[3]

All social media presents positive and negative experiences. But there is a sense that apps like TikTok have turned life itself into a kind of living movie, allowing for a way of filling up every 24 hours with continuous content. Life is no longer to be experienced in

that "one moment," as Williams wrote, but to be mined and used as material to be shared in the hope that it generates enough buzz and likes to hit that viral moment. And that viral moment must be a positive. A negative viral hit damages your real-life existence. Ask Amy Cooper, the white lady who, in October 2020, called 911 in New York's Central Park and accused Christian Cooper, a black male birdwatcher, of harassment and making threats to her and her dog.[4] What Christian Cooper was actually doing was pointing out quite politely that Amy Cooper's dog should be kept on its leash. For an even earlier example of negative impact, one need only look at the torment suffered by Ghyslain Raza, more famously known as "the Star Wars Kid." Raza filmed himself on a school camcorder twirling a golf-ball retriever in his school's gymnasium in the style of Darth Maul, the Sith villain from *Star Wars: The Phantom Menace*. This took place in 2002 and could be described as one of the first viral memes and certainly one of the first cases of internet cyberbullying, even though social media and video sites such as YouTube barely existed at this early moment in the internet's history. Raza's mistake was leaving the cassette tape of his warrior moves lying around in the school environment for his classmates to find and share. Amy Cooper's mistake was using her whiteness and knowledge that police often use racial profiling and unnecessary force against black males to her advantage. Arguably, these misdemeanors offer the same result.

Life is delicate and mistakes take place all the time. In a normal environment, or a pre-internet world, such a mistake would be an opportunity to learn and grow, involving a small group of family and friends. Now, a mistake, a slip, a moment of frustration, or a true revelation of racism recorded and shared to "go viral" becomes a forever-defining moment.

A positive viral moment enhances the lived experience. You can make a fast buck on a positive moment, move to sunnier climes, and move into the circles of other positive internet influencers. A

negative hit might mean you lose your job, your friends, your lover, your right to privacy, or your quiet existence. You might even have to move to a new home, city, or country. The internet never forgets a negative. Any misdeed captured in public can be revisited again and again. It never needs reediting or rehashing. It's perfectly awful as it is.

On the flip side, the positive viral hit needs constant tweaking. You only get one good shot at the big time. Follow it up with failure and you're done for. But keep hitting those positives and social media will make you a star with the demands of more and more material. Life must be captured in all its realness. Fakery, aggression, frustration, rudeness will be called out instantly by followers. If the mask of authenticity slips, you'll know about it.

But this leads to a conundrum. Everyday life is to be experienced and then relegated to a memory. We can't exist with the notion that moments in life have to be hyperreal and then technologically preserved and shared. Can we really spend every waking minute developing material for our so-called personal narrative? How do we develop and grow if all we are doing is simply maintaining our current moment? In the 2014 book *10/40/70: Constraint as Liberation in the Era of Digital Film Theory*, Nicholas Rombes states that "it has become evermore difficult to escape ourselves; we are reflected and reproduced everywhere, our intentions and desires mirrored across the interwebs, in targeted ads, the ubiquity of ourselves reaching an ever higher-pitched madness."[5] This, ad nauseam. We are forever in our own presence and we are transferring that presence online.

II

TikTok is not to blame. We landed here decades ago. The internet might not even be to blame. Game shows from the mid-20th century placed a real person on-screen to win or lose, but television

shows like *The Real World*, which aired from 1992 to 2017, and *Big Brother*, which began in 1999 and franchised across the globe from then on, were the real starting pistols of what we see today. This trend in reality television continued and mutated with *Pop Idol*, *America's Got Talent* (and its international variants), *Dragon's Den*, and *The Apprentice*, to name only a few. In these shows, the ordinary citizen was thrown into the extraordinary realm that would usually be occupied by incredible talent and celebrity. Yet, in this organized and televised realm, there existed a gatekeeper of sorts. A recognizable media personality to swat the contestants away, or, in the case of the American version of *The Apprentice*, a future president to proclaim "You're fired" or "You're hired" to the contestants. Some of the contestants on these shows were viewed with awe; most were ridiculed and sent home in disgrace and never heard from again.

The stunted growth of humans has arguably been in place since Francis Fukuyama's "end of history" declaration, when we reached "the end-point of mankind's ideological evolution and the univer-salization of Western liberal democracy as the final form of human government."[6] When Communism fell in 1989, there was "no real alternative,"[7] as British Prime Minister Margaret Thatcher had so bluntly put it in the 1980s. Neoliberalism was now the ideology for humanity's long haul.

With the friction of combative ideological competition absent from our lives, we have morphed into what Alex Williams and Nick Srnicek point out as an eternal present: "rather than a world of space travel, future shock, and revolutionary technological potential, we exist in a time where the only thing which develops is marginally better consumer gadgetry."[8]

Williams and Srnicek are on point. Social-media apps have gotten marginally better since Myspace was first introduced. And the tech-nology to engage with social media and the internet has improved a great deal. We all now carry a professional-quality digital camera in our pocket, able to record and photograph in incredible depth

and color. The whole history of human endeavor and knowledge is just a click away.

This has allowed Facebook, YouTube, Instagram, Twitter, and TikTok, among others, to thrive and provide its users with unlimited content. But that is also the extreme downfall. We have become the supplier and the demander, the provider and the consumer. The apps are simply the platform, quiet and omnipotent in the background of our lives and unable and unwilling to help us navigate. We've posted our lives to these social-media apps, and in turn they have generated great wealth off the back of our endeavors, what might be considered our actual labor. Our positive and negative viral hits are equally lucrative to these apps. I suspect the negatives are maybe more lucrative. The apps offer no support network for those thrown into the limelight, no guidance on how to navigate a new realm of continuous content creation and unending audience interaction of comments and messages.

Our faces and memories are stored in the ether of the internet, accessible to us, but also to everyone else. Life is no longer memory in the way Tennessee Williams considered it. Life is not a passing moment that you can hardly catch, but an "eternal present" which we're completely stuck in.

This is fame now. No hard work, no education, no training in the art, just the luck of the draw — although this is somewhat unfair to the Tiktokers named above, as they have very clearly trained in the art of dance or had singing lessons. But still the fame of TikTok is accidental. Every second of our existence is an opportunity to find the zeitgeist. It could take months, years, but it takes zero practice.

We've committed to the existence of never moving forward. Our only pursuit is the "pursuit of TikTok," the idea of accidental internet fame, which isn't a pursuit at all, but a stumbling in the dark.

Before I'm called out for the geriatric millennial grouch I probably am, let me clarify a few points. The Gen-Z and younger millennial users who dominate social-media platforms with their dancing,

timely memes, and comedic exploits are filling a void left by the lack of actual opportunities in work and life that they are currently faced with. The users themselves might not realize this is the case, and only in some subconscious layer would they even consider it to be true. The users of apps like TikTok are creating a culture and work environment for themselves after actual work was ripped away from them by the financial crash of 2008. Yet, even before this event, the decline in decent-paying work, union membership and influence, good benefits, and bright futures was already evident.

Citizens of the West have seen and indeed lived with a crumbling economy, the decline in health-care benefits, ecological collapse, and the subversion of media forms to pass lazy opinion off as mainstream news. The current crop of Gen Z acknowledges that life for them is going to be tougher when they see people the same age or only a few years older than they are working "gig economy" or "bullshit" jobs for platform-based apps like Uber, Lyft, or Skip the Dishes, working on Fiverr projects for literally $5 per project, stacking shelves at Walmart or Target, or packing up Amazon orders in a hot and dangerous work environment on casual, nonunionized contracts. Scraping together a living and being only a paycheck away from destitution and malnutrition are the unfortunate outcomes for many. Social media offers an emotional outlet for some, but it also offers a way out of this possible future.

The issue here is that the commodity being sold is life itself. The product is the individual. And the paycheck for this commodity only occurs if the act is embraced on a massive scale and on a positive hit. The "wage" doesn't come from the app, but from the outside opportunity it provides: the brand endorsements, the modeling contracts, the product collaborations. There is no payoff for being outed as a racist "Karen" or a white supremist, an anti-masker, a conspiracy nut, a brutal cop, or even a supporter of Donald Trump. The insurrection by MAGA pro-Trump supporters in Washington, D.C., on January 6, 2021, hasn't led to a single insurrectionist being offered a Fox

News slot or a radio hosting gig. Mostly, those involved have been arrested and tried in court. No matter how many times the video of the event is viewed, it's not paying a dime, and it's unlikely to lead to a lucrative future for the individual. Rightly so in this case, though the app will benefit greatly from their felonies. Nobody should be profiting from the promotion of hate, bigotry, misogyny, or racist views, although plenty of so-called "legitimate" news sources do. Yet, the "wages" from any kind of labor performed on TikTok and social media go directly to the platform and its owners and shareholders. In this sense, life is subservient to the app.

III

Is there a way out? In "Nosedive," the first episode of Season 3 of the satirical futuristic noir series *Black Mirror*, which debuted on Netflix in October 2016, the whole of society works on a ranking system in which interactions are "liked" and each citizen's score out of a possible five is available and monitored by a kind of Google Glass optical implant that seemingly everyone has had installed. Sweet-natured Lacie Pound (Bryce Dallas Howard) seems to be doing everything right by society's standards. She hovers at a respectable low-four ranking and her interactions with others are mostly positive, which means her score and status are continuously on the rise.

When Lacie is invited to be maid of honour at her best friend's wedding, she leaps at the opportunity to see her social standing skyrocket by performing an emotional and engaging speech to a prestigious audience of those rated in the high fours of social standing. However, her journey to the wedding becomes an odyssey into a personal hell. Lacie is stripped of one point in her ranking when she has a public outburst at the airport after learning that her flight has been cancelled. She rents an older-model electric car to drive to the wedding, but the car loses power and an adapter for

the charger can't be found. Lacie publicly loses her cool, again. She then hitches a ride with a low-ranking truck driver who informs Lacie that not caring about the ranking system was a liberating experience. The trucker drops her off close to the wedding venue, and leaves Lacie with a bottle of liquor. When she finally arrives at the wedding, she is emotional, her dress is torn and dirty, her mascara smeared across her eyes and cheeks; she is consumed by desperation to regain her original ranking. During her rambling speech, the police arrive and escort her away. She is placed in a glass prison cell across from a male who has also suffered from having his ranking ripped away from him. They joyfully hurl insults at each other, knowing no ranking system will care. In the space of only a few hours Lacie has become an outcast of society, but she has also become free from the tyranny of the app.

Considering Lacie's journey is an odyssey of social alienation, I took an immensely positive message from this episode of *Black Mirror*. Lacie finds a way to unshackle herself from society's expectations of her and the expectations that social media places on all of us, and in doing so actually allows herself to become free of the burden that seems to continuously eat away at our existence. We should certainly be more like Lacie when it comes to the realization that freedom from social media is freedom from the constraints of society.

The focus on TikTok here has been mostly negative, but let me be clear: the internet and social-media platforms are hardly the issue. The issue is the way in which we use these platforms. This is my chief complaint. Using social-media apps to capture moments of our lives perhaps isn't the best use of what these apps offer. Apps like Facebook, Twitter, and TikTok can be used and indeed have been used to great effect to organize resistance movements and allow acts of peaceful civil disobedience. They can also allow users to highlight and share atrocities, acts of violence, acts of police brutality. They allow users who are powerless in society to suddenly take the reins of power in creative ways. A few examples: When Donald Trump

announced a rally in Tulsa in 2020, TikTok users who identified as fans of K-pop (a genre of Korean music) applied for tickets to the event with no intention of ever showing up. This made the event appear to be a much-anticipated rally to Trump and his cronies, but left hundreds of seats empty. As an act of civil protest, this may have seemed miniscule, but when it brought together hundreds if not thousands of users, it suddenly created a massive impact.[9]

In the U.K., university students have used TikTok to highlight the appalling condition of houses, apartments, and halls of residence they are forced to inhabit. Users of the app have created short videos showing mold, mysterious stains, floods, fire damage, and unlockable doors. The very health and safety of the students are at risk, and by calling it out via social media and flagging the issue to a wider public, they create a discourse that will hopefully be addressed by landlords and local authorities.[10]

Here's where social media and the devices we carry with us become useful. We now have on our person the means to create visual stories. In some cases, we are using the narrow time limits this offers to our advantage.

The use of social media will only increase in popularity, but users should begin a self-directed program of slowly dissolving away from the online environment before the real dissolve happens from our side of the screen. This isn't to propose a technological detox or "unplug." Simply turning off our devices and walking away will never work out well for us. But we need to acknowledge that the deeper we fall in, the harder it will be to eventually claw our way out. The unstable climate, the political discord, the abandonment of societal needs and desires for advancement and equality have been swept aside and forgotten, bred out of our existence because of the distraction we supply ourselves with. When it's too late and the collapse really begins, we will have to take notice, but our social networks won't be there to help us. They'll stutter, disperse, and be gone. We'll only have each other.

The Watchlist:
Black Mirror, "Nosedive" (2016)
HyperNormalisation (2016)
Lo and Behold, Reveries of the Connected World (2016)
The Social Dilemma (2020)
Jexi (2019)
The Congress (2013)

AFTERWORD: CINEMA DURING AND AFTER A PANDEMIC

It is odd to conclude a book that concerns the subject of film and the cinematic encounter when film itself, or the collective experience of going to an actual cinema, has been off the radar in recent times.

The Covid-19 coronavirus pandemic that began its relentless crawl across the globe in late 2019 and early 2020 shut up shops, gyms, libraries, live venues, workplaces, schools, and, of course, cinemas. Not only was a whole schedule of planned releases shelved, postponed, or diverted to online streaming, but film production itself also had to pull down the shutters. Jobs in the creative industries were all at risk. Production crews had to be laid off, actors had to return to their homes, and, in this void of sudden worklessness, they waited out the storm. The slow reopening of public spaces in mid-2020 meant only a slow trickle of patrons returning to movie theaters. The mass-attendance of the latest blockbusters has not seen an immediate return to normality. As the wave of infections rises and falls in different parts of the globe, cinema spaces have had to re-open and close again and again in reaction. Film productions have resumed under very tightly run and coordinated pacts of safety and restrictions, with Covid-19 officers present at all times and monitoring and testing cast and crew daily.

The changes to the industry could now be permanent. In December 2020, movie powerhouse Warner Bros. Pictures announced that its entire 2021 slate of films would be available on the HBO Max streaming service at the same time the scheduled films hit movie theaters. There will be an uneven balance between letting younger

patrons who might be at less risk of serious health problems, those willing to take that risk, and those who have been vaccinated occupy the cinema space, and requiring some of us to stay home and pay a subscription fee to a streaming service to watch the latest movie releases. When the pandemic passes completely, this new routine of staying home and seeing the latest films on television screens will be hard to break for many of us.

While the majority have been concerned with the demise of the big-chain multiplex, the movie venue that relies heavily on the distribution of big-budget blockbusters, not much thought has been lent to the smaller independent and art-house cinemas across the world. The business model of socially-distanced seating and continuous cleaning of the space applies less well to smaller spaces that rely on volunteer staff and on screening films that play better in these environments.

This is obviously a sad situation in any circumstance. Not only is the loss of jobs a crushing blow to the industry on both sides of the screen, but we the audience lose the sometimes beautiful, sometimes frustrating, always memorable experience of watching a film on a massive screen, surrounded by complete strangers munching on popcorn and offering spontaneous commentary. The inclusion of many of the films discussed in this collection, either at length or in passing, stems from the experience of watching them on the big screen. This is not to say that the only experience must be this one. Far from it. I first saw some of the films discussed here while lounging in bed on a Sunday afternoon as a kid, or, as an adult, after scrolling through Netflix and being hooked in by the autoplay trailers. To me, the impact is just as visceral. But I believe that the anticipation, immersion, and concentration offered by the cinematic experience help with peeling back the layers far quicker than lounging on a bed in a pair of jammies can ever hope to.

The films of the Marvel Cinematic Universe, just to pull on an example, are a roller-coaster ride when seen on the big screen. The

action sequences fly off the screen, while the audience interaction heightens the drama and overall experience. As these films moved from Netflix to Disney+, and the first Covid-19 lockdowns forced me to revisit them in chronological order, it was harder to pay attention to the long-playing narrative that threads the films together. Did Steve Rogers fight Bucky in this film or that one?

So, sitting in a cinema is better for a certain type of film. But if the Covid-19 pandemic has taught us anything, it's that we cannot take anything for granted anymore. Movie theaters across the globe, chains and independents alike, are dying out. This was happening even before we suddenly were not allowed to go to the movies. If they survive, it will be in a reduced capacity. Social-distancing measures and mask-wearing were hard to get used to. Going without a mask or feeling safe again will be a long way off. Will film adapt to this new norm?

I would argue that film already has begun that adaptation, and this might mean that access to film will become much wider. It took a pandemic to initiate the changes. During the first virtual version of my city's annual film festival in winter 2021, it was noted that in attendance were patrons from Paris, Ontario, and Paris, France. With film festivals across the globe opting to present virtually, the attendance isn't localized to one region, but instead reaches out globally. This scenario played out in countless festivals. Of course, it is not the same as enjoying these films collectively, but as Alissa Wilkinson noted in *Vox* as the 2021 Oscar nominations were announced, it was far easier to watch the nominated films via streaming services than it would have been in a normal year, when the smaller independent films might show only at a handful of cinemas or festivals to achieve eligibility. Wilkinson also noted in the same article that the diversity of voices in the films that were nominated was far wider than in previous years.[1] Smaller independent films from across the globe had risen above the din of major blockbusters and showy dramas.

If most people are not going to sit in a full auditorium to experience the thrill ride of blockbuster cinema, does Hollywood still need to be making films that require such mass attendance to recoup? A better model for the future of film would be to invest in smaller films that cost less to make and market, and to allow a smaller audience to seek them out and appreciate them. The change we see could be seismic. More films, more experiences, more perspectives.

This scenario is sad for the appreciator of the lowbrow cinematic spectacle, but it supplies a unique opportunity for the art lover. Imagine where we'll be five years down the line. Film may not be a collective experience, like a sporting event or a concert, but it will be more so an artistic expression of humanity that channels experience to enlighten and educate the masses. I do not mean this in any dry socialist-realist sense, but film might not be popcorn-centered entertainment. What it might be is a story that tells us who we are and what we could be. In the post-pandemic world, I cannot think of a better way to reinterpret and reconnect our human purpose and our sense of renewed community than through film.

And we, the audience, can and absolutely should lead this change. We should not just be relegated to the role of audience or attendee when it comes to the future of film, we should become patrons of film.

Patron participation, however rudimentary, in a film's production could be a step toward more democratic inclusion in the future of film and filmmaking. For almost a century, film studios, producers, and directors have bestowed their vision upon us. Never has an audience collectively and actively participated in the process of casting decisions, which director and production team best suits the material, which cinemas the finished film should play in, the budget required. Even judgments about which film is the best of the year, or which has the best technical qualities, are made by a cabal of film-academy insiders who proclaim their evaluation sound and in no way incorrect, yet often these decisions are up for debate among film critics

and audiences alike, who get no say whatsoever in the process. So, in the post-pandemic world, let us abolish the best-film Oscar! In fact, abolishing all awards shows and competitions would be preferable.

As our world faces constant calls for more freedom, democracy, and social justice, and an end to bureaucracy and inequality, we should look to film as an apparatus for change, a reflection of our society as it stands and a pointer toward one we want. Perhaps the best way to claim ownership over film is to demand films that offer insight and intelligence and abandon the spectacle of mainstream Hollywood productions. And if a cinematic spectacle must happen, a Star Wars film or a Marvel movie, a post-catastrophe disaster flick, make it say something, give us the reflection of our current condition and a way out.

We should insist on better access to the types of films that promote change and expand on new ideas. The way that we can make this change and refresh the mediocre cinematic landscape is by using the very backbone of democracy: voting. Not by filling out ballots or placing films in competition, but by taking the cinema-ticket purchase to the smaller, independently made, and provocative movies that do make it to cinema screens, and then taking it further by purchasing the DVD or streaming the film online, which in this case might be the only way we first access these types of films. Take those hard-earned dollars to the downtown indie cinema, not the conglomerate multiplex that sits atop a vast car park. All this activity sends a message to the film producers that as patrons we demand the right to access film that says something realistic about who we are and where we are.

It seems like an impossible change, but it has happened before. Movements within film have reflected wider changes in society. The New Hollywood era of films that ran from the mid-1960s to the early 1980s featured uncompromising critical reflections of America at that point in time. The vast number of films that were produced under the New Hollywood banner were wildly diverse, but also

made with slim budgets and small casts and crews. These films were made because Hollywood was losing touch with the audience, producing often huge spectacles and musicals that didn't fairly reflect the divisions and the cultural experiences of American life. The same could be said for the very brief period of post-war British films that came under the banner of the British New Wave, which, like its later American variant, showed the trials of working-class life and contained the so-called "kitchen-sink realism" of the everyday. The mumblecore movement that rose in the mid-to-late 2000s, led by filmmakers such as Mark and Jay Duplass, Greta Gerwig, Lynn Shelton, Andrew Bujalski, and Joe Swanberg, is another example of young, ambitious, and diverse voices using film as an apparatus of expression and critique of American life, in this case on behalf of those living in the post-9/11, post–2008-financial-crash landscape. These films show how limited opportunities in jobs and life have emotionally affected and traumatized the older, liberally educated millennial generation. They use a cheap, naturalistic methodology of creating films and tell an immediate narrative of contemporary life.

And from a patron perspective, there is a promising start to envisioning a future. Film patrons are campaigning, creating a stink, demanding better representation and acknowledgment of the achievements of female, black, and Asian filmmakers and actors. Hashtags such as #OscarsSoWhite have trended on social media and shamed the academy into representing diversity. The 2021 Oscar nominations are a testament to the strength this one campaign has had to recognize diverse voices. The hill to climb is still a slog, but progress is being made.

Another case in point is the fan campaign to release the Zack Snyder cut of 2017's *Justice League.* The campaign began as a targeted hashtag on social media and eventually led to Warner Bros. handing over $70 million to the film's original director, Zack Snyder, to recut the film in his own vision. The result: a four-hour version of the film that includes newly shot and unused footage and effects work. Say

what you will about the quality or the need to witness a four-hour superhero film, but patron voices were heard. A cultural moment arose out of the desire of some who were simply unhappy with the studio release of a superhero franchise movie, causing the shooting, editing, and release of a new version

Film is a window into another world, and that world should feel wholly different from our own. It should be a short exodus to a way of thinking, feeling, knowing, and believing that other perspectives exist and matter. *Screen Captures* is the title of this book. Most obviously, I chose that title to express my desire to capture the essence of what is explored here. But it has other senses. Screens now define not only cinema and television, but also our own pocket devices that can show us a film at any time and allow us to capture ourselves and our own lives. Finally, *screen capture* reflects the captivating nature of film on a personal level that leads us to imitate and emulate what we have grown up to believe: that film is the pinnacle of prominence in our society. The ultimate accessible art form.

ACKNOWLEDGMENTS

Some of the writings collected here have been published in various forms and numerous places, mostly online, but also in print. Many thanks to the editors of the journals in which some these essays first appeared: Victor Fraga at *Dirty Movies*, Dominic Preston at *Candid Magazine*, Alfie Bown, Daniel Bristow, and Grant Hamilton at *Everyday Analysis* and the *Hong Kong Review of Books*, Rosemary Deller at *LSE Review of Books*, Houman Barekat at *Review 31*, John Whitehead at *Gadfly*, Jeff Barbeau and Wendy Huot at *The Screening Room*, Marshall Poe at *New Books Network*, Justin Chadwick at *Albumism*, Denise Enck at *Empty Mirror*, Liza Palmer at *Film Matters*, Sam Stolton at *3:AM Magazine*, Mat Colgate at *The Quietus*, David Kerekes at Headpress Books, Doug Lain at Zero Books, Jeroen Sondervan at Amsterdam University Press. I would also like to thank the past and present members of CUPE 2202 and 2202.1 for their friendship and solidarity, "We bring your library to life."

David and Kate, David and Signe, Bec and Tim, Michael and Sam, Andrew and Hannah, Gareth and Charlotte, Dipesh, Mariam, Iain, Clare, Jeff, Wendy.

Stay Beautiful to the friends made on Twitter.

Mum, Dad, Joanne, Libby, Evie, Brian, Kara, Gail, Ross.

Many thanks to the wonderful team at New Star Books for commissioning this work and for their continued support.

As always, thank you to my wife Jamie, my son Hayden, my daughter Isla, and Puff the cat.

SOURCES

Shut Up, Capitalism!

1. Alexander Reed Kelly, "Chris Hedges on 'The Pathology of the Rich,'" *Truthdig* (6 December 2013), https://www.truthdig.com/articles/chris-hedges-on-the-pathology-of-the-rich/.
2. Jarad Bernstein, "In the New Progressives vs. Davos, Round One Goes to the Left," *Washington Post* (28 January 2019), https://www.washingtonpost.com/outlook/2019/01/28/davos-vs-new-progressives-round-one-goes-left/.

Star Wars Accelerationism

1. Dita Von Teese, *Burlesque and the Art of the Teese/Fetish and the Art of the Teese* (New York: Harpercollins, 2006), https://www.harpercollins.ca/9780060591670/burlesque-and-the-art-of-the-teesefetish-and-the-art-of-the-teese/.
2. Von Teese, 255.
3. "Star Wars Episode I: All I Need Is an Idea Webisode" can be found here: https://www.youtube.com/watch?v=kUn3nohOtVQ.
4. Jimi Famurewa, "John Boyega: 'I'm the only cast member whose experience of Star Wars was based on their race,'" *GQ* (2 September 2020), https://www.gq-magazine.co.uk/culture/article/john-boyega-interview-2020.

Post-Catastrophe Cinema

1. Mark Fisher, *Capitalist Realism: Is There No Alternative?* (Alresford: John Hunt, 2009), 2. In *Capitalist Realism*, Fisher attributes "It's easier to

188 | SCREEN CAPTURES

imagine the end of the world than the end of capitalism" to Fredric Jameson and Slavoj Žižek, but Fisher defines and encapsulates the slogan, and even the first chapter of his book is titled this.

2. Stephen Lee Naish, "Life on Earth Is Evil: Cinema and the Collective Longing for Annihilation," *The Quietus* (24 February 2014), https://thequietus.com/articles/14569-stephen-lee-naish-uessay-disaster-movies-and-the-collective-longing-for-annihilation.

3. Film director Robert Altman was forward in his rebuke of Hollywood after 9/11, stating that "Nobody would have thought to commit an atrocity like that unless they'd seen it in a movie." See: Stephen Prince, "Shadows Once Removed," *Firestorm: American Film in the Age of Terrorism* (New York: Columbia University Press), 71–123.

4. Chris Hedges and Joe Sacco, *Days of Destruction, Days of Revolt* (New York: Random House, 2013), p. xi.

5. Richard Kearney, *On Stories* (London: Routledge, 2002), 5.

6. Kearney, 4.

7. Kearney, 1.

8. Bertolt Brecht, "Motto," *Bertolt Brecht Poems, 1913-1956*, ed. Erich Fried (Eyre Methuen, 1972), 320.

9. Roy Scranton, *Learning to Die in the Anthropocene: Reflections on the End of a Civilization* (San Francisco: City Lights, 2015), 79.

Men on the Verge of a Nervous Breakdown

1. Valerie Solanas, *SCUM Manifesto* (London: Verso, 2015), 38.

2. This begins Donald Trump's official biography on the Trump Organization website, located here: https://www.trump.com/leadership/donald-j-trump-biography.

3. Solanas, 50.

4. Donald Trump's comments can be found on the *Guardian* newspaper website here: "'I'll keep you in suspense': Trump Refuses to Say He Will Accept Election Result — Video" (20 October 2016), https://www.theguardian.com/us-news/video/2016/oct/19/donald-trump-accept-election-result-debate-video.

5. Solanas, 38.
6. Ben Schreckinger, "Trump Attacks McCain: 'I like people who weren't captured,'" *Politico* (19 July 2015), https://www.politico.com/story/2015/07/trump-attacks-mccain-i-like-people-who-werent-captured-120317.
7. Solanas, 39.
8. Solanas, 55.
9. Solanas, 64.
10. Solanas, 40.
11. Solanas, 40.
12. Nick Gass, "Trump on Small Hands: 'I guarantee you there's no problem,'" *Politico* (3 March 2016), https://www.politico.com/blogs/2016-gop-primary-live-updates-and-results/2016/03/donald-trump-small-hands-220223.
13. Solanas, 40.
14. Solanas, 46.
15. Solanas, 55.
16. Solanas, 43.
17. Solanas, 71.
18. Solanas, 75.
19. Solanas, 58.
20. Solanas, 78.
21. Solanas, 55.

Northern Exposure
1. Daniel C. Dennett, "Living Without the Internet for a Couple of Weeks," *What Should We Be Worried About?: Real Scenarios That Keep Scientists Up at Night*, ed. John Brockman (New York: Harpercollins, 2011), 15.
2. Ben Beaumont-Thomas, "North Korea Complains to UN About Seth Rogen Comedy *The Interview*," *Guardian* (10 July 2014), https://www.theguardian.com/film/2014/jul/10/north-korea-un-the-interview-seth-rogen-james-franco.

3. Paul Fischer, *A Kim Jong-Il Production: The Extraordinary True Story of a Kidnapped Filmmaker, His Star Actress, and a Young Dictator's Rise to Power* (New York: Flatiron, 2015), 224.

4. Paul French, *North Korea: State of Paranoia* (London, Zed, 2015), 24.

The Middle Word in Life

1. Jason Barlow, "'Easy Rider' Rides Again," *Independent* (23 October 2011), https://www.independent.co.uk/life-style/easy-rider-rides-again-1189241.html.

2. Geoffrey Wansell, "The Remarkable Story Behind Rudyard Kipling's 'If' — and the Swashbuckling Renegade Who Inspired It," *Daily Mail* (15 February 2009), https://www.dailymail.co.uk/news/article-1146109/The-remarkable-story-Rudyard-Kiplings-If--swashbuckling-rene-gade-inspired-it.html.

3. Rudyard Kipling's poem "If" is sourced from the Poetry Foundation website: https://www.poetryfoundation.org/poems/46473/if---.

4. Kipling, "If."

5. Kipling, "If."

6. Charles Drazin, *Blue Velvet* (London: Bloomsbury, 1999), 53.

Being Nicolas Cage

1. Lindsay Gibb, *National Treasure* (Toronto: ECW, 2015), 2.

2. Gibb, 37.

3. Gibb, 16.

4. Gibb, 19.

5. Gibb, 34.

6. Gibb, 36.

7. Gibb, 65.

8. Gibb, 69.

9. Gibb, 70.

10. Gibb, 74.

11. Gibb, 75.

The Opening Line

1. Hunter S. Thompson, *Fear and Loathing in Las Vegas and Other American Stories* (New York: Random House, Modern Library Edition, 1998), 3.

Crying at Robots

1. Douglas Hofstadter, *I Am a Strange Loop* (New York: Basic, 2007), 20.
2. Hofstadter, 20.
3. Richard Brody, "'Rogue One' Reviewed: Is It Time to Abandon the 'Star Wars' Franchise?" *New Yorker* (13 December 2016), https://www.newyorker.com/culture/richard-brody/rogue-one-reviewed-is-it-time-to-abandon-the-star-wars-franchise.
4. Brody.

The Slow Dissolve

1. Neal Gabler, *Life: The Movie: How Entertainment Conquered Reality* (New York: Vintage, 1998), 58.
2. Tennessee Williams, *The Milk Train Doesn't Stop Here Anymore*, in *Plays 1957–1980* (New York: New Direction, 2000), 525. This quotation from Williams came to me via a back-screen projection that my favorite band, Manic Street Preachers, used during their 2018 UK tour. The quote struck me as incredibly important and precise for our times.
3. Leila Kozma, "Addison Rae Shares New Details About Her Studies at LSU," *Distractify* (1 April 2020), https://www.distractify.com/p/addison-rae-lsu.
4. Troy Closson, "Amy Cooper Falsely Accused Black Bird-Watcher in 2nd 911 Conversation," *New York Times* (14 October 2020), https://www.nytimes.com/2020/10/14/nyregion/amy-cooper-false-report-charge.html.
5. Nicholas Rombes, *10/40/70: Constraint as Liberation in the Era of Digital Film Theory* (Alresford: John Hunt, 2013), 1.
6. Francis Fukuyama, "The End of History," *National Interest* (summer 1989), https://www.embl.de/aboutus/science_society/discussion/discussion_2006/ref1-22june06.pdf.

7. Margaret Thatcher, Speech to Conservative Women's Conference (21 May 1980), https://www.margaretthatcher.org/document/104368.

8. Alex Williams and Nick Srnicek, "#Accelerate Manifesto for an Accelerationist Politics," *Critical Legal Thinking* (14 May 2013), https://criticallegalthinking.com/2013/05/14/accelerate-manifesto-for-an-accelerationist-politics/.

9. Taylor Lorenz, Kellen Browning, and Sheera Frenkel, "TikTok Teens and K-Pop Stans Say They Sank Trump Rally," *New York Times* (21 June 2020), https://www.nytimes.com/2020/06/21/style/tiktok-trump-rally-tulsa.html.

10. Daisy Schofield, "TikTok Is Exposing the Scandal That Is Bad Student Housing," *Refinery29* (9 February 2021), https://www.refinery29.com/en-gb/2021/02/10284529/poor-student-accommodation-uk-tiktok.

Afterword: Cinema During and After a Pandemic

1. Alissa Wilkinson, "A Guide to the 2021 Oscars, Which Are Still Happening," *Vox* (22 March 2021), https://www.vox.com/22213752/oscars-2021-coronavirus-date-streaming.